Documentary Monographs in Modern Art

general editor: Paul Cummings

CNBA
LV

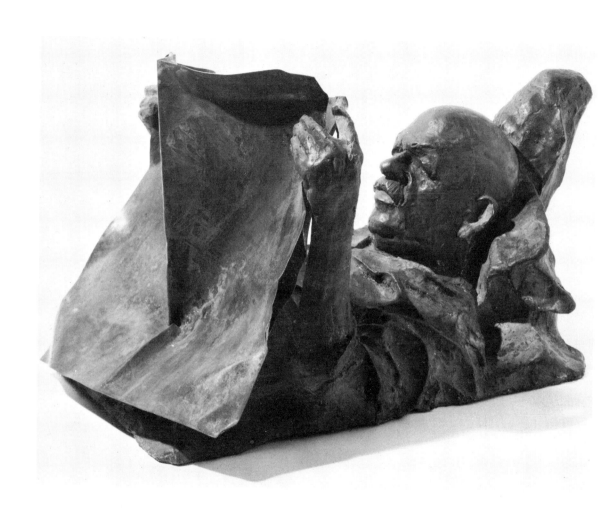

Ben Shahn

edited by

John D. Morse

Praeger Publishers New York · Washington

Frontispiece: Bust of Shahn by his son Jonathan, 1967. National Portrait Gallery, Smithsonian Institution, Washington, D.C.

BOOKS THAT MATTER

Published in the United States of America in 1972
by Praeger Publishers, Inc.
111 Fourth Avenue, New York, N.Y. 10003, U.S.A.

© 1972 by Praeger Publishers, Inc.

Second printing, 1974

Library of Congress Catalog Card Number: 76-178226

Printed in the United States of America

contents

VI COMMERCIAL ART

VII PHOTOGRAPHY

VIII GRAPHICS

IX AESTHETICS

X THE ARTIST AND SOCIETY

XI EPILOGUE

Contents

list of illustrations

Illustrations

acknowledgments

My greatest debt is to Bernarda Bryson, Ben Shahn's wife, who not only typed all of his manuscripts, but made them available to me through the Archives of American Art, the excellent organization that all workers in the field have found indispensable.

For permission to reprint copyrighted text material, I am indebted to the Harvard University Press for *The Biography of a Painting* and *The Education of an Artist;* W. W. Norton & Company for the paragraph from *The Notebooks of Malte Laurids Brigge* by Rainer Maria Rilke; radio station WJBH-FM and Mrs. Lyman Bryson for the interview *Creative Mind and Method;* Grossman Publishers for *Love and Joy About Letters; Harper's* Magazine for excerpts from "After Hours"; the *New Yorker* for "In Homage" from "Talk of the Town." I am also indebted to Charles Coiner for his statement about Ben's commercial art.

For the illustrations I am indebted to the institutions and individuals named under each one. Because no complete list of Shahn's work exists, I wrote to all the known collectors asking them for photographs of any work by Ben Shahn in their possession. Their response was heartwarming, and I take this opportunity to thank them all. Also, I thank in advance any reader of this book for writing me about a Shahn work in his possession— for an inclusion in a *catalogue raisonné* I am preparing.

For help with both text and illustrations I am indebted to Lawrence A. Fleischman of New York's Kennedy Galleries, Shahn's friend and dealer during the last years of his life. Shahn's *Afterword* and Bernarda's *Ben and the Psalms* are reprinted from print portfolios published by Kennedy Galleries. The drawings throughout the book are from the Kennedy collection.

For the Chronology and Bibliography I am largely indebted to members of the staff of the New Jersey State Museum: Kenneth W. Prescott, former director; Leah Phyfer Sloshberg, assistant director; and Peggy Lewis, publications editor. Their catalogue of the Museum's retrospective exhibition of Shahn's work, held in the autumn of 1969, six months after his death, was recommended to me by Mrs. Shahn for its completeness and accuracy. Most useful also was the *Chronology and Bibliography* prepared by Barbara Novak for the Institute of Contemporary Art, Boston, which was published in James Thrall Soby's book *Ben Shahn: Graphic Art.*

Among Ben's many friends who have been helpful and stimulating are Mr. and Mrs. Joseph Blumenthal, Mr. and Mrs. Will Burtin, Walker Evans, Richard Grossman, Russell Lynes, Stephan Martin, and James Thrall Soby.

Finally, I want to thank Paul Cummings, general editor of the Documentary Monographs in Modern Art series, for his gentle, thoughtful prodding which enabled me to finish the book on schedule.

JOHN D. MORSE
October, 1971

introduction,
chronology

Introduction

Ben Shahn was born on September 12, 1898, to a family of Jewish Lithuanian craftsmen—potters on his mother's side and woodworkers on his father's. He had been drawing for many of his eight years when the Shahns immigrated to New York, and so it was natural that at the age of fourteen Ben be apprenticed in a lithographer's shop. The shop was Hessenberg's at 101 Beekman Street in downtown Manhattan, where Ben worked from 1913 to 1917 while attending high school at night in Brooklyn.

These were eventful years in New York—especially so for a sensitive young man who wanted to become an artist and whose family shared with other immigrants a deep concern about working conditions in the lofts and factories where most of them earned their living. The memory of the Triangle Fire lived long after the event of 1911 that claimed the lives of 145 garment workers because the exits had been locked to keep out union organizers. (Twenty-seven years later, Shahn pictured the building in his mural at Jersey Homesteads; see *Ill. 6.*)

There were wonderful new things to see in New York. The Woolworth Building, tallest in the world, was going up around the corner from Hessenberg's. On 8th Street the Whitney Studio Club opened, where Shahn was to exhibit his first paintings; as the Whitney Museum of American Art, it acquired its first Shahn in 1938 (*Scott's Run, West Virginia; Ill. 9*). In 1916, the year Shahn enrolled in a life-drawing class at the Art Students League, Robert Henri and John Sloan were among the teachers there.

All the while, at Hessenberg's shop, Shahn's style was developing under stern supervision. In *Love and Joy About Letters,* Shahn recalls how the foreman made him draw the letter *A* hundreds of times before he would accept it and allow him to proceed with *B,C,D,* and so on, and how he then showed Shahn a craftsman's simple method for determining how to space letters—including the letters of the Hebrew alphabet that Shahn had been drawing since childhood. There can be no doubt that the discipline of this apprenticeship accounts for the vital, flowing line that is the hallmark of a Shahn drawing—and the despair of his imitators.

Shahn engaged in another kind of discipline when, in 1919, he enrolled at New York University. A high school course had interested him in biology, so he decided to pursue the subject in college. He flourished under this discipline of the mind as well as he had under that of the eye and hand, winning three summer schol-

arships at the Marine Biological Laboratory at Woods Hole, Massachusetts. Although Shahn later quipped that he went to Woods Hole to learn how to draw fish, the fact is, it was hard cerebral work that earned him three summers on Cape Cod, where he was to return as an artist in 1925.

After three years of study, Shahn decided that biology was not for him and reconsidered his early ambition of becoming an artist. He transferred to City College in 1921, and the following year he enrolled at the National Academy of Design. It is commonly held that four years of hard work is the least amount of time it takes an art student to learn how to draw. When Shahn enrolled at the Academy, he was a journeyman lithographer with nine years of professional drawing experience behind him. The Academy had little to offer such a student, so it is no wonder that Shahn soon left—to get married and, in 1924, to make the American artist's traditional pilgrimage to Europe. (In addition to giving him professional skill at drawing, Shahn's apprenticeship at Hessenberg's earned him a membership card at Local One of the Amalgamated Lithographers of America, which enabled him to work whenever and wherever he wanted.) Shahn's advice to art students reflects his own European experience: "Go to Paris and Madrid and Rome and Ravenna and Padua. Stand alone in Sainte Chapelle, in the Sistine Chapel, in the Church of the Carmine in Florence."

On returning from Europe and North Africa in 1925, Shahn and his first wife, the former Tillie Goldstein, took a house on Willow Street in Brooklyn Heights. There he met Walker Evans, the photographer, with whom he was to remain lifelong friends. They met in the home of Dr. Iago Goldston, an amateur photographer who had seen Evans at work with his camera and had spoken to him on the street. Other members of Dr. Goldston's circle in Brooklyn Heights were the painter Jules Pascin, the sculptor Robert Laurent, and the poet Hart Crane.

The summer art colony at Truro, near Provincetown on Cape Cod, was a natural extension of Brooklyn Heights for the Shahns. They took a place there in 1925, and Shahn painted beach scenes and landscapes (*Ill. 1*). (His daughter Judith Shahn Dugan now lives in the house with her husband, the poet Alan Dugan, and makes drawings that appear in the *New Yorker* and other magazines). Shahn was not at all satisfied with his painting during this period and declined an invitation to exhibit at the Montross Gallery in 1926 because he felt that his Truro paintings were too derivative of the artists whose work he had sought out in Europe:

Ben Shahn

Matisse, Dufy, Rouault, Picasso, and Klee. Nevertheless, in 1927, he and Tillie returned to Europe and North Africa.

When asked later why he returned to North Africa to spend almost a year, Shahn replied, "I'm a romantic. Delacroix had gone there. So I went. I can't think of another reason." Whatever the reason, the trip produced the material for his first one-man show —at The Downtown Gallery in 1930. It consisted of seventeen watercolors and three oils, chiefly of North African subjects. The sketch on which Shahn based an advertisement for the Container Corporation (*Ill. 17*) may have been one of those shown in the 1930 exhibition; Shahn continually returned to his vast file of drawings to find ideas and images for his later work.

Shahn emerged as an American painter of significance in 1932 with The Downtown Gallery exhibition of twenty-three gouache paintings entitled *The Passion of Sacco and Vanzetti*. He had returned from Europe and North Africa in 1929, still uncertain about how and what he wanted to paint. "Then," he told me in 1944, "I got to thinking about the Sacco-Vanzetti case. . . . Ever since I could remember I'd wished that I'd been lucky enough to be alive at a great time—when something big was going on, like the Crucifixion. And suddenly I realized I was! . . . I painted twenty-three pictures about the Sacco-Vanzetti case in seven months. . . . I don't know where they are now. But from then on I knew what I wanted to do, and I've been doing it ever since."

In 1932, the depths of the Great Depression, Shahn's union lithographer's card was no longer an assurance of income. On the proceeds of the Sacco-Vanzetti show, he painted another series on the trial and conviction for bombing of the California labor leader Tom Mooney. The Mooney series was shown at The Downtown Gallery in 1933, with a catalogue introduction by Diego Rivera. Rivera had become interested in Shahn and offered him a job as assistant on the ill-fated mural he was painting at Rockefeller Center. While working with Rivera, Shahn met Bernarda Bryson, an artist-journalist who had come to New York from Ohio, and whom, after separation from Tillie, Shahn was to marry.

The Mooney series did not sell particularly well, and Shahn encountered the problem that plagued every American artist in 1933—keeping alive while working. Of the many government agencies established by the New Deal, the Resettlement Administration was ideal for Shahn. It needed designers, painters, and photographers. Shahn was a professional artist with three one-man shows to his credit. He knew something about photography

through his association with Walker Evans. Ernestine Evans (no relation to Walker) of the Administration recognized these qualifications and invited him to come to Washington. It was a major turning point in Shahn's career.

Shahn's work as an artist-photographer for the Resettlement Administration, and later the Farm Security Administration, took him to the South and Midwest, where he saw at first hand the effects of the Depression on individuals—"people of all kinds of belief and temperament," he recalled years later, "which they maintained with a transcendent indifference to their lot in life. Theories melted before such experience. My own painting turned from what is called 'social realism' into a sort of personal realism. I found the qualities of people a constant pleasure."

The first evidence of this change in Shahn came in an exhibition at the Julien Levy Gallery in 1940. He had by then completed two murals, one for the Farm Security Administration at Jersey Homesteads (near Princeton) and the other (with Bernarda Bryson) for the Section of Fine Arts, U.S. Treasury, at the Bronx Central Annex Post Office. These were commissioned murals, and their execution on schedule left no time for painting. But Shahn was full of his experience in the South and Midwest and wanted to get it down in paint—with the help of nearly 3,000 photographs he had taken. So he painted on weekends, and therefore called these pictures his "Sunday paintings." (Years later, when asked by a doctor-painter what *he* did on Sundays, Shahn replied, "Oh, on Sundays I practice a little surgery.") *Pretty Girl Milking a Cow* (*Ill. 12*) is a "Sunday painting." Its title is taken from the song of the lonely harmonica-player. He might very well be one of the Musgrove brothers whom Shahn recalls fondly in *The Biography of a Painting*. "There were the five Musgrove brothers who played five harmonicas. . . . There were the poor who were rich in spirit, and the rich who were also sometimes rich in spirit. There was the South and its story-telling art, stories of snakes and storms and haunted houses, enchanting; and yet such talent thriving in the same human shell with hopeless prejudices, bigotry, and ignorance."

The 1940 exhibition marked another turning point in Ben Shahn's career. He now knew what direction he wanted his art to take, and he followed that direction for the rest of his life with only stylistic variations. His own words, in this and other passages quoted in this book make the direction clear: "It is my belief that the work of art is a product of the human spirit," he told art students of Smith College in 1949, "and that, conversely, the function

Ben Shahn

of the work of art is to broaden and enrich the human spirit." This direction has many names, but "humanitarianism" seems to me to come closest—the humanitarianism of Mahatma Ghandi, Dag Hammarskjöld, Edward R. Murrow, and Martin Luther King, all of whom Shahn drew or painted.

By now he and Bernarda were settled in a house at Jersey Homesteads, where he was to spend the rest of his life and rear their three children: Susanna, Jonathan, and Abigail. Shahn explained this move to the *New Yorker* in 1962: "From 1935 to 1938, I worked as an artist with the F.S.A., so I was in on the program from the beginning and knew all about this town. I have five children—all of them are now grown and have left home—and in 1939, when they were kids, I wanted to get them into the country, out of Yorkville, where we were then living. When I heard that a house was available here, it seemed a natural thing to move down." (As a leading citizen of Jersey Homesteads, Shahn was instrumental in having its name changed to Roosevelt in 1945, shortly after the President's death.)

Shahn's greatest triumphs were still to come—in both America and Europe. In America: one-man exhibitions at The Museum of Modern Art, the Phillips Memorial Gallery in Washington, The Art Institute of Chicago, the Fogg Art Museum in Cambridge, the Philadelphia Museum of Art; election to the American Academy of Arts and Sciences and the National Institute of Arts and Letters; honorary doctorates from Princeton and Harvard universities.

In Europe: election to the Accademia dell' Arte e del Disegno of Florence (Shahn was fond of mentioning casually that Michelangelo had also been a member); a one-man exhibition presented in Amsterdam, Brussels, Rome, and Vienna. This exhibition was organized and circulated in 1962 by the International Council of The Museum of Modern Art, which collected and translated eight pages of the critical acclaim it received. The following are examples of that acclaim:

It is possible that Shahn (after Hartley and possibly Marin) is one of the first and at the same time last typical American painters who, precisely owing to their national characteristics, have reached an international importance.—GERRIT KOWENAR in *Het Vrijevolk*, Amsterdam

A great graphic master whose exceptionally personal painting ignores all the styles of the day. Technique often close to naïf painting, transcended by the intentions and the liberty of the drawing. Painting which haunts the memory by its pictorial eloquence and

technique, the profound style and moral content.—*Présence de Bruxelles,* Brussels

The coherence—which in many painters of today identifies itself with the repetition "ad infinitum" of formal inventions—in Shahn's works is a result which originates naturally: each sign, each image has deep roots in the artist's conscience, humanity, political and religious ideas, humor. Shahn's formal coherence, therefore, is nothing but a reflection of man's coherence.—*Auditorium,* Rome

Why does this art speak so strongly to the public? Because Ben Shahn always takes a definite stand and has a very definite thing to say: he is speaking for the social, for the positive, against the provincial, for peace, for humanity.—*Arbeiter Zeitung,* Vienna

Two stylistic changes that accompanied Shahn's transition from "social realism" to "personal realism" appeared gradually in these exhibitions. These were the appearance of symbols together with realistic details, and an increasing warmth of color. These shifts of direction are particularly evident in Shahn's *Allegory* and *The Red Staircase* (*Color Plates IV and II*).

When *The Red Staircase* was first shown at The Downtown Gallery, I took a writer friend to see the exhibition. He stood in the center of the gallery, which was ablaze with color, and looked around. "So beautiful!" he exclaimed. "So beautiful and hard boiled." When I repeated this remark to Shahn, he was so pleased that he asked to meet my friend—and then presented us each with a copy of his silk-screen print *Vandenberg, Dewey, and Taft* (*Ill. 14*).

Shahn had made a limited number of the *Vandenberg, Dewey, and Taft* prints in 1941—just to give away to his friends. His return to serious printmaking in the 1950's was part of his efforts to reach the people whose "qualities" he had found "a constant pleasure." It was not a messianic drive. Shahn simply wanted to share the pleasure of his visual discoveries. In 1949, he told the art students at Andover that the potential artist must choose between being communicative or expressive, but that the two were overlapping. He described himself as primarily a communicative artist, and certainly no artist in America has been technically better equipped to communicate, nor had more of value to say. Because he recognized this with appropriate humility, and because he recognized the fact of the limited audience for easel paintings, Shahn spent the last two decades of his life doing an incredible amount of teaching, writing, lecturing, and printmaking, as well as painting.

He achieved professional status in all of these expressive media,

18

but especially in his writing appear the qualities we have come to look for in any Shahn work: clarity, pungency, coherence, humor, and rhythm. Most of his activities in all five media I have tried to document here. This book is, in fact, an extension of Ben Shahn's art. I like to think he would have enjoyed seeing it in print.

<div align="right">J.D.M.</div>

Chronology

1898	Born September 12, Kovno, Lithuania (then a province of czarist Russia).
1906	Moved with family to Brooklyn, New York.
1913–17	Apprenticed to Hessenberg's Lithography Shop at 101 Beekman Street, Manhattan, while attending high school at night and reading in the public library. Enrolled at the Art Students League of New York for a one-month session, November, 1916.
1919–22	Attended New York University, City College of New York, and National Academy of Design, while pursuing his trade as a union lithographer. Three summer scholarships at the Marine Biological Laboratory at Woods Hole, Massachusetts.
1922	Married Tillie Goldstein, whom he had met in 1919, and by whom he had two children: Judith and Ezra.
1924–25	Traveled with his wife to North Africa, Spain, Italy, and France. During the summer of 1925, in Truro, Cape Cod, Massachusetts.
1926	Lived on Willow Street, Brooklyn Heights. Offered an exhibition at the Montross Gallery and the sponsorship of Frank Crowninshield, but declined.
1927–29	Traveled again in Europe and North Africa, returning in 1929 with wife and three-month-old daughter Judith to Willow Street residence and summer cottage at Truro. Met Walker Evans, the photographer, with whom he later shared a studio on Bethune Street.
1930	First one-man show at The Downtown Gallery, New York, April 8–27: chiefly African subjects. Painted beach scenes at Truro, also *The Dreyfus Case* watercolors. Began ten lithographs illustrating Thomas De

1931	Quincey's essay "Levana and Our Ladies of Sorrow." Painted Sacco-Vanzetti series—twenty-three gouaches on the trial of Nicola Sacco and Bartolomeo Vanzetti, convicted in 1921 of the 1920 murder in South Braintree, Massachusetts, of a paymaster and his guard. They were executed in 1927, when Shahn was in Europe and witnessed many demonstrations against the trial.
1932	One-man show at The Downtown Gallery, April 5–17: *The Passion of Sacco and Vanzetti*. Worked during March–April with Diego Rivera on the ill-fated mural *Man at the Crossroads* in Rockefeller Center. Separated from his wife. Met Bernarda Bryson, who as an artist-journalist in Ohio had favorably reviewed the Sacco-Vanzetti show. They were married in 1935 and had three children: Susanna, Jonathan, and Abigail.
	Group exhibition at The Museum of Modern Art, New York, summer: mural exhibition included two panels by Shahn based on the Sacco-Vanzetti paintings. Exhibition at Harvard Society of Contemporary Art, Cambridge, Massachusetts, October 17–19: *The Passion of Sacco and Vanzetti* and *The Dreyfus Case* (thirteen watercolors).
1933	One-man show at The Downtown Gallery, May 2–20: *The Mooney Case*—fifteen gouaches telling the story of the trial and conviction for bombing of the California labor leader Thomas J. Mooney (he was pardoned in 1939).
1934	Enrolled with Public Works of Art Project. Executed a series of eight tempera paintings on Prohibition theme for a projected mural decoration for the Central Park Casino under the auspices of the Public Works of Art Project (*Ill. 2*). The project was abandoned.
1934–35	With artist Lou Block, worked on mural project for Rikers Island Penitentiary, New York. Sketches approved by the prisoners, Mayor LaGuardia, and the Commissioner of Correction, but rejected by the Municipal Art Commission.
1935–38	Employed by the Farm Security Administration as

Ben Shahn

artist, designer, photographer. For this administration, completed the fresco mural for the community center of Jersey Homesteads (community name changed to "Roosevelt" in 1945). Also took approximately 3,000 photographs (now in the Library of Congress and Fogg Art Museum), some of which were exhibited in a group show at WPA Federal Art Project Gallery, New York, December, 1936. Other exhibitors were Walker Evans, Arnold Rothstein, Dorothy Lange, T. Jung, Carl Mydans, E. Johnson, and P. Carter.

1938–39 With Bernarda Bryson, executed thirteen large tempera panels for the Bronx Central Annex Post Office, commissioned by the Section of Fine Arts, Public Buildings Administration, United States Treasury. Completed August, 1939. Lived during this time at 89th Street and Second Avenue, in the Yorkville section of Manhattan. Moved with family to Jersey Homesteads and remained there the rest of his life.

1939–40 Executed for Public Buildings Administration nine sketches for a series of murals on the Four Freedoms for the St. Louis, Missouri, post office. Not accepted. Completed for same agency an over-door tempera panel on same theme for Jamaica, Long Island, post office. Easel paintings executed on weekends and off-hours while working on Federal mural projects, and therefore called "Sunday paintings" by Shahn.

1940 One-man show at Julien Levy Gallery, New York, May 7–21. Entered (and, in 1942, won) in competition with 375 artists a commission to paint murals in the main corridor of the Social Security Building (now the Department of Health, Education, and Welfare), Washington, D.C.

1941 Studied technique of fresco painting with Jean Charlot at the Art Students League of New York. Learned silk-screen technique from a fellow artist and executed his first serigraph, *Immigrant Family*.

1942–44 Designed posters for the Office of War Information, only two of which were published (*Ill. 16*). (In protest to what the staff members felt was a managerial "Madi-

son Avenue approach to winning the war," they made a finished sketch showing a hand rising out of a bleak, empty ocean and clutching a familiar soft-drink bottle. The caption read "Taste Our Four Delicious Freedoms.")

Painted first of several advertising illustrations for the Container Corporation, drawing on his North African visits for a picture of Arabs carrying cartons (*Ill. 17*). Entitled *Gasoline Travels in Paper Packages,* it appeared in *Fortune* magazine, April, 1944, and on the cover of the *Magazine of Art,* October, 1946. Shahn continued to do commercial work of one sort or another until he died.

Shahn represented by eleven works in a group exhibition, "American Realists and Magic Realists," at The Museum of Modern Art, February, 1943. One-man show at The Downtown Gallery, November–December, 1944: easel paintings and posters.

1945–46 Became director of the Graphic Arts Section of the CIO and published four posters, including the one showing heads of two welders (*Ill. 20*). Group exhibition, "Survey of American Painting," The Tate Gallery, London, 1946.

1947 Taught at Boston Museum of Fine Arts' Summer School, Pittsfield, Massachusetts. Began illustrating for *Harper's* magazine.

Retrospective exhibition of ten paintings circulated by the Arts Council of Great Britain to F. H. Mayor Gallery, London (April 19–25); Brighton Art Gallery (May 3–26); Regional Office of the Arts Council, Cambridge (May 31–June 21); City Art Gallery, Bristol (June 28–July 12).

Exhibition at The Museum of Modern Art, September 30–January 4, 1948: one-man show of paintings, drawings, posters, illustrations, photographs.

1948 Selected as one of America's "Ten Best Painters" in poll by *Look* magazine. Designed posters and material for Henry A. Wallace's Progressive Party campaign.

1949 Exhibition at The Downtown Gallery, October 25–

Ben Shahn

	November 12: easel paintings. Produced booklet *Partridge in a Pear Tree* for The Museum of Modern Art.
1950	Taught for ten weeks at University of Colorado Summer Session, Boulder. Exhibition at Albright Art School, Buffalo, New York, March 17–April 27. One-man show at Frank Perls Gallery, Los Angeles. Exhibition at Phillips Memorial Gallery, Washington, D.C., November 19–December 12.
1951	Taught at The Brooklyn Museum Art School. Visiting artist, Summer Session, Black Mountain College, North Carolina. Exhibition at The Downtown Gallery, May 22–June 8: drawings. Group exhibition at Art Club of Chicago, October 2–27: three-man show with Willem de Kooning and Jackson Pollock.
1952	Attended and made drawings of Democratic National Convention in Chicago. One-man show at The Downtown Gallery, April. One-man show at Boris Mirsky Gallery, Boston. Group exhibitions with Lee Gatch and Karl Knaths at Santa Barbara Museum of Art, California; California Palace of the Legion of Honor, San Francisco; Los Angeles County Museum.
1953	Won $800 award offered by Museum of São Paulo, Brazil. Produced *Alphabet of Creation* for Pantheon Books.
1954	Represented United States at Venice Biennale with Willem de Kooning. Exhibition at The Art Institute of Chicago, March 26–April 26: drawings.
1955	One-man show at The Downtown Gallery, January 18–February 12. Celebration of twenty-fifth year of association with this gallery.
1956	Wrote *The Biography of a Painting* for Fogg Museum, Cambridge, Massachusetts. Produced *Sweet Was the Song* for The Museum of Modern Art. Elected to membership in National Institute of Arts and Letters. Awarded Joseph E. Temple Award at Pennsylvania Academy. Traveled with his wife in Europe.
1956–57	Named Charles Eliot Norton Professor of Poetry at Harvard University (the lectures Shahn gave were in-

cluded in *The Shape of Content,* published in 1957 and again in 1960). Commissioned by the New York City Board of Education to design mosaic mural for the William E. Grady Vocational High School in Brooklyn. Illustrated *The Sorrows of Priapus* for New Directions Publishing Corp.

Exhibition at Fogg Art Museum, Cambridge, Massachusetts, December 4–January 19, 1957. Exhibition of The Institute of Contemporary Art, Boston, May, 1957: Documentary exhibition surveying separate aspects of his work.

1958 Designed sets and poster for Jerome Robbins's ballet *New York Export—Opus Jazz,* performed at Festival of Two Worlds, Spoleto, Italy. Illustrated *Ounce Dice Trice* for Little, Brown & Co. Awarded Institute Medal by American Institute of Graphic Arts. Included in group exhibition, "American Artists Paint the City," at Venice Biennale.

1959 Elected member of American Academy of Arts and Letters. Completed mosaic mural for Congregation Oheb Shalom, Nashville, Tennessee. Traveled with his wife to the Orient. One-man show at The Downtown Gallery, March 3–28. Exhibition at Leicester Galleries, London, December.

1960–62 Designed sets for e e cummings's play *Him,* and for Jerome Robbins's ballet *Events,* performed at Festival of Two Worlds, Spoleto, Italy. Completed mosaic mural for Congregation Mishkan Israel, New Haven, Connecticut.

Exhibition at University of Louisville, Kentucky; serigraphs, 1960. Exhibition at University of Utah, Salt Lake City, 1960. Retrospective exhibition through the International Council of The Museum of Modern Art, New York, 1961–62, circulated to Stedelijk Museum, Amsterdam; Palais des Beaux-Arts, Brussels; Galleria Nazionale d'Arte Moderna, Rome; Albertina, Vienna. Exhibition, "The Saga of the Lucky Dragon," at The Downtown Gallery, October 10–November 4, 1961: Eleven paintings inspired by an article by Ralph E.

Lapp in *Harper's* magazine that Shahn had illustrated. The article described the tragedy of the Japanese fishing boat Fhkuryn Maru (Lucky Dragon), which in 1954 had sailed into the hydrogen bomb testing area, resulting in the maiming of several members of the crew and the death of one (*Color Plate V*).

1962–63 Completed mural for Lemoyne College, Memphis, Tennessee. Made posters for Lincoln Center for the Performing Arts, New York, and the Boston Arts Festival. Wrote and illustrated *Love and Joy About Letters* for Grossman Publishers.
Exhibition through the International Council of The Museum of Modern Art, New York. Circulating exhibition of prints opened at the Staatliche Kunsthalle, Baden-Baden, Germany, August, 1962, and closed in Japan, October, 1963.

1963–64 Illustrated *Love Sonnets* for Odyssey Press. Executed two mosaic murals for the S.S. *Shalom,* which were purchased by the New Jersey State Museum when the ship was sold by the American-Israeli Shipping Company in 1968.

1964–65 Completed mosaic murals for estate of Mr. and Mrs. Sidney Spivack, Far Hills, New Jersey. Illustrated *Ecclesiastes or, The Preacher* for Spiral Press. Completed window for Temple Beth Zion, Buffalo, New York. *The Shape of Content* translated into Japanese as "The Outside of the Inside."
Exhibition at Leicester Galleries, London, June–July, 1964.

1966 Illustrated an edition of *The Biography of a Painting* for Grossman Publishers. Attended design conference at Aspen, Colorado, and delivered talk, "In Defense of Chaos."

1967 Completed outdoor mosaic mural on Sacco-Vanzetti theme for the Huntington Beard Crouse Building at Syracuse University, Syracuse, New York.
Exhibition of "The Collected Prints of Ben Shahn" at Philadelphia Museum of Art, November 15–December 31. Exhibitions at Santa Barbara Museum of Art,

California, July 30–September 10; La Jolla Museum of Art, California, October 5–November 12; Indianapolis Museum of Art, Indiana, December 3–January 3, 1968: Paintings and prints.

1968 Completed twenty-four color lithographs and wrote an afterword to "For the sake of a single verse . . ." (from *The Notebooks of Malte Laurids Brigge* by Rainer Maria Rilke), a portfolio published by Atelier Mourlot (*Ill. 51*). Completed fourteen drawings for *Hallelujah,* a portfolio published by Mourlot in 1970, with a foreword by Mrs. Shahn.

One-man show at Kennedy Galleries, New York, October 12–November 2: paintings, prints, drawings.

1969 Died in New York City, March 14. Retrospective exhibition at New Jersey State Museum, September 20–November 16: 133 prints, paintings, drawings.

1970 Retrospective exhibition at National Museum of Modern Art, Tokyo; City Art Museum, Osaka; Ishibashi Art Museum, Kurume City; May 5–July: 170 paintings, prints, illustrated books, drawings. Exhibition of drawings at Kennedy Galleries, October.

‖ self-portrait

In 1944, Ben Shahn gave his first interview—to the editor of this book, who was then editor of the Magazine of Art. *When Shahn brought the typescript back to the office after taking it home over a weekend, he said, "This doesn't sound like me to me, but it does to my wife, so I guess it's okay." The first part of that interview is given below. Other parts appear in the sections Painting and Photography.*

I like the little details and contrasts that make people human— Governor Rolf of California and his official car, all dressed up, only the car about three models old. Or the tragic intensity of the face of a little girl having a good time jumping rope. Or the wires holding together the rickety chair of the condemned Vanzetti. I like the comic relief in serious situations—the play back and forth that keeps the balance.

I like painting that is tight and clear and under control. That's why I use tempera instead of oil. It's too easy to paint out your mistakes in oil. Among the old masters naturally I like the ones that worked like I do—Giotto and the Florentines instead of the Venetians and all their paint.

I hate injustice. I guess that's about the only thing I really do hate. I've hated injustice ever since I read a story in school, and I hope I go on hating it all my life.

[Ben Shahn pulled a cigarette out of his coat pocket without extracting the package, lit it, tossed the match at an ashtray on my desk, and leaned back in his chair. His eyes followed the pattern made by a cloud of smoke that rose toward the ceiling. His voice is surprisingly gentle, coming from a big man, and he seldom raises it, even when he is saying something that other people would shout from a soapbox. His voice is like his painting—delicate treatment of subjects that are sometimes called indelicate, such as Sacco and Vanzetti, or Tom Mooney, or just plain people that nobody notices much. I asked him about that story in school.]

In Russia I went to a Jewish school, of course, where we *really read* the Old Testament. That story was about the ark being brought into the temple, hauled by six white oxen, and balanced on a single pole. The Lord knew that the people would worry about the ark's falling off the pole, so to test their faith He gave orders that no one was to touch it, no matter what happened. One

Excerpt from "Ben Shahn: An Interview," *Magazine of Art* (April, 1944).

man saw it beginning to totter, and he rushed to help. He was struck dead. I refused to go to school for a week after we read that story. It seemed so damn unfair. And it still does.

My family moved from Russia to America in 1906 when I was eight, and when I was [fourteen] I went to work for one dollar a week as a lithographer's apprentice. My grandfather was a wood carver who used to tell wonderful stories which he drew as he told them. My father was a wood carver too, only he called himself a carpenter. And I'd always wanted to be an artist, so this lithographer's job seemed just the thing.

About that time I started to read. I went to the public library and told the librarian I would read everything she gave me, and she started me right out on the classics. I think I read the *Iliad* first, then right down the line. I recited Shakespeare as I ground down the lithographic stones, keeping up the rhythm of the lines. Later on I read Ernest Poole's *The Harbor*. I didn't think such a book existed. I moved to Brooklyn Heights because of it. And then years later I learned that Ernest Poole had never lived in Brooklyn himself. I think Jules Romains' *Men of Good Will* is the greatest book of our times. But I like Sinclair Lewis too and Dos Passos, and Hemingway, especially *For Whom the Bell Tolls*. I guess I like writing that's tight and clear and full of facts—the way I want my painting to be.

Along with a smattering of subjects in high school I took biology, and I decided to go on to college to learn more about it. As a biology student at N.Y.U., I went to Woods Hole in the summer of 1921, and it was wonderful. Only, I didn't see biology as an end in itself, like they did, so I tried City College when I came back to New York, and in 1922 I figured I'd had enough college. I entered the National Academy.

By this time I was a craftsman lithographer, and could work whenever I wanted to. I saved my money and went to Europe, like everybody else. My first trip was in 1925. I remember how thrilled I was one day when Picasso and Derain came into a café where I was sitting. After about a half an hour I'd slyly eased my way from table to table towards them until I was close enough to hear their conversation. Now, I thought, I'm going to learn something. Now I'll get the low-down. I held my breath so as not to miss a word they were saying. They were saying:

Dites. T'as mangé?

Non. J'ai pas mangé. Ou est-ce qu'on mangé par ici?

Je sais pas.

I didn't know either where I stood when I came back to America

Ben Shahn

in 1929. I had seen all the right pictures and read all the right books—Vollard, Meier-Graefe, David Hume. But still it didn't add up to anything. Here I am, I said to myself, [thirty-one] years old, the son of a carpenter. I like stories and people. The French school is not for me. Vollard is wrong for me. If I am to be a painter I must show the world how it looks through my eyes, not theirs.

Then I got to thinking about the Sacco-Vanzetti case. They'd been electrocuted in 1927, and in Europe of course I'd seen all the demonstrations against the trial—a lot more than there were over here. Ever since I could remember I'd wished that I'd been lucky enough to be alive at a great time—when something big was going on, like the Crucifixion. And suddenly I realized I was! Here I was living through another crucifixion. Here was something to paint! I painted [twenty-three] pictures about the Sacco-Vanzetti case in seven months, and Edith Halpert exhibited them at The Downtown Gallery in 1932. A lot of people came and looked at them, and bought most of them. I don't know where they are now. But from then on I knew what I wanted to do, and I've been doing it ever since.

In Homage *Thomas Meehan*

In 1935, Shahn was commissioned by the Farm Security Administration to paint a mural for the experimental community of Jersey Homesteads, New Jersey (Ill. 6). When the mural was finished he bought a house in the town, moved his family from New York, and spent the rest of his life there. In 1945, the town was renamed Roosevelt, and seventeen years later a bronze head of the President by Shahn's sculptor son Jonathan was unveiled as a memorial. The New Yorker *magazine reported the event, and because it gracefully tells a great deal about both Shahn and his home town, we reproduce the report in full.*

At the edge of a wood on the grounds of an elementary school in Roosevelt, New Jersey, there is a four-tiered red brick open-air theater, seating about two hundred people, that faces a reflecting pool and a fountain above which, on a marble pedestal, looms a massive bronze head of President Franklin D. Roosevelt. This was built by the citizens of Roosevelt in memory of the late President, and one afternoon not long ago we drove to the town, which

From "Talk of the Town" in the *New Yorker* (September 29, 1962).

is some twelve miles southwest of Princeton, to have a look at the memorial and to talk with the man who is mainly responsible for its existence—Ben Shahn, the painter, who has been a resident of Roosevelt for twenty-three years. On a quiet rear porch of his house, shaded by an enormous willow tree, we sat with Mr. Shahn as he smoked a pipe and told us the story of the memorial.

"I first had the idea in the early summer of 1945, just a couple of months after President Roosevelt's death, and that November we voted to change the name of this town from Jersey Homesteads to Roosevelt," said Mr. Shahn, a soft-spoken man with a big frame, who at sixty-four, has thinning white hair, an imposing white mustache, and the ruddy complexion of one who spends a good deal of time out-of-doors. "I think perhaps I should begin by telling you a little bit about this town (it's really unique), so that you'll understand about the memorial—why we built it. This town was founded in 1936 by the Farm Security Administration. They bought twelve hundred acres of woodland and farmland and built the place from the ground up—with streets and shops, two hundred low-cost houses, a garment factory, a six-hundred-acre farm, and everything else that a small town needed. Then they rented the houses to New York City garment workers whom they persuaded to come down here to live. At that time, work in the garment factories was pretty much seasonal, with three-month layoffs in the summer; the F.S.A.'s theory was that a man could work on the farm in the summer and in the local factory during the rest of the year. In any case, the chief idea was to get workers and industry out of the city, and, at the same time, stimulate an interest in farming. Jersey Homesteads was a pilot project to test this idea, and, frankly, it didn't work very well. A number of the workers soon moved back to the city, and within a decade the F.S.A. withdrew its support of the town. Nevertheless, about a quarter of the original settlers—the Mayflower group, they like to call themselves—are still here. The factory is operating—it's turning out buttons now—and some local people work on the farm, so the project wasn't a total failure. The same two hundred houses are standing, each one on a half acre of ground, and the population is just about the size it was in 1936—around eight hundred. This is a small place. When the F.S.A. created the town, they zoned it so that only a few additional homes could be built; half the land was for farm, two hundred acres was for streets and residences and so forth, and the remaining land was for a so-called green belt—meadows and woods. We've kept it that way. Most of the Mayflower group were immigrant Jews, and, as good members of

Ben Shahn

the International Ladies' Garment Workers' Union, they were also liberal Democrats, and revered President Roosevelt, particularly since he was so enthusiastically behind the Homesteads program. Now the town is quite a mixture. From 1935 to 1938, I worked as an artist with the F.S.A., so I was in on the program from the beginning and knew all about this town. I have five children—all of them are now grown and have left home—and in 1939, when they were kids, I wanted to get them into the country, out of Yorkville, where we were then living. When I heard that a house was available here, it seemed a natural thing to move down."

Mr. Shahn relit his pipe, reflected for a moment, and then went on with his story. "In the fall of 1945, I collected two thousand dollars from local people to build a memorial here to President Roosevelt," he said, "but I found that it would cost ten thousand dollars to execute my design for it—which was basically the design we finally used—so I returned the money and abandoned the idea. Then, in the fall of 1960, when a committee of townspeople came around asking if I had any thoughts on how Roosevelt might celebrate its twenty-fifth anniversary, I remembered the memorial. I got out my old sketches, and everyone became very excited. At once, we formed a nonprofit corporation, called the Roosevelt Memorial Association, to raise money to finance the project. I ended up as president. At that time, we figured that the memorial would cost twenty thousand dollars, but it ultimately cost even more—around twenty-three thousand. My son Jon, who is twenty-four and grew up here in Roosevelt, is a sculptor, and I asked him if he'd be willing to sculpt the head of President Roosevelt for no pay. He realized that it would take several months of work, but he agreed to do it. On the Fourth of July of 1961, we had a groundbreaking ceremony. I hoped then that the memorial would be finished by the fall, but it took quite a bit longer. For one thing, the necessary money was difficult to raise. Everyone here contributed, and the Town Council gave a thousand dollars, but we were still far from our goal. Then, at a dinner party in New York, I was introduced to Dore Schary, and, knowing his interest in President Roosevelt—as you remember, he wrote 'Sunrise at Campobello'—I told him about the plans for the memorial. He immediately helped me line up several major contributors, and, with his help and the help of a friend who gave us a three-thousand-dollar interest-free loan, we eventually got the money together. It took almost a year—a year in which I was so busy raising money that I had just about no time for my work."

While Mr. Shahn was busy raising money, he went on to tell us,

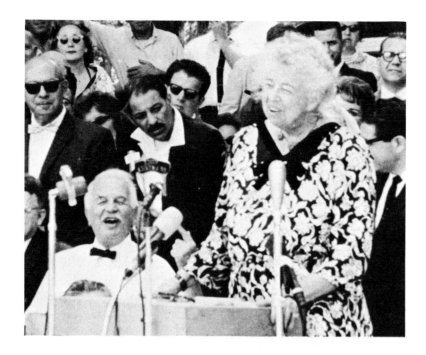

Jon, working from photographs of President Roosevelt, was busy
modeling the head in clay in a garage in Cambridge, Massachu-
setts. When at last the time came to cast it in bronze, the Shahns
were staggered to discover that the cost would be eight thousand
dollars—more than double what they had estimated. After search-
ing around, they found that the same casting could be done in
Rome for fourteen hundred dollars, and therefore, just before
Christmas, 1961, Jon went to Rome, where, after two and a half
months of further work, the head was completed. "The casting,
plus Jon's trip and his stay in Italy, cost only three thousand
dollars," Mr. Shahn continued. "Basically, labor and materials
were just about our only expenses. Everyone in Roosevelt gave his
services for nothing, of course; it was a real community project.
The Board of Education leased the land for the memorial for vir-
tually nothing; Marvin Field, a landscape architect who had been
born in Roosevelt, directed the placement and the grading of the
lawn that surrounds the memorial; Bertram Ellentuck, an architect
who lives down the road, did the theatre; and Jacob Grossman,
who is the chief dress cutter for Ceil Chapman, was our hard-
working and indefatigable treasurer. Our Mayor, Irving Plungian,
whose construction company did all of the building work at cost,
served as the guiding spirit of the operation. In the late spring, the
head, which is five feet four inches high and weighs fifteen hundred

34 Ben Shahn

pounds, finally arrived from Italy, and it was put on its pedestal, which, by the way, is nine and a half feet high. Everything else was completed, and on June 2nd, which was a Saturday—and a warm, sunny day, thank goodness—we had the dedication ceremony. It was a gala occasion, with more than two thousand people on hand. Mrs. Roosevelt, Governor Hughes, and Dore Schary were here, and so was Anne Bancroft, the actress, who read excerpts from several of President Roosevelt's speeches. Mrs. Roosevelt gave a brief, lovely talk, and the Hightstown High School band played "Happy Days Are Here Again." Everyone agreed—and I agreed, too—that Jon had done a damn good job. After the dedication, my wife and I gave a luncheon on the lawn here for about a hundred people. Mrs. Roosevelt was marvelous—shaking hands and chatting with all the old-timers who had so worshipped her husband. A woman in her eighties who lives across the street made *gefüllte fisch* especially for Mrs. Roosevelt and presented it to her. Mrs. Roosevelt tasted it and said that it was the best she'd ever eaten. I think that was the happiest moment of that old woman's life. So that's the whole story, straight through to the *gefüllte fisch*. Let's go have a look at the memorial."

We drove with Mr. Shahn in his car, a Volkswagen, to the school grounds, where we parked at the back of the school building and walked across the still, shadowed lawn to the memorial. Dusk was falling, and, silhouetted against the woods, the bronze head rose up solemn and austere—all in all, an impressive piece of work. Carved on the pedestal were the words "Franklin Delano Roosevelt, in Homage." At the foot of the pedestal, we noted, was a bouquet of wild flowers.

"Well, that's it," said Mr. Shahn gently. "It took a year out of my life and an enormous effort on the part of a lot of people—especially my son Jon—but I think that it was worth it. You see the flowers? People drive up and leave them. Cars from practically every state park here. The people in them place flowers at the foot of the pedestal and sit for a few quiet minutes in the theatre. It's a nice thing."

Afterword to "For the sake of a single verse . . ." by Rainer Maria Rilke *Ben Shahn*

In 1968, the year before his death, Ben Shahn achieved a life-long goal. He completed twenty-four color lithographs illustrating a paragraph from The Notebooks of Malte Laurids Brigge, *by the German poet Rainer Maria Rilke (1875–1926), which*

*he had discovered in Paris in 1926. The paragraph, the litho-
graphs, and an afterword by Shahn were published in portfolio
form. A drawing for one of the lithographs is reproduced here
(Ill. 51). The paragraph that so impressed Shahn when he was
twenty-eight years old and illuminates every one of his subse-
quent paintings, prints, and drawings appears below, followed
by Shahn's afterword.*

For the sake of a single verse, one must see many cities, men, and
things. One must know the animals, one must feel how the birds
fly and know the gesture with which the little flowers open in the
morning. One must be able to think back to roads in unknown
regions, to unexpected meetings and to partings one had long seen
coming; to days of childhood that are still unexplained, to parents
whom one had to hurt when they brought one some joy and did
not grasp it (it was joy for someone else); to childhood illnesses
that so strangely begin with such a number of profound and grave
transformations, to days in rooms withdrawn and quiet and to
mornings by the sea, to the sea itself, to seas, to nights of travel
that rushed along on high and flew with all the stars—and it is not
yet enough if one may think of all this. One must have memories
of many nights of love, none of which was like the others, of the
screams of women in labor, and of light, white, sleeping women
in childbed, closing again. But one must also have been beside
the dying, must have sat beside the dead in the room with the
open window and the fitful noises. And still it is not enough to
have memories. One must be able to forget them when they are
many, and one must have the great patience to wait until they
come again. For it is not yet the memories themselves. Not till
they have turned to blood within us, to glance, and gesture, name-
less, and no longer to be distinguished from ourselves—not till
then can it happen that in a most rare hour the first word of a
verse arises in their midst and goes forth from them.

Afterword

I was twenty-eight years old; I had just recently arrived in Paris.
I had certainly never heard of Rainer Maria Rilke when I found
on one of the bookstalls along the Seine a small volume called

"For the sake of a single verse . . ." reprinted by permission of the W. W.
Norton Company, Insel-Verlag, and the Hogarth Press, Ltd. Translated by
John Linton.

Afterword reprinted by permission of Mourlot Graphics and Kennedy
Galleries, Inc.

Ben Shahn

Les Cahiers du Malte Laurids Brigge. I was entranced by the writer's observations, not just upon Paris, but on life itself. Malte Brigge had only just arrived in Paris when the notebooks began. He too was twenty-eight. This young man seemed almost to be me.

I had arrived in Paris via the Gare de l'Est. I had walked and walked, never getting enough of seeing and being where I was. I came to know Boulevard Sebastopol, then the networks of little streets, Rue du Roi de Sicile, Rue des Rosiers, Rue des Francs Bourgeois. I made the Carnavalet my personal museum; Place des Vosges was my own private retreat. I was the discoverer; surely no one had seen this place as I now saw it.

I imagined that Rilke had arrived in Paris by way of the Gare d'Austerlitz. He had walked along the Seine, crossed to the Île de la Cité where he came upon the Hôtel Dieu and made in that vicinity so many touching observations. Such was the beginning of my sense of kinship with Rilke.

But there were other and more profound reasons for this kinship. Like every young artist under the sun, I was intent upon finding the deep and abiding nature of things. I read the constantly proliferating art literature of the late twenties in Paris—the manifestos, the tracts, the declarations, the testaments, the confessions, the diaries, the autobiographies, the monographs, always seeking the clue, the magic key to what was what, the elusive ingredient that made art, art, and not just more paint upon canvas, more filled-up space. There must be something, I thought—as young artists still think, and that they still seek—some knowledge that must be possessed by the elect, that must endow them with those especial powers not possessed by ordinary persons.

But however avid my reading, my looking, seeking, pondering, I did not find any such clue at all. The tracts and manifestos said too much the same thing. Oh, certainly, line, form, color, texture were the stuff of the images of art—no denying that. But one had to be honest with himself; this was all rudimentary. Essential, indeed, but there was more. There was something further that infused an image that gave it life. I agreed with the manifesto-writers that art should not be burdened by mission to uplift, nor should it be loaded with academic rules and principles. I was ready as anyone to throw off the traces and be free.

But I wanted to be free also of the new academy that was already moving in, already setting up its cast-iron rules for the new generation of painters. Indeed it did create them, and indeed the artists of today are still tyrannized over by its grim ethic of disengagement. (When will they free themselves? Who knows?)

Alone, now in my thinking, I began to believe that art did, after all, have a mission—certainly not the Beaux-Arts kind of mission, but another one. Its mission was to tell what I felt, to say what I thought, to be my own declaration. I could not accept the current ones; they expressed some other fellow's beliefs and intentions, not mine. Pictures would be my manifesto.

Rilke wrote: "I am learning to see; yes, I am beginning to see." How wonderful! No one could take that away from him. That is the great experience of life. No one would take it away from me either. It is tempting to be part of the avant-garde, it is so exciting to be part of a movement, daring and yet secure. But it is an illusion and it creates within the painter a complacent sense of having done things which in truth he has not done.

The way to painting is a lonely road, a one-man path. It holds no security; it is not cozy. Every moment of painting is a moment of doubting. The only criterion is the criterion of self, of what one wants, what one thinks he believes, his own shaky philosophy. There are no guideposts, no maps, no geography to tell him that he is on the right path. No friend, however sympathetic he may be, can predict the quality or the validity of the image that the painter hopes to bring forth. The only vindication of his course of action is a realized image, a work of art.

I read and was so lured by the manifestos. I avoided them but still with a great nostalgia to participate in the socializing and the ferment that were part of them—of what today would be called "the scene." But I knew they were foreign to me and that in truth there was for me no choice.

I had now long ago found in Rilke the passage that came to mean so much to me. Here was a writer about the processes of art who was not telling me what to do, what to think, how to paint. No; he was too engrossed in his own discoveries. He was sharing with me the doubts and the hesitations of art, the probings, the slow emergence of forms. His every line of writing was art, and yet such art was inseparable from its life content. No manifesto could ever tell me more clearly than this one paragraph of Rilke's that art is an emanation from a person; that it is shaped and formed out of the shape and form of that person. In being so acutely personal to him it achieves also a rare universality. Rilke is speaking (is he not?) to the innermost recesses of the consciousness, an area in which we spend so much of our time and expend so much of our feeling, and yet an area that is so remote from communication with our fellow-beings, an area that is, unhappily, increasingly remote from the reaches of art.

Ben Shahn

III the creative mind
and method

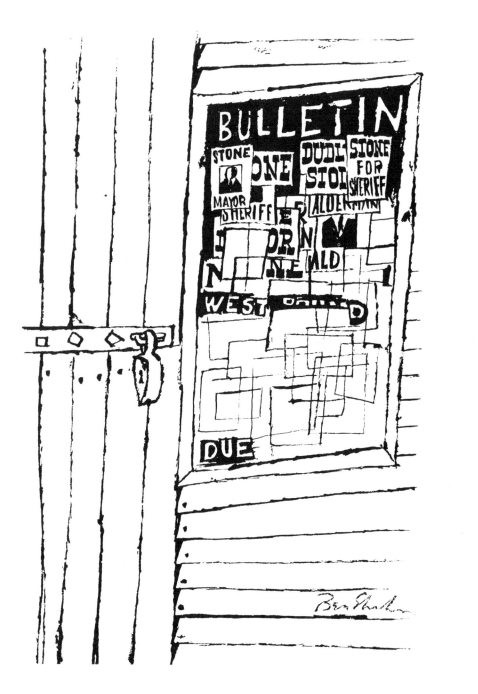

In 1957, when Shahn was delivering the Norton Lectures at Harvard, Lyman Bryson, the noted educator and chairman of the radio program "Invitation to Learning," conducted a series of radio broadcasts entitled "The Creative Mind and Method" over station WJBH-FM, Boston. For the painter among his creative artists, he chose Ben Shahn and commissioned Nadya Aisenberg to interview him. Following are edited excerpts from that interview.

Nadya Aisenberg: *Do you think that the traditional or classic symbols create a problem for the painter today, when he can't presuppose general knowledge of them?*

Ben Shahn: Well, of course it is a problem if you assume a series of symbols that are immediately communicable, such as the blue robe you mentioned, or the lamb, or what have you, in religious painting. Then, half the area of communication was covered by those symbols, which were common to the audience and the artist. So that the difficulty today is rather greater than in the period when half the communication was taken for granted. But that should make it all the more of a challenge today to evolve one's own symbols.

Do you think that the style a painter evolves is a parallel to his personal development, or to a technical development? Does he progress to a more difficult style of painting as a result of proficiency that he has gained in the course of time, or an inner compulsion to try new forms to express new things?

Well, there are both of these things, and there is one other thing that development of style presupposes; it presupposes that one is ready to assume the responsibility of maturity. Now that is an interesting way of looking at it. And I hope that I can make myself clear. When a person begins, you see, every door is open to him. He starts in a direction; as far as he is concerned, it has never happened, and then he tries the next door. But if he has consciousness and responsibility toward maturity, he will be unwilling to repeat himself; he will not try the door again, he has been there before, and then an evolution of style does take place.

Do you think that certain subjects lend themselves particularly to certain media: to oil, to tempera, to watercolor? Is this simply a personal choice on the part of the artist?

Personally, I don't have this hierarchy of values about media:

An oil painting in a gold frame is just so much better than one in an ordinary wooden frame, and an oil painting is just so much better than a tempera painting, and a tempera better than a watercolor, and a watercolor better than a lithograph or an etching, or the lowest thing they are drawing. Now we know that there are drawings that transcend certain oil paintings, and so on, so the whole hierarchy is pretty meaningless. I personally chose tempera, after having worked in oils for years, because of its rapid drying qualities—because I began to dislike the impasto, the thick paint that builds up in oil. I had been to Italy; I had seen those frescoes and the temperas of the early Italians, and I was very much taken with the smoothness and the rather matte surface of them, and that drew me very much to tempera. But that was purely a personal choice. Tempera has no value over any other medium whatsoever.

Did you choose painting in the beginning?

Well, the first thing that I can remember (and it is almost the first thing I can remember) I drew, and it was natural that as soon as I could have access to coloring material, I colored, whether it was crayon or watercolor. Now when I was a youngster of about twelve, I looked upon oil as the very highest thing, and begged for oil paints. But with experience, I revalued all those things. But I did think of myself as an artist, awfully young.

In the selection of subject matter for a painting, do you think true tragedy in art can come from the depiction of man's relation to man? I think that most of your paintings have been concerned with man's values and with his effects, and I was wondering whether you felt in the material of man himself and not in man's relation to the fates, or the tragic flow of human nature, or the medieval concept of the wheel of fortune—that there was innate tragedy that could be expressed.

Well, I frankly didn't think of it as tragedy. If it sometimes appeared so, it was not through a conscious effort. I can say that very honestly. But I am most interested in the relation of man to man, and if sometimes it does have a tragic impact upon the onlooker, it was not a conscious one on my part.

Is your painting, then, a social compulsion as well as an artistic one?

This is a question I am asked very often, so I'll say that every single painting done in the year 1957, or any other year, is always a social one. I say it in this sense: I am aware of, as everyone else is aware of, social relationships. Now those can be on the level of a ball game, and we know that is a very important social relationship. So one who would paint a ball game is making some kind of

42 Ben Shahn

social comment. A person who paints a bowl of pansies is making a social comment in the other direction. He says, I don't care about all this that is going on around me. I am going to remove myself from this. He is making a negative social comment, if you wish. But it is all social to me, you see. I cannot conceive of its being anything else. In other words, if one makes a painting and shows it to one person, it is a social act.

When you start painting—getting down to the specifics now—do you have a conception of the whole in your mind?

No, I don't.

You start with an image or an idea?

Well, I am actually more inclined to work with images. And I keep notes. And the notes are made half in little images and half in single words. A kind of shorthand of image words, if you wish. But I certainly do not have a complete image because if I had a complete image I think I would lose my interest in it. The area of discovery, the area of exploration that exists in painting is to me the most intriguing and the most rewarding one.

The painting gives back to you a response?

That's right. If I had this complete image that you speak of, I would be inclined to exercise complete control over it. And some of the greatest mistakes I have made in my own work resulted from exercising this complete control. I don't want to sound metaphysical, but there arrives a period during the painting when the painting itself makes certain demands, and if you are not hypersensitive to it, you know you're going to lose a good quality of the painting.

It becomes a living thing?

It definitely becomes a living thing.

Do you go through certain stages in your work that are generally the same? Let us say, do you start with a drawing first?

More or less. Now, I have something on the table here—this lute that I started first just to make a casual drawing of as a record for myself, because I thought that at some time I would use it. I have an enormous collection of things. It is my vocabulary, my dictionary, my everything. Now when I was just about half way though this thing I changed my mind about merely making a record of that particular instrument; I wanted to do something more than that. And now it is going into something I didn't conceive of at all when I began.

Do you have any external habits that aid you in the creative process—any type of work-discipline or crutch? Do you have to create in a certain room or at a certain time of day?

Not particularly. You spoke of crutches, one gets crotchety I guess, and used to a particular easel, and table, and so on. And I was a little worried coming up here, coming to a fresh studio, whether I would be able to work and how long it would take, and I was rather pleasantly surprised that within less than a week I was in it. I must confess I spent a couple of days equivalent to what a writer does by cleaning his typewriter keys and this and that. But I finally saw that this was it. This was my environment and here I was. Now another crutch that I would like to speak of is the effort (I don't know whether you would call it a crutch) of trying to see the things that I paint as if they never existed before in my experience. If I can get into this relationship with my work, then it is going all right. But if I don't have this particular sense of awe and wonder about it, then it isn't going very well.

I think that this is a very interesting point. The painter essentially presents a composition to the viewer so that he may see it fresh. But how does a painter keep his painting fresh?

I don't know. But I certainly try to. I think it becomes a habit after a while to regard anything as something that one is seeing for the very first time in one's life—as if it comes from a very strange and distant country. It is a matter of looking very intensely at things and feeling them very intensely, I imagine. I don't know —it would take a psychologist to explore that.

Going back to the choice of image in the painting, do you find that you create new images to express an idea? That is, if something has an emotional impact upon you, when you reproduce the impact, you don't necessarily reproduce the scene that produced the impact?

Not necessarily, but I do hope to reproduce the intensity of feeling that I have about it. And if I don't have it, then God knows, I will not be able to transmit it.

The idea of synthesizing the thought and the image: I wonder whether you could elaborate on that a little?

Well, it is sometimes very difficult for me who most often thinks in images rather than in ideas. I have occasionally done magazine illustrations, and I bring them in to the editor, who is essentially a word man. And until I have surrounded the image that I have brought in with certain words, he does not get it. Then suddenly some word helps him get it. He needs that bridge apparently. But my own habit is naturally to think in images.

Are these images that you think of essentially paint images?

Well, only in the sense that the most elementary image is there,

Ben Shahn

but not necessarily in terms of paint. I state my images, as it were, beyond the one I have in mind, on a sheet of paper, and they are very elementary images. Occasionally I will rummage through those drawings, sometimes finding a drawing that I had been looking at for say two years, each time pushing it aside because it wasn't worth any further development. Suddenly this drawing takes on a significance; it begins to grow in my mind as paint images, and then I am terribly excited and wonder why I hadn't seen it that way two years before. But this is the experience we all go through, isn't it, when we read a poem or a book that has no meaning for us, and two years later that poem or that book has a great deal of significance for us.

Do you think that the imitation of other artists is a necessary preamble to the development of style?

I would say yes. You know the very first impulse of painting is imitation—beginning with the cave paintings of Altamira. Those were imitations of animals encountered every day. So the very first impulse in a child is to imitate, and that will last during his student days, and sometimes the personality of the individual will never assert itself. Sometimes it does a little earlier, sometimes a little later. But apparently that period of imitation or influence is an inevitable one.

And do you think this influence is sometimes simply a pendulum swing?

Well, that again will depend upon temperament, and particular contacts, and so forth. It seems to me there are two reasons for influence in the mature person. There is an influence that is purely venal. In other words, if X is a successful painter it seems logical to say to oneself, well, I'll think like X and I, too, shall be a successful painter. That it has been proved wrong endlessly doesn't seem to impress the young painter at all. The second reason is that there may be a very necessary solution, or help in a solution to a problem. I remember many years ago I used to run up to the Metropolitan Museum three and four times a week. How did so-and-so solve this particular problem? I leaned on him not because he was particularly in vogue at that moment but because he had that much to offer to me, you see. I make this rather delicate distinction between influences.

But there comes a time when one begins to question all influences, and then begins the expression of the personality. The important thing is that the artist draw endlessly from his own experiences. Even when he is commenting on a thing that he has

not actually experienced, it will be through the medium of his own personal experiences. His reactions will be those of his own experience.

If these experiences are not readily communicable to an audience through something, for instance, like surrealistic art, do you feel that this is still valid?

It is valid for the creator if he has been perfectly honest with himself. It is valid for him. It is valid for a certain audience. Let us assume that the audience is equally honest in its appreciation. Now, the danger in this kind of thing is to evaluate a work of art by the size of the audience, and that is something that must be very carefully watched for and avoided. Let us assume that when Picasso painted *Guernica* there were only twelve people who understood it—like the twelve who understood Einstein's theory of relativity. It did not lessen the concept of relativity because only twelve understood it.

Let us say that now there are 120,000 who understand *Guernica,* and I believe there are that many who are moved by it. That hasn't increased the value of the painting, because nothing has been added to it since. One has to be fairly strong in one's own convictions, faced with a work of art. It is possible that I myself, though I understand a work of art now, will not value it two years from now. And conversely, that which I do not understand now, I ought to be very honest with myself about and say I don't understand it. But I don't want to be fatalistic and say I'll never understand it. If I keep my mind open and honest, it may be that in two years I *will* understand it.

Do you think, then, there is a process of almost re-creation that goes on for the audience as it views a painting?

Oh, absolutely. The audience brings to a painting, which is the sum total of the artist's experience, the sum total of its own experience, and it becomes a different thing to every member of the audience.

We find, for instance, in a painter like Paul Klee, the use of titles as very integral parts of his paintings, or at least integral to the viewer, to whom they give more than a clue.

I am all for that. As a matter of fact, in a certain painting I did called *Liberation,* where there are some children swinging wildly around a kind of pole against a background of war devastation, I was so eager to have people stop in front of the picture when it was to be exhibited that I suggested that a little Swiss music box be put inside the frame. It would play a little melody for two minutes, or a minute, which would be ten times longer than the

Ben Shahn

average viewer looks at a painting. Well, the people who were in charge of hanging thought that was the most vulgar thing I could possibly suggest, and the idea was abandoned. But I believe in all aids because I think that expression is expression and I don't want to make sharp limitations. I would use literary aids, musical aids—anything at all.

One of the other forms of outlet we haven't discussed at all is the civic outlet: murals for the post office, the synagogue or church, and so forth.

Well, there is a great deal of mural work going on. The synagogue seems to have taken the lead for some reason or another. I am engaged in an enormous mosaic right now that is being executed in a huge public high school in New York, and I have to go down every two weeks to supervise it. There is a great deal of activity of that kind all over—a kind of renaissance, if you wish.

There always has been, and I am afraid there will always have to be some kind of patronage. Willy-nilly, the universities are becoming the patrons—if not of concept, of economic aid.

Do you think that the commission is a hampering thing?

No, I don't think so at all. I think the history of art is filled with commissions—the Egyptians and the Greeks and the Romans, and the whole history of the Renaissance, and the whole Byzantine movement. The commissioners were more intelligent perhaps—I don't know—but it is history and we have to face it.

The quality of painting, then, is not so inspirational that it cannot be channeled slightly?

Well, it *is* inspirational. To return to the mural that I mentioned a moment ago—the architects came and said that they had this space for me, and even discussed the space before the building was finally designed. They said this will be a trade high school. Now, there is a popular conception that trade schools are a kind of fancy reform school. I thought the thing through (to me inspiration is thinking); I thought, now what would I like to put on that wall? Here these kids are going to learn dozens of trades. I want to emphasize that we are living in a technological society and are beginning to believe that technology will solve all the problems that we are faced with. (I personally don't think so. I think that technology without an awareness of the humanities will lead to endless Hiroshimas.) So in this particular mural, I stressed both the good and the evil of technology, and stressed the importance of the humanities in our society. Now, that was inspiration. There was no dictation whatsoever. When someone tells me to do exactly thus, in

this particular style, that is going to be a pretty empty thing. There are those kinds of commissions, too. The worst type would probably be the portrait commission.

Do you think that the act of creation brings the artist closer to society, or does his creation, in a sense, remove him from society?

Again, any answer to that would be a very broad generalization. I was once asked by some students whether I was a very lonely person, and I asked them why they asked. They said, "Well, in your paintings there seems to be a sense of the loneliness of the individual," and I answered facetiously, I said, "Well, suppressed desires—we have five children and I sometimes would like to be alone." But I think that the creative act *is* a pretty lonely business, you know. Once it is done, one can participate again, but I think that during the whole period of gestation it is pretty lonely. I don't think that it is tragic in any sense. I think one desires to be alone.

You mentioned that in the early stages of your painting you started with the particular and then tried to get a general statement from it. You spoke of documenting and taking photographs. But isn't there a certain process of selection from the particular, of the relevant detail?

Oh yes, of course. When I said documenting I meant, for instance, that at one particular time I felt that the painting of a coat a man wore was terribly important. Now, the way I painted that coat should have expressed to the onlooker whether it was bought for fifteen dollars or a hundred dollars. The kind of shoe, or the kind of house, and so on—those were all-important things to me. They have ceased to be that for me now. But at that time they were terribly important. There were areas within a larger concept that I wanted to document. I always felt that the particular area of what I call intense reality had an aura that sort of spread over a larger area that might not have been equally well observed, and it would endow that surrounding area with the particular sense of intense reality.

The authentic detail gave an impression of general sincerity, was that it?

Well, that was my feeling about it, yes.

But you then became dissatisfied with that approach?

Well, very slowly. It would be hard to say at what point; it actually didn't happen at a point. It was such an imperceptible thing, like the growth of anything. You knew it grew but you weren't aware of time. I ought to state that for me there were actually three stages. There was the period of schooling when I was under the influence of one painter or another, both in style and content.

I. *Sacco and Vanzetti*, 1932. (Mural project.) Tempera, 21" x 48". Private collection. Photograph courtesy of Kennedy Galleries, Inc., New York.

II. *The Red Staircase*, 1944. Tempera, 16" x 23¼". City Art Museum of St. Louis.

III. *Phoenix*, 1952. Serigraph (hand-colored), 30¾" x 22⅝". Collection of Kennedy Galleries, Inc., New York.

IV. *Allegory*, 1948. Tempera, 36" x 48". Fort Worth Art Center Museum. Gift of W. P. Bomar, Jr., in memory of Jewel Nail Bomar and Andrew Chilton Phillips.

V. *Lucky Dragon*, 1960. Tempera, 84" x 48". Collection of Kennedy Galleries, Inc., New York.

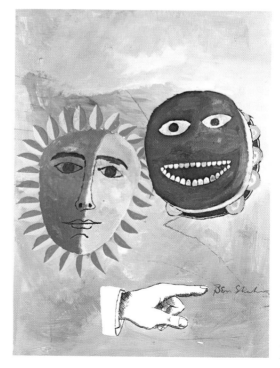

VI. *Sun, Moon, and Hand—The Elements*, 1961. Gouache, 25" x 19". Collection of Kennedy Galleries, Inc., New York.

I was a fairly obedient student and believed what I was told. I had reservations always, but I felt unsure about those reservations and generally went along and did what was being done. This kind of thing went on for several years after school, actually, but at a certain time I began to question these values, these contents, these forms, though I was charitable enough to grant them as valid for their practitioners. I had to face up to the fact that a particular practitioner who was having a strong influence on me had a totally different set of experiences in his life. I must get closer to myself, I thought. And there followed a period of self-analysis where I sort of put down the debit and credit side, and had to face certain inadequacies of mine. I had learned in school that telling a story with a painting was terrible; it was just the worst thing that you could do. But I also had to face the fact that I liked to tell stories, you see, whether in words or in pictures. Well, this was one of my inadequacies and I had to face it. And there were a number of other things. I learned the whole Impressionist technique, but when I went outdoors to sketch, I did not see purple shadows. If I stretched myself, as it were, I could make myself believe that I did see them, but I honestly did not see them. I concluded "so what," and that was the beginning of recognizing my own personality for whatever it was worth.

Then came this period of interest in the specific. It was a kind of revolt against the general kind of thinking I had been subject to as a student and a post-student. Now came another revolt, but a much slower one, back to the general. The first one was a very dramatic one. This one was much slower; it was a kind of transition.

Let me add that I haven't abandoned the particular entirely. There are times when I feel that a certain area of a picture needs that particular, intense observation in what would otherwise be a very, very broad statement.

Yet in your recent painting there has been an introduction of fantasy, let us say, for want of a better word. I don't know what you would call it.

Yes, yes. Well, that reaction came actually from the war you know, the war was very emotionally disturbing for me. I saw parts of Italy I had known being destroyed. I saw them through pictures, through motion pictures, and it was a very shocking thing. Perhaps it was at that period that those almost allegorical treatments of real situations began to creep into my work. And it was also at that time that the more general statement began to creep into my work.

I think this is probably true of the painting you mentioned before, the children swinging and the rubble in the background?

Yes, that was all of that period, that war period.

Do you find that there is a particular point that serves you as sort of an entrée to the painting—a detail or a hook into it?

Oh very definitely. I sort of fence with a painting for the first couple of days, shadowbox, or what have you, waiting for that kind of opening. I am very alert at that particular time. And it goes off in various directions. But whatever it is that makes me recognize that opening, as it were—when that comes along I begin to be very clear about what I am going to do. There will be more struggles with it, you know. But by and large I know where I am going then.

Very recently some students asked me whether they could watch me paint, and I said no. I was rather sorry for this abrupt answer, and I said, well, they had talked earlier of their affection for Archibald MacLeish and his method of teaching, and I said, "Would you ask him whether you could stand over his shoulder while he said aloud why he chooses a word—whether for its tonal quality, whether for its meaning?" To me, painting is a very intimate and highly private thing—while I am doing it. And I said further, "If I knew how to make the next painting, you would be welcome, but I don't know how I am going to make the next painting." I was sorry that I had to say no to them.

But in answer to your question, I must have a method, I must have something, because although the paintings seem to resemble each other in style or in quality, each one is still a big area of discovery. If it is repetitious, as it sometimes is, it isn't happy, and I am unhappy with it.

Do you have simultaneous ideas that enable you to work on many paintings at the same time?

No, I am unable to work on more than one thing at a time. This is a strictly personal thing. I saw an artist of very high reputation, when I lived in France, who was working from a model, and he had six easels around him, and when one got wet he would go to the next one. (One of the reasons I abandoned oil was the slow drying.) I am utterly incapable of working on more than one painting at a time. I am rather single-tracked anyway, so that even when I begin to work on something that has nothing to do with painting—a hobby—I find I do nothing but that hobby. For example—I do a lot of cabinetwork and I make frames; well, I'll save frames for a week of frame-making, nothing else. I am just not able to do more than one thing at a time. Sometimes I feel this a

Ben Shahn

great hindrance, but then something often generates another idea, and sometimes when I am halfway through with a picture I am thinking while I am working. It is when I have passed the bridge, as it were, the difficult moment, that I am already thinking of the next one.

In one instance I had to do a series of illustrations on a mine disaster. I have been quite familiar with mines (my wife comes from mine country and I have been down mines). It was a relatively easy thing, although I had never done anything like it before, but I was really eager to do this assignment. Even when I sent my drawings off to the editor I continued to draw the subject because it intrigued me so much. Over the following two years I made at least six paintings based on this subject. I remember once being at a mine disaster and seeing two rather official-looking gentlemen. They looked like mine inspectors or something —sort of dark clothes. They might have been undertakers. Well, they entered the first painting, and they were in the second painting and they were in the third painting. But they got smaller and smaller, and finally in one painting they were just in the doorway, no bigger than three inches. Then they disappeared completely and never appeared again.

This brings us to another point, which is the satisfaction you feel upon the completion of a painting.

Well, naturally you feel that no painting ever comes up to what you planned. That is an awful thing to admit, but that is so. But there are other times when I stand in awe of it. If a thing is finished that I like very much, I can just sit and look at it, and I can then feel like the outsider, the onlooker, and, well, actually admire it with a great deal of tenderness.

Does it usually take a while for you to detach yourself from it?

No. Generally, the painting is finished about four or five times. When it is actually finished, then there follows about a week of rather pleasurable activity. You are just going to refine a little thing which you know is not going to affect the whole thing at all. (Whether that refinement is good or bad is not going to make any difference. But the total is there.) That is the pure pleasure of craftsmanship. That is the kind of joyous, craftsmanlike pleasure that you get out of it. And then, the next day, you will pick it up again and find something else, and when you've put it down you think it is finished. But then you look at it again, and there are minor things—indulgences or self-indulgences for the pleasure of doing them. And then there comes a point when you feel that, well, there is nothing more that you can do to it. Any more of those re-

finements might actually change the character of it, and you say, well, just let that alone—really talking to yourself—and then it is finished.

Then there follows a period of drawings, oh, of minor things, some watercolors and so on, and then I generally take the picture out of my studio, take it to my dealer. If there is a picture present I can't begin on another one.

You have to get it beyond your field of vision as well as outside it?

Literally that, you know. If it is present, I feel, if it was a good painting, something inevitably creeping into the next painting, and that is what I would like to avoid.

What if you come in contact with it later?

Oh, then I can look at it with a fresh eye. I can see a lot of faults in it often, or some good things, but I can look at it. If it is several years later I can look at it very freshly.

Do you have arid stretches when you feel you are devoid of the desire to paint?

No—no—the habit is so long and so old with me of coming into the studio, that I am restless when I am not there. Now, what takes place in the studio can be something like—not working. But I am there. I can go in and have something I want to read and I'll just slip my apron on and read. I feel ill-at-ease without the apron, utterly restless without the apron. I had to do a little thing for a magazine when I was over in Rome last winter, and I missed—of all things—I missed this apron of mine. I hadn't taken it along because I had intended to do no work. I consciously gave myself a vacation. I hadn't done that in twenty-five years. Just stopped for that period. I didn't want to draw anything, didn't want to go to museums very much. I just wanted to see people.

Do you find that the progress of a painting varies from painting to painting?

It varies greatly. If you are familiar with my work, you'll see that there are large number of small brushstrokes that take a great deal of time, and very intensely observed areas, and so on. But as for the actual time (I have a sort of vanity about trying to make it look as if it were done within two days), it varies. You know you can be sitting and working all day and then it will get to be around four o'clock and something will happen, and the next hour or two till dark will sometimes make up for three days of nothing but feeling. That used to distress me, but not so much any more because I have had so many experiences with it. I just try to console

Ben Shahn

myself by saying that the two or three days before were a kind of preparation for this. It was an inevitable thing, and that's all.

Now, I change my mind a great deal in working. I remember one painting that I called *Miners' Widows* or *Miners' Wives,* which I started and carried along for several weeks with the idea of having two figures right in the foreground almost next to each other. After two or three weeks of that I realized there was something wrong with it. At first I didn't dare face it, and then I had to face it. One of the figures had to go out and go way back and become a little thing. And it meant that two weeks of work had to be scraped off and abandoned.

Is this process of change during the course of the painting a pragmatic one? Do you have to put it down before you see it is wrong or is it wrong in your mind?

Well, first you see it as wrong in your mind. Naturally, when the inner critic begins to talk and talk louder, and your vanity won't allow it, at first you sort of dismiss it. Then, finally, you have to listen to it. And then you face the fateful day when you have to destroy or abandon a particular area. Maybe more than half of it or all of it.

There is a painting I did that I call *Beatitude.* It merely showed a man in a wheat field. The man was holding a single stalk of wheat, and he has a rather beatific expression. Well, I have read of people working years on a painting, and I could almost claim that I did on that one. I made three successive starts on that thing. It became kind of a challenge, and I abandoned it after two or three weeks of work in three successive years. When I began it again with a little—well—fear almost this time, because I had fixed the thing so many times, I had an idea. Where the idea came from I don't know, but I began by thinking of the whole thing in yellows, which is something I hadn't done before. I sort of beat myself on the head and said why I hadn't thought of it before. It is so clear that this thing is wheat in June, when they cut it where we live. It is all a world of yellow. But in the back of my mind (being a rational person), I said, now, how am I going to get this wheat to look yellow against the yellow of the whole painting? I thought, well, I'll cross that bridge when I come to it, and finally I decided to make the wheat almost jet black against all the yellows. There are all tonal variations of yellow in it. It was a good solution, and I remember showing this painting to a close friend, who liked it very much. When we left the studio to go back to the house, I was very curious, and I asked him, "What was the

color of the wheat? Do you remember?" He said, "Yellow, of course." Then he said, "Wait a minute, I don't remember . . . yellow, it had to be yellow. Wheat is yellow." And we went back and it was jet black. That painting nagged me for four years. Now, don't go away thinking that I was thinking of it every moment. But those periods when I started and then abandoned it were pretty serious periods.

Do you feel that you can express everything you want to say in painting?

Painting can become, and has become for me, a way of life, so that inevitably I can express almost anything I feel better in that medium than in any other medium. And that would be equally true for anyone engaged in other fields. Of course, there are times when I wish I could sing, and I can't. There are times when I wish I could write, and I can't. Often I have started to write something and have abandoned it because of the insurmountable difficulties. I found I could say what I wanted to say much more effectively in a drawing or a painting. It is a way of life that is sometimes hard to make younger people understand. I am consulted constantly by students here about painting as a career. They think of it in terms of a livelihood or in terms of a profession, and I try to tell them about my feeling that painting covers every experience a human being can have. And consequently, to answer your question directly, I have not felt that there was any other medium that I could use more effectively to express what I want to say, or what I feel in the world around me, or about my inner world, than the one I feel most at ease with.

Ben Shahn

IV painting

Like most artists, Ben Shahn was reluctant to put into words the ideas that he had worked hard to express in line and color. Yet also like most artists, he could seldom resist requests to try. Following are five of his major efforts.

Easel Painting *Ben Shahn*

There's a place in heaven for all kinds of painters—social, regional, abstract. I'm usually lumped with the social painters, but I think of my work as abstract too. I do any number of sketches for every figure, "abstracting" each one from the preceeding one. That's after I've decided what I'm going to paint, of course, which is usually something I've seen, or heard, or read. Next comes the problem of how to present it in the most dramatic way I can— the big and little relationships of color and tone, like the big red brick wall dwarfing the boy playing ball all alone.

Another way my pictures are abstractions is that after I decide on the relationships I turn the sketches upside down to check abstractly the validity of color and composition. This is a good test for design in any picture, one that anybody can try for himself. It shows up the difference between just an illustration and a well designed picture. Familiarity with forms makes you blind to them. You take them too casually. Studying any form abstractly brings you closer to it again. Upside down, you see the right relationship of the parts to the whole.

After I've got the relationship of the forms working, then I go back to the details. They've got to be right too. There's a difference in the way a twelve-dollar coat wrinkles from the way a seventy-five-dollar coat wrinkles, and that has to be right. It's just as important esthetically as the difference in the light of the Île:de-France and the Brittany coast. Maybe its more important. If I look at an ordinary overcoat as I never saw it before, then it becomes as fit a subject for painting as one of Titian's purple cloaks. Grass *is* green, by God! And earth is black or brown. These plain facts are just as clear, and a lot more real, than Renoir's pseudo-scientific concept of color.

But most important is always to have the play back and forth, back and forth. Between the big and the little, the light and the dark, the smiling and the sad, the serious and the comic. I like to have three vanishing points in one plane, or a half dozen in three planes. My type of social painting makes people smile. The height of the reaction is when the emotions of anger, sympathy, and humor all work at the same time. That's what I try to do—play one against the other, trying to keep a balance. One of my favorite stories is *Rouge et Noir*.

Excerpt from "Ben Shahn: An Interview," *Magazine of Art* (April, 1944).

Murals *Ben Shahn*

I like doing murals because more people see them than they do easel pictures. I learned fresco technique working with Rivera on the Rockefeller Center mural, but I haven't quite got the mural style yet—the way I want it. My first big job was the Jersey Homesteads school, and in one way it's still the most successful. People really look at it. They know it by heart. To them it's like the building, a part of the community. When a building needs a new wing you add to it, and so not long ago they came and wanted me to add the portrait of a new union official to the mural—six years after it was finished. But I think I'd already put too much in it—too many details.

The Bronx Post Office was a different kind of job—thirteen separate panels in the lobby. My idea was to show the people of the Bronx something about America outside New York. So I painted a cotton picker, along with another panel showing a woman tending spindles in a city mill. I painted wheat fields, and power dams as well as steel workers and riveters. I stuck to big, simple shapes and solid warm colors. I think I handled them better than I did the one panel at Jersey Homesteads, but I'll bet not as many people really look at them. They were not planned as part of the building or community. They were an architect's afterthought. I went back to look at them one day and the service crew foreman saw me. "You the guy who did these pictures?" I said yes and asked him how he liked them. "Not particularly, but I'm sure glad you put all these guys in overalls up on the walls. It helped me organize the building crew. Made 'em think they were important."

I think the Social Security mural is the best work I've done. Anyway, it was the most satisfying. I felt I had everything under control—or almost under control—the big masses of color to make it decorative and the little details to make it interesting. You can see I borrowed some of these details from my own paintings— the handball players for instance.

I know the details are right because all sorts of people stopped to talk to me while I was working. One day when I was finishing the steel construction panel a rigger who had worked on the building pounded me on the back and said, "Good job, bud, good job. That stone carving out in front of the building ain't got nothing to do with anybody."

Then there was the guard in the corridor who had been standing

Excerpt from "Ben Shahn: An Interview," *Magazine of Art* (April, 1944).

Ben Shahn

there for weeks without taking any notice of the mural at all. Suddenly there he was beside me. I was painting the man letting wheat pour through his fingers, and the guard said, "Say, that's the first wheat I've seen since I left the state of Washington." I also liked the man from Iowa who stopped by when I was finishing the overalls on one of the carpenters. "Why," he said, "that's the spit'n'-image of my friend Ed Talbot."

But I liked best the Army colonel who came up one day when I was eating lunch in the building cafeteria. "I finally got the courage to come up and talk to you," he said. "I've been wanting to tell you that what you're painting up there on the wall is important to keep in front of all of us while we're fighting this war."

I'm not sure what I think about Tolstoy's definition of great art as the kind that pleases the most people. I suspect it's one of those half truths. I don't know. But I do know I get a kick out of being able to paint in the same picture the spit'in'image of Ed Talbot and the war aims of an Army colonel, while all the time other pictures of mine are hanging in the Museum of Modern Art. Back and forth, you know, between the big and the little shapes, between light and dark, serious and comic. Three vanishing points in one plane.

Letter to Mrs. Elizabeth S. Navas, New York
Ben Shahn

Roosevelt, New Jersey
March 7, 1955

Dear Mrs. Navas:

Concerning your request for some explanation of my purposes in painting *The Blind Botanist,* they were somewhat as follows:

First, I feel a little dubious as to whether one ought to place such an explanation upon a picture. Explanation tends to have a limiting effect; it makes definitive that which one wants to keep in an expanding state. I have always felt that any painting is one's own intentions, his feelings and his image, *plus* the complex imagery and feelings of the observer. A painting must be plastic in that it can expand with and respond to the intellectual and emotional processes of many people.

My own concern, with *The Blind Botanist,* was to express a curious quality of irrational hope that man seems to carry around with him, and then along with that to suggest the unpredictable

miraculous vocations which he pursues. This painting is in a sense a parallel to one called *The Red Staircase* in which I sought to formulate the same sort of idea. *The Red Staircase* is perhaps a little more "spelled out" than is *The Blind Botanist,* but I myself have had a great sense of realization in the latter picture.

I hope that the above will be adequate for your needs. If the sense of the painting is fugitive, that is as I have wanted it; I hope the explanation itself will not be too fugitive, but still a little so.

<div style="text-align: right">Very sincerely yours,
(Signed) Ben Shahn</div>

The Biography of a Painting *Ben Shahn*

In 1948, while Henry McBride was still writing for the *New York Sun,* I exhibited a painting to which I had given the somewhat cryptic title, *Allegory*. The central image of the painting was one which I had been developing across a span of months—a huge chimera-like beast, its head wreathed in flames, its body arched across the figures of four recumbent children. These latter were dressed in very commonplace clothes, perhaps not entirely contemporary, but rather as I could draw them and their details from my own memory.

I had always counted Henry McBride as a friend and an admirer of my pictures, about which he had written many kind words. Even of this one, he wrote glowingly at first. Then he launched into a strange and angry analysis of the work, attributing to it political motives, suggesting some symbolism of Red Moscow, drawing parallels which I cannot recall accurately, but only their tone of violence, completing his essay by recommending that I, along with the Red Dean of Canterbury, be deported.

Mr. McBride's review was not the first astonishing piece of analysis of my work that I have read, nor was it the last. Perhaps, coming as it did from a critic whom I had looked upon as a friend, it was one of the most disconcerting. In any case, it caused me to undertake a review of this painting, *Allegory,* to try to assess just for my own enlightenment what really was in it, what sort of things go to make up a painting. Of the immediate sources I was fully aware, but I wondered to what extent I could trace the deeper origins, and the less conscious motivations.

Reprinted by permission of the publishers from Ben Shahn, *The Shape of Content* (Cambridge, Mass.: Harvard University Press, copyright, 1957, by the President and Fellows of Harvard College).

I had an additional reason for undertaking such an exploration besides the pique which Mr. McBride's review had engendered. I had long carried in my mind that famous critical credo of Clive Bell's, a credo which might well have been erased by time, but which instead has grown to almost tidal proportions and which still constitutes the Procrustean bed into which all art must be either stretched or shrunk. The credo runs as follows: "The representative element in a work of art may or may not be harmful, but it is always irrelevant. For to appreciate a work of art, we must bring with us nothing from life, no knowledge of its affairs and ideas, no familiarity with its emotions."

Once proffered as an isolated opinion, that view of art has now become a very dominant one, is taught in the schools, and is laboriously explained in the magazines. Thus, in reconsidering the elements which I feel have formed the painting *Allegory,* I have had in mind both critical views, the one which presumes a symbolism beyond or aside from the intention of a painting, and the other, that which voids the work of art of any meaning, any emotion, or any intention.

The immediate source of the painting of the red beast was a Chicago fire in which a colored man had lost his four children. John Bartlow Martin had written a concise reportorial account of the event—one of those stories which, told in detail, without any emotionalism being present in the writing itself, manages to produce a far greater emotional impact than would a highly colored account.

I was asked to make drawings for the story and, after several discussions with the writer, felt that I had gained enough of the feel of the situation to proceed. I examined a great deal of factual visual material, and then I discarded all of it. It seemed to me that the implications of this event transcended the immediate story; there was a universality about man's dread of fire, and his sufferings from fire. There was a universality in the pity which such a disaster invokes. Even racial injustice, which had played its part in this event, had its overtones. And the relentless poverty which had pursued this man, and which dominated the story, had its own kind of universality.

I now began to devise symbols of an almost abstract nature, to work in terms of such symbols. Then I rejected that approach too. For in the abstracting of an idea one may lose the very intimate humanity of it, and this deep and common tragedy was above all things human. I returned then to the small family contacts, to the familiar experiences of all of us, to the furniture, the clothes, the

look of ordinary people, and on that level made my bid for universality and for the compassion that I hoped and believed the narrative would arouse.

Of all the symbols which I had begun or sought to develop, I retained only one in my illustrations—a highly formalized wreath of flames with which I crowned the plain shape of the house which had burned.

Sometimes, if one is particularly satisfied with a piece of work which he has completed, he may say to himself, "well done," and go on to something else. Not in this instance, however. I found that I could not dismiss the event about which I had made drawings—the so-called "Hickman Story." In the first place, there were the half-realized, the only intimated drawings in a symbolic direction which were lying around my studio; I would develop some of them. In the second place there was the fire itself; I had some curious sense of responsibility about it, a sort of personal involvement. I had still not fully expressed my sense of the enormity of the Hickman fire; I had not formulated it in its full proportions; perhaps it was that I felt that I owed something more to the victim himself.

One cannot, I think, crowd into drawings a really towering content of feeling. Drawings may be small intimate revelations; they may be witty or biting, they may be fragmentary glimpses of great feeling or awesome situation, but I feel that the immense idea asks for a full orchestration of color, depth, texture, and form.

The narrative of the fire had aroused in me a chain of personal memories. There were two great fires in my own childhood, one only colorful, the other disastrous and unforgettable. Of the first, I remember only that the little Russian village in which my grandfather lived burned, and I was there. I remember the excitement, the flames breaking out everywhere, the lines of men passing buckets to and from the river which ran through the town, the madwoman who had escaped from someone's house during the confusion, and whose face I saw, dead-white in all the reflected color.

The other fire left its mark upon me and all my family, and left its scars on my father's hands and face, for he had clambered up a drainpipe and taken each of my brothers and sisters and me out of the house one by one, burning himself painfully in the process. Meanwhile our house and all our belongings were consumed, and my parents stricken beyond their power to recover.

Among my discarded symbols pertaining to the Hickman story there were a number of heads and bodies of beasts, besides several Harpies, Furies, and other symbolic, semi-classic shapes and fig-

Ben Shahn

ures. Of one of these, a lion-like head, but still not a lion, I made many drawings, each drawing approaching more nearly some inner figure of primitive terror which I was seeking to capture. I was beginning to become most familiar with this beast-head. It was, you might say, under control.

Of the other symbols, I developed into paintings a good menagerie of Harpies, of birds with human heads, of curious and indecipherable beasts all of which I enjoyed immensely, and each of which held just enough human association for me to be great fun, and held just enough classical allusion to add a touch of elegance which I also enjoyed. (And this group of paintings in turn led off into a series of paintings of more or less classical allusion, some only pleasant, but some which like the *City of Dreadful Night* or *Homeric Struggle* were major paintings to me, each having beside its classical allusion, a great deal of additional motivation.)

When I at last turned the lion-like beast into a painting, I felt able to imbue it with everything that I had ever felt about a fire. I incorporated the highly formalized flames from the Hickman story as a terrible wreath about its head, and under its body I placed the four child figures which, to me, hold the sense of all the helpless and the innocent.

The image that I sought to create was not one of a disaster; that somehow doesn't interest me. I wanted instead to create the emotional tone that surrounds disaster; you might call it the inner disaster.

In the beast as I worked upon it I recognized a number of creatures; there was something of the state of an abnormal cat that we once owned that had devoured its own young. And then, there was the wolf.

To me, the wolf is perhaps the most paralyzingly dreadful of beasts, whether symbolic or real. Is my fear some instinctive strain of my Russian background? I don't know. Is it merely the product of some of my mother's colorful tales about being pursued by wolves when she was with a wedding party, or again when she went alone from her village to another one nearby? Does it come from reading Gogol? Whatever its source, my sense of panic concerning the wolf is real. I sought to implant, or, better, I recognized something of that sense within my allegorical beast.

Then, to go on with the wolf image; I had always found disconcerting the familiar sculpture of Romulus and Remus being suckled by the She-Wolf. It had irritated me immensely, and was a symbol that I abhorred. Now I found that, whether by coincidence or not I am unable to say, the stance of my imaginary beast was

just that of the great Roman wolf, and that the children under its belly might almost be a realization of my vague fears that, instead of suckling the children, the wolf would most certainly destroy them. But the children, in their play-clothes of 1908, are not Roman nor are they the children of the Hickman fire; they resemble much more closely my own brothers and sisters.

Such are a few of the traceable sources of imagery, and of the feeling of a single painting—mine, only because I can know what these sources are, because I am able to follow them backward at least to that point at which they disappear into the limbo of the subconscious, or the unconscious, or the instinctive, or the merely biological.

But there are many additional components present within a painting, many other factors that modify, impel, restrain, and in unison shape the images which finally emerge.

The restraining factors alone wield a powerful, albeit only negative, invisible hand. An artist at work upon a painting must be two people, not one. He must function and act as two people all the time and in several ways. On the one hand, the artist is the imaginer and the producer. But he is also the critic, and here is a critic of such inexorable standards as to have made McBride seem liberal even in his most illiberal moment.

When a painting is merely in the visionary stage, the inner critic has already begun stamping upon it. The artist is enthusiastic about some idea that he has. "You cannot," says the inner critic, "superimpose upon visual material that which is not essentially visual. Your idea is underdeveloped. You must find an image in which the feeling itself is embedded. An image of a fire? Not at all! A fire is a cheerful affair. It is full of bright colors and moving shapes; it makes everybody happy. It is not your purpose to tell about a fire, not to describe a fire. Not at all; what you want to formulate is the terror, the heart-shaking fear. Now, find that image!"

So the inward critic has stopped the painting before it has even been begun. Then, when the artist strips his idea down to emotional images alone and begins slowly, falteringly, moving toward some realization, that critic is constantly objecting, constantly chiding, holding the hand back to the image alone, so that the painting remains only that, so that it does not split into two things, one, the image, and another, the meaning.

I have never met a literary critic of painting who, whatever his sentiments toward the artist, would actually destroy an existing painting. He would regard such an act as vandalism and would never consider it. But the critic within the artist is a ruthless

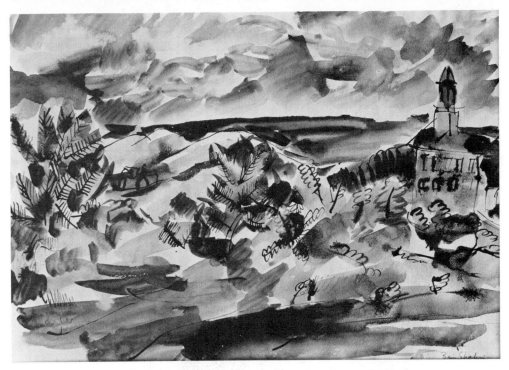

1. *Little Church*, c. 1925. Watercolor, 14¾'' x 21¾''. Collection of The Newark Museum.

2. *WCTU Parade*, c. 1934. (Mural project for New York's Central Park Casino.) Gouache, 16'' x 31½''. Collection of the Museum of the City of New York.

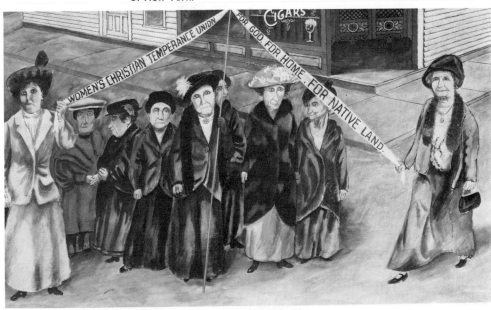

3. Untitled photograph, New York City, c. 1934. (Used as a basis for *Vacant Lot*.) Photography Collection, Fogg Museum, Harvard University, Cambridge, Massachusetts.

4. Photograph, *Wheat in Shock*, Central Ohio, 1938. Photography Collection, Fogg Museum, Harvard University, Cambridge, Massachusetts.

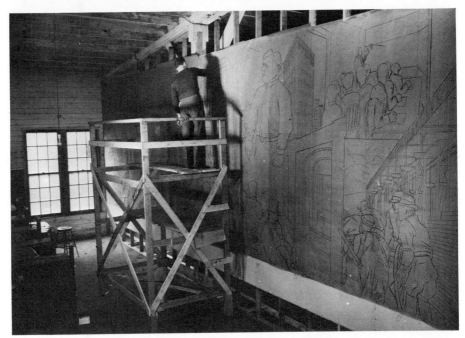

5. Shahn working on cartoons for mural in the Community Center, Roosevelt, New Jersey, 1937. Photograph courtesy of Bernarda Shahn.

6. Mural in the Community Center, Roosevelt, New Jersey, 1937–38. From James Thrall Soby, *Ben Shahn: Paintings* (New York: George Braziller, 1963). Photo Meyer.

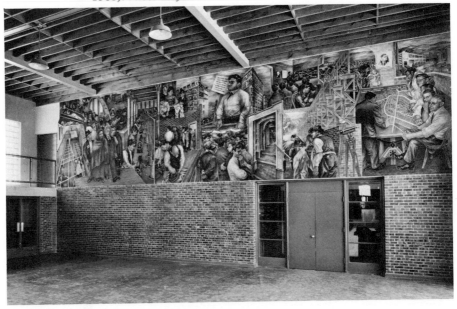

7. Photograph, *Roadside Inns,* Central Ohio, 1938. Photography Collection, Fogg Museum, Harvard University, Cambridge, Massachusetts.

8. Photograph, *Main Street,* Plain City, Ohio, 1938. (Used as a basis for *Triple Dip.*) Photography Collection, Fogg Museum, Harvard University, Cambridge, Massachusetts.

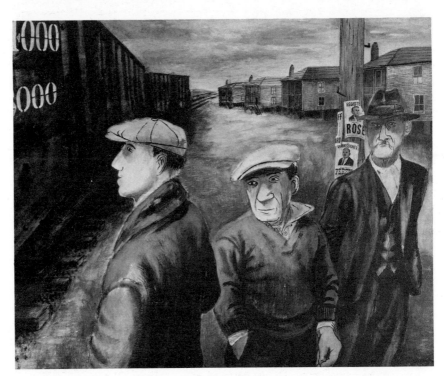

9. *Scotts Run, West Virginia,* 1937. Tempera, 22¼'' x 27⅞''. Collection of the Whitney Museum of American Art, New York.

10. *Sunday Football,* 1938. Tempera, 16'' x 23½''. Estate of Herman Shulman. Photograph courtesy of George Braziller, Inc., New York.

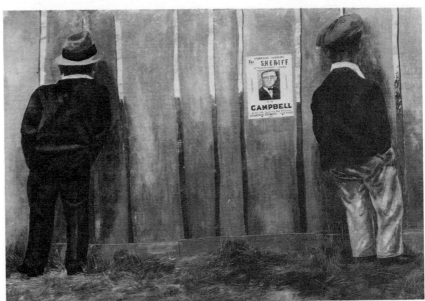

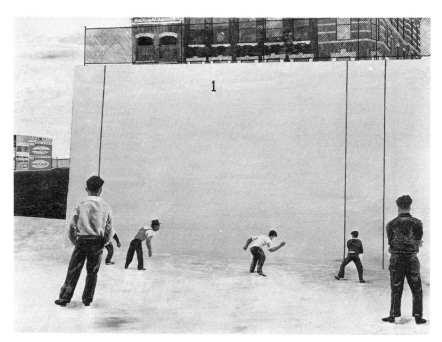

11. *Handball*, 1939. Tempera, 22¾″ x 31¼″. Collection of The Museum of Modern Art, New York. Abby Aldrich Rockefeller Fund.

12. *Pretty Girl Milking a Cow*, 1940. Tempera, 22″ x 30″. Collection of Edgar Kaufmann, jr. Photograph courtesy of The Museum of Modern Art, New York.

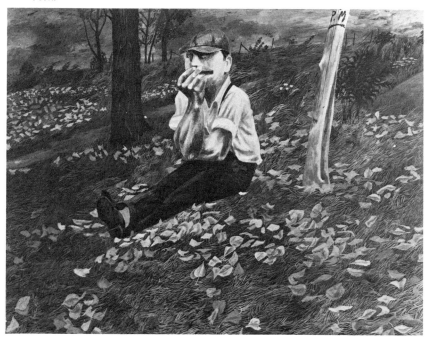

13. *Vacant Lot,* 1939. Watercolor and gouache, 19" x 23". Courtesy of the Wadsworth Atheneum, Hartford. The Ella Gallup Sumner and Mary Catlin Sumner Collection.

14. *Vandenberg, Dewey, and Taft*, 1941. Serigraph, 15'' x 22⅛''. Collection of Mr. and Mrs. John D. Morse.

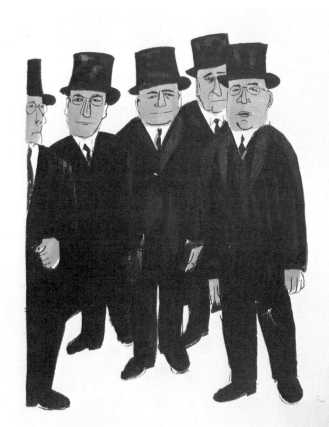

15. *4½ out of 5 Businessmen*, 1941. Serigraph, 13½'' x 10½''. Collection of Mr. and Mrs. John D. Morse.

destroyer. He continually rejects the contradictory elements within a painting, the colors that do not act upon other colors and would thus constitute dead places within his work; he rejects insufficient drawing; he rejects forms and colors incompatible with the intention or mood of the piece; he rejects intention itself and mood itself often as banal or derivative. He mightily applauds the good piece of work; he cheers the successful passage; but then if the painting does not come up to his standards he casts aside everything and obliterates the whole.

The critic within the artist is prompted by taste, highly personal, experienced, and exacting. He will not tolerate within a painting any element which strays very far from that taste.

During the early French-influenced part of my artistic career, I painted landscapes in a Post-Impressionist vein, pleasantly peopled with bathers, or I painted nudes, or studies of my friends. The work had a nice professional look about it, and it rested, I think, on a fairly solid academic training. It was during those years that the inner critic first began to play hara-kiri with my insides. With such ironic words as, "It has a nice professional look about it," my inward demon was prone to ridicule or tear down my work in just those terms in which I was wont to admire it.

The questions, "Is that enough? Is that all?" began to plague me. Or, "This may be art, but is it my own art?" And then I began to realize that however professional my work might appear, even however original it might be, it still did not contain the central person which, for good or ill, was myself. The whole stream of events and of thinking and changing thinking; the childhood influences that were still strong in me; my rigorous training as a lithographer with its emphasis upon craft; my several college years with the strong intention to become a biologist; summers at Woods Hole, the probing of the wonders of marine forms; all my views and notions on life and politics, all this material and much more which must constitute the substance of whatever person I was, lay outside the scope of my own painting. Yes, it was art that I was producing, perfectly competent, but foreign to me, and the inner critic was rising up against it.

It was thus under pressure of such inner rejection that I first began to ask myself what sort of person I really was, and what kind of art could truly coincide with that person. And to bring into this question the matter of taste I felt—or the inner critic felt —that it was both tawdry and trivial to wear the airs and the artistic dress of a society to which I did not belong.

I feel, I even know, that this first step in rejection is a presence within the fire-image painting of which I have undertaken to

speak. The moving toward one's inner self is a long pilgrimage for a painter. It offers many temporary successes and high points, but there is always the residuum of incomplete realization which impels him on toward the more adequate image.

Thus there began for me the long artistic tug of war between idea and image.

At first, the danger of such a separation did not appear. For my first disquisition in paint was only semi-serious. My friend Walker Evans and I had decided to set up an exhibition in the barn of a Portuguese family on Cape Cod. He would exhibit a series of superb photographs which he had made of the family there; I would exhibit a few watercolors, most of them not yet in existence.

At just that time I was absorbed in a small book which I had picked up in France, a history of the Dreyfus case. I would do some exposition of the affair in pictures. So I set to work and presented the leading malefactors of the case, the defenders, and of course Dreyfus himself. Under each portrait I lettered in my best lithographic script a long or short legend setting forth the role which the original of the portrait had played in the celebrated affair.

What had been undertaken lightly became very significant in my eyes. Within the Dreyfus pictures I could see a new avenue of expression opening up before me, a means by which I could unfold a great deal of my most personal thinking and feeling without loss of simplicity. I felt that the very directness of statement of these pictures was a great virtue in itself. And I further felt, and perhaps hoped a little, that such simplicity would prove irritating to that artistic elite who had already—even at the end of the twenties—begun to hold forth "disengagement" as the first law of creation. As artists of a decade or so earlier had delighted to *épater le bourgeois,* so I found it pleasant, to borrow a line from Leonard Baskin, to *épater l'avant-garde.*

Having returned only recently from France where the Sacco-Vanzetti case was a national fever, I now turned to that noted drama for the theme of a new group of paintings, and set about revealing the acts and the persons involved with as rigorous a simplicity as I could command. I was not unmindful of Giotto, and of the simplicity with which he had been able to treat of connected events—each complete in itself, yet all re-creating the religious drama, so living a thing to him.

The ensuing series of pictures was highly rewarding to me. First, I felt that my own work was now becoming identified with my person. Then there was the kind of response which met the pic-

Ben Shahn

tures; not only did the customary art public receive the work kindly, but there was also an entirely new kind of public, a great influx of people who do not ordinarily visit galleries—journalists and Italian immigrants and many other sorts of sympathizers. And then there was the book about the case which [Robert] Benchley sent to me, inscribed, "to Ben Shahn without whom this crime could never have been committed."

I continued to work in terms of pictures which related to a central theme, the inner critic being somewhat appeased and exercising only a certain technical stringency. A new series of questions now arose for me, and with them the inevitable consequent rejections. I began to question the degree of my belief in the views which I held. It became uncomfortably apparent to me that whatever one thinks as well as whatever one paints must be constantly reexamined, torn apart, if that seems to be indicated, and reassembled in the light of new attitudes or new discovery. If one has set for himself the position that his painting shall not misconstrue his personal mode of thinking, then he must be rather unusually alert to just what he does think.

I was impelled to question the social view of man to which I had adhered for a number of years without actually doubting that it might be either a right view or a natural one to me. Now it dawned upon me that I had always been at war with this idea. Generalities and abstractions and vital statistics had always bored me. Whether in people or in art it was the individual peculiarities that were interesting. One has sympathy with a hurt person, not because he is a generality, but precisely because he is not. Only the individual can imagine, invent, or create. The whole audience of art is an audience of individuals. Each of them comes to the painting or sculpture because there he can be told that he, the individual, transcends all classes and flouts all predictions. In the work of art he finds his uniqueness affirmed.

Yes, one rankles at broad injustices, and one ardently hopes for and works toward mass improvements; but that is only because whatever mass there may be is made up of individuals, and each of them is able to feel and have hopes and dreams.

Nor would such a view invalidate a belief which I had held about the unifying power of art. I have always believed that the character of a society is largely shaped and unified by its great creative works, that a society is molded upon its epics, and that it imagines in terms of its created things—its cathedrals, its works of art, its musical treasures, its literary and philosophic works. One might say that a public may be so unified because the highly personal experience is held in common by the many individual

members of the public. The great moment at which Oedipus in his remorse tears out his eyes is a private moment—one of deepest inward emotion. And yet that emotion, produced by art, and many other such private and profound emotions, experiences, and images bound together the Greek people into a great civilization, and bound others all over the earth to them for all time to come.

So I had crossed the terrain of the "social view," and I would not return. At the same time, I feel that all such artistic terrain which one has crossed must to some extent affect or modify his later work. Whatever one has rejected is in itself a tangible shaping force. That all such work improves the skill of the hand or the discernment of the eye is only a minor consideration. Even of one's thinking, however much his views may change, one retains a great deal, rejecting only that which seems foreign to him or irrelevant. Or, one may wholly reject the social view of man and at the same time cherish its underlying sympathies and its sense of altruism.

Such a process of acceptance and rejection—the artist plus the inner critic, or you might just say, the informed creator—is present in the most fragmentary piece which an artist produces. A small sketch of Picasso's, a drawing by Rouault, or Manet or Modigliani, is not to be dismissed as negligible, for any such piece contains inevitably the long evolutionary process of taste, deftness, and personal view. It is, if brief, still dictated by the same broad experience and personal understanding which molds the larger work.

I was not the only artist who had been entranced by the social dream, and who could no longer reconcile that view with the private and inner objectives of art. As during the thirties art had been swept by mass ideas, so during the forties there took place a mass movement toward abstraction. Not only was the social dream rejected, but any dream at all. Many of those names that, during the thirties, had been affixed to paintings of hypothetical tyrannies and theoretical cures were now affixed to cubes and cones and threads and swirls of paint. Part of that work was—and is—beautiful and meaningful; part of it does indeed constitute private experience. A great part of it also represents only the rejection, only the absence of self-commitment.

The change in art, mine included, was accomplished during World War II. For me, it had begun during the late thirties when I worked in the Resettlement Administration. I had then crossed and recrossed many sections of the country, and had come to know well so many people of all kinds of belief and temperament, which they maintained with a transcendent indifference to their lot in life.

Ben Shahn

Theories had melted before such experience. My own painting then had turned from what is called "social realism" into a sort of personal realism. I found the qualities of people a constant pleasure; there was the coal miner, a cellist, who organized a quartet for me—the quartet having three musicians. There was the muralist who painted the entire end of his barn with scenes of war and then of plenty, the whole painting entitled *Uncle Sam Did It All*. There were the five Musgrove brothers who played five harmonicas —the wonderful names of people, Plato Jordan and Jasper Lancaster, and of towns, Pity Me, and Tail Holt, and Bird-in-Hand. There were the poor who were rich in spirit, and the rich who were also sometimes rich in spirit. There was the South and its story-telling art, stories of snakes and storms and haunted houses, enchanting; and yet such talent thriving in the same human shell with hopeless prejudices, bigotry, and ignorance.

Personal realism, personal observation of the way of people, the mood of life and places, all that is a great pleasure, but I felt some larger potentiality in art.

During the war I worked in the Office of War Information. We were supplied with a constant stream of material, photographic and other kinds of documentation of the decimation within enemy territory. There were the secret confidential horrible facts of the cartloads of dead; Greece, India, Poland. There were the blurred pictures of bombed-out places, so many of which I knew well and cherished. There were the churches destroyed, the villages, the monasteries—Monte Cassino and Ravenna. At that time I painted only one theme, "Europa," you might call it. Particularly I painted Italy as I lamented it, or feared that it might have become.

It had been my principle in painting, during all the changes that I had undertaken, that outer objects or people must be observed with an acute eye for detail, but that all such observation must be molded from an inner view. I had felt consistently, also, that any such content must be painted in a way wholly subject to the kind of medium, whether oil, tempera, fresco, or whatever.

But now I saw art turning abstract, courting material alone. It seemed to me that such a direction promised only a cul-de-sac for the painter. I wanted to find some deeper source of meaning in art, a constant spring that would not run dry with the next change in political weather.

Out of the battery of acceptances and rejections that mold the style of a painter, there rises as a force not only his own growing and changing work, but that of other work, both contemporary and past. He must observe all these directions and perhaps continue those which appear to be fruitful, while shunning those which

appear to be limited and of short duration. Thus a degree of sophistication is essential to the painter.

While I felt a growing conviction as to the validity of the inner view, I wanted not to re-tread the ground which had been so admirably illuminated by Surrealism. Indeed the subconscious, the unconscious, the dream-world does offer a rich, almost limitless panorama for the explorations of art; but in that approach, I think we may call it the psychological approach, one may discern beyond the rich imagery certain limits and inevitable pitfalls.

The limitation which circumscribed Surrealist art arose from its efforts to reveal the subconscious. For in that effort control and intention were increasingly relinquished. Surrealism and the psychological approach led into that quagmire of the so-called automatic practices of art—the biomorphic, the fecal, the natal, and the other absurdities.

The subconscious may greatly shape one's art; undoubtedly it does so. But the subconscious cannot create art. The very act of making a painting is an intending one; thus to intend and at the same time relinquish intention is a hopeless contradiction, albeit one that is exhibited on every hand.

But the great failure of all such art, at least in my own view, lies in the fact that man's most able self is his conscious self—his intending self. The psychological view can at best, even assuming that it were accurate, tell us what man is in spite of himself. It may perhaps discover those animal motives which are said to lurk beneath the human ones. It may unmask selfish purposes lying within altruism. It may even be able to reveal primitive psychological states underneath the claims and achievements of philosophy—the brute beneath the intellect. But the values of man, if he has any at all, reside in his intentions, in the degree to which he has moved away from the brute, in his intellect at its peak and in his humanity at its peak.

I do not conceive it to be the role of art to retrogress either into the pre-natal or into the pre-human state. So while I accept the vast inner landscape that extends off the boundaries of consciousness to be almost infinitely fruitful of images and symbols, I know that such images mean one thing to the psychologist and quite another to the artist.

One might return to Oedipus. For, to the psychologist, Oedipus is a symbol of aberration only—a medical symbol. But to the artist Oedipus is a symbol of moral anguish, and even more than that, of transcendent spiritual power.

Or, consider Van Gogh; to the psychologist it is the periodic insanity of Van Gogh that is preeminent, and the psychologist de-

Ben Shahn

duces much from that. But to the artist it is clear that it was the great love of things and of people and the incredible suffering of Van Gogh that made his art possible and his insanity inevitable.

I know that there must be an ingredient of complete belief in any work of art—belief in what one is doing. I do not doubt that those artists who work only for pure form believe in form alone as the ultimate possible expression in art. Those who look upon their art as therapy probably believe with equal fervor in what they are doing. And I am sure that the artists who only manipulate materials believe firmly in that method. But here again one must be impelled by rejection. Such art can contain nothing of experience either inward or outward. It is only a painted curtain resting midway between the subjective and the objective, closing either off from the other.

To me both subjective and objective are of paramount importance, another aspect of the problem of image and idea. The challenge is not to abolish both from art, but rather to unite them into a single impression, an image of which meaning is an inalienable part.

I had once believed that the incidental, the individual, and the topical were enough; that in such instances of life all of life could be implied.

But then I came to feel that that was not enough. I wanted to reach farther, to tap some sort of universal experience, to create symbols that would have some such universal quality.

I made a series of paintings during the war which, in my own view—and what other view has an artist?—began to realize this more difficult objective. I shall discuss the pictures themselves, but again it is necessary to emphasize the conflict which arises in any such change of view, and the painful necessity to be aware of what one really thinks and wants in art.

I have already mentioned my personal dislike of generalities. Now, one must ask, is not the universal merely another term for the generality? How can one actually achieve a universality in painting without becoming merely more generalized and abstract? I feel that this question is one which greatly concerns artists. Its resolution will greatly affect the kind of an artist one is to be.

My own approach can only be to ask myself just what it is that I so dislike all statistics and most generalities. The answer that I find is simply that I dislike such material because it is impersonal. In being average to all things, it is particular to none. If we were to attempt to construct an "average American" we would necessarily put together an effigy which would have the common qualities of all Americans, but would have the eccentricities, pecu-

liarities, and unique qualities of no American. It would, like the sociologist's statistical high-school student, approximate everyone and resemble no one.

But let us say that the universal is that unique thing which affirms the unique qualities of all things. The universal experience is that private experience which illuminates the private and personal world in which each of us lives the major part of his life. Thus, in art, the symbol which has vast universality may be some figure drawn from the most remote and inward recesses of consciousness; for it is here that we are unique and sovereign and most wholly aware. I think of Masaccio's *Expulsion from the Garden,* so intensely personal that it leaves no person untouched. I think of a de Chirico figure, lonely in a lonely street haunted by shadows; its loneliness speaks to all human loneliness. As an experience, neither painting has anything of the average; both come from extreme limits of feeling and both paintings have a great universality.

The paintings which I made toward the close of the war—the *Liberation* picture, *The Red Staircase, Pacific Landscape, Cherubs and Children, Italian Landscape,* and quite a number of others— did not perhaps depart sharply in style or appearance from my earlier work, but they had become more private and more inward-looking. A symbolism which I might once have considered cryptic now became the only means by which I could formulate the sense of emptiness and waste that the war gave me, and the sense of the littleness of people trying to live on through the enormity of war. I think that at that time I was very little concerned with communication as a conscious objective. Formulation itself was enough of a problem—to formulate into images, into painted surfaces, feelings, which, if obscure, were at least strongly felt.

But in my own view these paintings were successful. I found in them a way to go, actually a liberation of sorts for myself. I became most conscious then that the emotional image is not necessarily of that event in the outside world which prompts our feeling; the emotional image is rather made up of the inner vestiges of many events. It is of that company of phantoms which we all own and which have no other sense than the fear sense, or that of the ludicrous, or of the terribly beautiful; images that have the nostalgia of childhood with possibly none of the facts of our childhood; images which may be drawn only from the recollection of paint upon a surface, and yet that have given one great exaltation— such are the images to be sensed and formulated.

I became increasingly preoccupied with the sense and the look, indeed, with the power of this newly emerging order of image. It

Ben Shahn

was, as I have indicated, a product of active intentions plus the constant demands and rejections of the inward critic; even perhaps of a certain striving to measure my own work critically with some basic truth in art. At the same time I read and do read comments about my work by outer critics, some referring to the work as "Social Realism," some lamenting its degree of content, holding that to be irrelevant to any art, but most employing certain labels which, however friendly they may be in intention, have so little relation to the context of a painting. I believe that if it were left to artists to choose their own labels most would choose none. For most artists have expended a great deal of energy in scrambling out of classes and categories and pigeon-holes, aspiring toward some state of perfect freedom which unfortunately neither human limitations nor the laws allow—not to mention the critics.

I don't just think, I know, that this long historical process which I have just described is present within the one painting of the fire animal which is called *Allegory*. There is considerable content which extends through one's work, appearing, disappearing, changing, growing; there is the shaping power of rejection which I have discussed, and the constant activity of revising one's ideas—of thinking what one wants to think. All these elements are present to a greater or less degree in the work of any painter who is deeply occupied in trying to impress his personality upon inert matter.

But allowing all this procedure and material, I must now say that it is, in another sense, only background. It is formulative of taste; it is the stuff and make-up of the inner critic; it is the underground stream of ideas. But idea itself must always bow to the needs and demands of the material in which it is to be cast. The painter who stands before an empty canvas must think in terms of paint. If he is just beginning in the use of paint, the way may be extremely difficult for him because he may not yet have established a complete rapport with his medium. He does not yet know what it can do, and what it cannot do. He has not yet discovered that paint has a power by itself and in itself—or where that power lies, or how it relates to him. For with the practiced painter it is that relationship which counts; his inner images are paint images, as those of the poet are no doubt metrical word images and those of the musician tonal images.

From the moment at which a painter begins to strike figures of color upon a surface he must become acutely sensitive to the feel, the textures, the light, the relationships which arise before him. At one point he will mold the material according to an intention. At another he may yield intention—perhaps his whole concept—to emerging forms, to new implications within the painted surface.

Idea itself, ideas, many ideas move back and forth across his mind as a constant traffic, dominated perhaps by larger currents and directions, by what he wants to think. Thus idea rises to the surface, grows, changes as a painting grows and develops. So one must say that painting is both creative and responsive. It is an intimately communicative affair between the painter and his painting, a conversation back and forth, the painting telling the painter even as it receives its shape and form.

Here too, the inward critic is ever at hand, perpetually advising and casting doubt. Here the work is overstated; there it is thin; in another place, muddiness is threatened; somewhere else it has lost connection with the whole; here it looks like an exercise in paint alone; there, an area should be preserved; thus the critic, sometimes staying the hand of the painter, sometimes demanding a fresh approach, sometimes demanding that a whole work be abandoned—and sometimes not succeeding, for the will may be stubborn enough to override such good advice.

I have spoken of the tug of war between idea and image which at an earlier time in my painting had plagued me so greatly. I could not reconcile that conflict by simply abandoning the idea, as so many artists had done. Such an approach may indeed simplify painting, but it also removes it from the arena of challenging, adult, fully intellectual and mature practice. For me, there would be little reason for painting if idea were not to emerge from the work. I cannot look upon myself or upon man generally as a merely behaving species. If there is value it rests upon the human ability to have idea, and indeed upon the stature of the idea itself.

The painting of the red beast, *Allegory,* is an idea painting. It is also a highly emotional painting, and I hope that it is still primarily an image, a paint image. I began the painting, as I have said, with no established idea, only with the sense of a debt to be paid and with a clamoring of images, many of them. But as to the fire itself, and as to fires, I had many ideas, a whole subcontinent of ideas, none of which would be executed to measure, but any one of which might rise to become the dominating force in the painting. So it was with the series of paintings which I made during and after the time of the fire animal. There was the painting *Brothers.* Paint, yes, but also reunion, reconciliation, end of war, pain of strong feeling, family, brothers. There was the painting called *City of Dreadful Night*—a forest of television aerials—lines in paint—splashes of light or heads of ancient demons tangled in the antennae—a somber building with moldering Greek heads. All of these images arose out of paint, yes, but they also arose out of the somewhat ominous implications of television for the mind,

Ben Shahn

for the culture. Out of a chain of connective ideas, responding to paint and color, rises the image, the painted idea. Thus the work may turn in an amusing direction, in a satirical direction. Or sometimes images are found—image ideas which are capable of great amplification, which can be built up to a high point of expressive power, at least for my purposes.

I cannot question that such a two-way communication has always constituted the painting process, sometimes with greater insistence of idea, sometimes with less, or none. Personal style, be it that of Michelangelo, or that of Tintoretto, or of Titian or of Giotto, has always been that peculiar personal rapport which has developed between an artist and his medium.

So I feel that painting is by no means a limited medium, neither limited to idea alone, nor to paint alone. I feel that painting is able to contain whatever one thinks and all that he is. The images which may be drawn out of colored materials may have depth and luminosity measured by the artist's own power to recognize and respond to such qualities, and to develop them. Painting may reflect, even brilliantly, the very limitations of an artist, the innocence of eye of a Rousseau, of a Bombois, of a John Kane. Painting can, and it has at various times, contained the whole of scholarship. Painting can contain the politician in a Daumier, the insurgent in a Goya, the suppliant in a Masaccio. It is not a spoken idea alone, nor a legend, nor a simple use or intention that forms what I have called the biography of a painting. It is rather the wholeness of thinking and feeling within an individual; it is partly his time and place; it is partly his childhood or even his adult fears and pleasures, and it is very greatly his thinking what he wants to think.

Concerning "Likeness" in Portraiture
Ben Shahn

In 1959, the National Museum in Stockholm asked Ben Shahn to paint a portrait of Dag Hammarskjöld, Secretary General of the United Nations, to hang in Sweden's National Portrait Gallery at Gripsholm. Shahn agreed, and met Hammarskjöld for the first time the following year. They apparently liked each other, for a series of sittings was scheduled. However, African affairs intervened, and the sittings were postponed until September, 1961, when Hammarskjöld was to return from the Congo. He of course never did.

Shahn completed the portrait from photographs and sketches he had made (Ill. 45) and wrote the following article about his experience for a Stockholm newspaper. He also sent a letter to an official of the Stockholm Museum: "I did not like the notion of a conventional portrait. That seemed to me a commonplace. I wanted to express [Hammarskjöld's] loneliness and isolation, his need, actually, for such remoteness in space that he might be able to carry through, as he did, the powerful resolution to be just. His unaffiliated kind of justice, it seems to me, held the world together through many crises that might have deteriorated into world conflicts. I have a truly profound feeling for this man, and I hope that it will be felt in the painting. I must mention, too, the threat that hung over him as it hung over the world, and does still. [The atomic cloud in the portrait.] All this was in my mood in doing this piece of work."

The first problem having to do with likeness in portraiture is that of whether one is primarily a portrait painter, or whether he is primarily a painter, as such. I have a notion that the principal difficulty facing the professional portrait painter is one of personalities. Indeed, every sitter for a portrait has a thousand faces, and the one that he wants to see appear on the canvas is his most comely face—probably imaginary, at that. If his portraitist is inclined to candor, the sitter may be deeply grieved; he may, I am sure that he often does, reject the work on the ground that it does not resemble him.

My son Jonathan Shahn recently made an impressive monumental head of Franklin Roosevelt. The comments upon his work interested me greatly. To some, the head is overwhelming—moving in its likeness to Roosevelt. To others, the head bears not the slightest resemblance to the man. So one must ask himself the question, "Which Roosevelt is portrayed?" Is it the young Roosevelt of the early years—gay, confident, not yet made stubborn and grave by ruthless opposition and by deep responsibilities? Is it the Roosevelt of the disastrous war years? Is it the indomitable fighter of New Deal Days—determined, yet always quick to laugh? Is it the Roosevelt of the final years, broken, thin in countenance, still an unconquerable reformer, but now always serious? Is it the Roosevelt of real life, or the Roosevelt of news photographs? Is it the left side of that mobile and uneven face, or the right side? Is it the Roosevelt viewed with enmity and dislike, or the Roosevelt

From *Statens Konstsamlingars Tillväxt och Förvaltning* (1962). *Meddelande från Nationalmuseum*, no. 87, by permission of Carl Nordenfalk, former director of the National Museum, Stockholm.

Ben Shahn

adored and looked at with compassion? These are all different Roosevelts, different-looking faces. My son sought to invest his portrait with something of each, and I believe that his reward came when Mrs. Roosevelt herself first saw the portrait, looked at it long and intently and then said, "This is the portrait of the soul and the meaning of the man!"

There have been times in the history of painting when a painter was expected to approach every object, panorama or landscape as though he were painting a portrait of that particular subject. The academic rule-makers always seek to impose upon the painter a series of rules and regulations about just how he should approach the work and just how he should execute it. (Since the academists are seldom primarily painters, but are, rather, theorists, historians and critics, such rules are an almost indispensable prop to their trade, since the rules make it quite simple to measure the work of art without actually having to bring sensitivity, feeling or intelligence to the work.) Such rule-makers forget that the painter makes his painting because he wants to do that, and that the purpose of the painting is to manifest his own thinking, his belief and his feeling. There are no outside rules for such a manifestation, only the inside rules of what things count most in the heart of the painter, and how he can best formulate those things in a visible perceptible manner.

What would have been lost to the world if Van Gogh had painted a perfect portrait—a "resemblance" of a landscape! What if Renoir had devoted himself to likenesses! What if Cézanne had thought of likeness instead of the structure, the color, the feeling for his painting, the whole ambience of his works! What if the Romanesque sculptors had concentrated in likeness in faces, likeness in draperies, rather than the beautiful flow of line, the expressiveness of countenance, the attitudes, the thousand simplifications and the other thousand elaborations which have nothing to do with likeness to some possible original sitter or model for these works. All art that has ever been recognized as worthy has developed its own reasons and its own rigorous discipline in illuminating those reasons.

I believe that it is thought in some quarters that the very failure to pursue likeness is a want of discipline. Let me quickly assure the holders of such opinion that just the reverse is the case. To realize a likeness does require a careful study of the structure of, let us say, a particular head. It requires a knowledge of the norm and attention to those characteristics in which this particular head departs from the norm, then, a simple copying and either delicate or exaggerated emphasis upon the non-normal characteristics. But

all this is craft and can be learned. The understanding of the meaning of an individual is quite another thing. The knowledge of the position of a human being in the world, the compassion with that human being, the sharing of this loneliness, the accord with his thinking, and the realization of the necessity of such thinking—these perceptions are not art school courses. There are many painters—excellent portrait painters—who could depict with accuracy the features of a man, but who, if they could read his thoughts, could never share them, nor indeed know what was the meaning of such thinking.

I knew Dag Hammarskjöld; I knew him personally, but even more, in a certain spiritual way. I am not a portrait painter, and I should never have wanted to paint a portrait of this man had I not been so deeply moved by what he was. I saw him as isolated by his very sense of justice, standing against pressures by his enemies, but even more insistent pressures by his friends. I saw him as being the kind of person who could make the United Nations a functioning reality. If the United Nations is that slim thread upon which a possible hopeful future for the entire earth hangs, then an individual at its head capable of rising above either personal or national or East-West interests is an even slimmer thread on which all our hopes must hang. If the United Nations is to become, or be, a simple battering place for all sorts of vested interests, then it is nothing and can offer no solution for our growing powers and difficulties. That Dag Hammarskjöld could and did maintain an Olympian aloofness to "interests" to this side and that side was to many of us a source of joy and of hope. His calm justice, his vast perspective upon human affairs were those of the philosopher rather than of the politician. Let me reiterate that they condemned him to a personal loneliness that he accepted with some amusement as the burden of his position.

I made my first large drawing for the Hammarskjöld portrait emphasizing the figure and perhaps with more likeness to the man than I felt necessary in the final painting. I did not feel satisfied with the first presentation, and explored somewhat further into my own feelings about Hammarskjöld. Not until I had succeeded (to my mind) in placing the individual, a lonely figure in a vast uncharted space in which some new way had to be found, perhaps some new reality created, did I feel that I had come close to my own feeling as to the significance of this great, profoundly understanding, and very modest man. I have sought to make a portrait about, rather than of a man.

Ben Shahn

V education

Shahn always maintained that teaching, being a creative activity in itself, robbed an artist of his own creativity. Yet his experience contradicted this contention. The year 1957, when he was living in Cambridge while delivering the Norton Lectures at Harvard, was one of his most productive years as a painter.

When once asked by a student to name a good art school, Shahn replied, "A good art school is one that has a good art museum you have to pass by to get to."

If I Had to Begin My Art Career Today

Ben Shahn

I have a slight edge over you young people in that I can look upon my art career with a degree of hindsight. I can know that the things which I undertook, and which were looked at so askance by many of my friends were all right after all. They were all right in that they have, through my life, so far, provided me with a great deal of personal satisfaction.

You, on the other hand, are looking forward along a dubious series of highways and byways, any of which may yield either rich accomplishment or utter frustration. Art is certainly not one of the highly recommended ways to choose for a career. The roadside warnings are all clearly marked in big letters: "Folly," "Look Out!", "Travel at Your Own Risk," and so on.

But, if you have a flair for adventure, if your interest is in the humanities, if you feel a need to affect the course of human behavior, if you have a philosophic bent or a poetic one, these warnings are not for you. Go ahead.

If, on the other hand, your major objective in life is a house with gold-plated plumbing and three swimming pools—then I would say that art is no career for you.

But, assuming that you do intend to become artists, I think my role here is to pass on to you a bit of my hindsight. I note that the title of this discussion is: "If I Had To Begin My Art Career Today." That being the case, I will try to tell you approximately what I would, and what I wouldn't do.

I'm going to begin by making a distinction between two functions performed by art. Now I want to emphasize strongly, and urge you to remember, that these functions merge and overlap; that the distinction is made *only* that the artist himself may understand his own orientation and his needs.

The two functions to which I refer are, one, the communicative function of art; the other, the expressive function.

I speak as an artist of the communicative sort and whenever I touch upon the outlook of the purely expressive artist I do so strictly as an observer and appreciator from the outside. And you are certainly at liberty to take issue with me on any point I make in that regard.

From an art-school student symposium, Andover, Massachusetts, September 15, 1949.

If I were a young artist beginning to paint today, I would want to be clear as to whether my own need were to communicate, or whether, on the other hand, the paramount desire in me were to express—to crystallize—the moods of my innermost self; to explore the subjective part of me; to make permanent some of the transitory vistas of my own imagination.

Because the techniques to be developed, the training which the artist must get for himself, must be geared to those objectives. If the artist's primary need is to communicate, he must school himself in an art language which is comprehensible to other people. If his major objective is the discovery of his own soul, then his self-discipline may be of another kind—his language may be as abstruse as you will. Its success will depend upon a high degree of sensitivity, upon freedom from banality in form and—actually upon how great a soul he has to explore.

I do not place either of these two functions of art above the other. Both have given us paintings of the utmost worth and beauty. The paintings of Fra Angelico, of Giotto, of Cimabue were story-telling paintings, in other words, communicative. And let me hasten to remind you that I have said that these functions overlap. For the paintings of these artists are also expressive—self-exploratory and sensitive to the highest degree. But there is in them this distinguishing quality: since their need was to communicate, they necessarily observed a certain discipline in language and presentation. Their message had to be comprehensible to other people.

Modern painting has been freed from such restraint. Art in the last century ceased to be a sole means of communication. At the same time, the great progress in psychoanalysis, in the probing of the subconscious self provided a status and a logic for pure self-expression. It is surely no accident that Picasso's search for expressive form, the exploration into self of the Dadaists, of Klee and the German Expressionists, of de Chirico and numerous other artists parallel the most intensive scientific probing of self ever undertaken by man.

So the crusade of the modern painters has been one of a search for form, expressive and self-revealing, and has not been in any sense geared to public acceptance.

We cannot question the value of such work. If it is successful to the artist that is all that's to be asked of it. There is no yardstick for measuring its greatness. That is a matter of the capacities of the artist himself: his intellectual stature, his breadth of imagination, his sense of workmanship, his depth of feeling, his cultural equipment—all these things which he may or may not succeed in realizing visually.

Ben Shahn

You, in observing such art may or may not catch on. That's entirely up to you. If you do, you will consequently enjoy a broadening of your own imaginative scope and a great personal enrichment. But the artist hasn't asked you to appreciate his work—he is entirely too preoccupied with his own creative problems to be concerned with you. And, that being the case, neither critics nor other observers have any ground for tearing their hair or ranting against such painting.

Every kind of art that has been produced throughout history seems to have been accompanied by its body of canonical writings. These have laid down the rules and regulations about art and have told us what is exclusively good and what is exclusively bad. The art of our era, that is, modern art, has possibly produced more than its share of such literature, and it seems to me more fiercely dogmatic than any earlier art writing. Because expressive art is admittedly good, frequently great, its disciples, its canonical writers flay the public for not accepting such work. There, you see, lies the confusion in function. Such art was not produced for the public, but only for the artist and for those who are in rapport with his aesthetics.

Art, because it is of the communicative sort, is no less exalted than is the expressive kind. The great art of the Renaissance, of Greece, of Persia, India, China, of Egypt, and even of ancient Chaldea was communicative and story-telling. I said above that the two functions overlap. I will repeat that in order to point out that communicative art is also expressive, but that, in modern times, especially, it is the expression of a particular kind of person, namely that one who feels keenly his integration with society. He is greatly concerned with man's fate and hopes to project his creative work in such a way as to affect the outlook of other people.

It is necessary that the artist himself be clear as to his intention, that he know what kind of person he is, so that he will not expect his work to gain wide acceptance if he speaks in an abstruse vein.

Since I regard myself as a primarily communicative artist, I will tell you those things which I should endeavor to master if I were beginning a career now.

The communicative artist must first consider his audience. To whom does he want to speak and how will he reach these people? What will be his media? Must his work be strictly literal or may he use imaginative and inventive forms?

There are numerous ways of reaching an audience. The easel painting is one which reaches a limited and highly select group, the mural a larger one. Posters and other media which can be

mass-produced have, of course, the widest reach. It is important to the communicative artist to master the techniques of all these media. He ought to know printing processes and the differences in effectiveness and in cost between them.

When I went to work for the Political Action Committee in 1944, I found that they were paying twenty-one cents each for two-color posters eight by eleven inches in size. That the posters were thoroughly ordinary and unimaginative in design was only one defect. In an office of seventy people, many of whom had, no doubt, taken "Art 117," or Art Appreciation, or Art Practice course, there was no one who knew how to design or order a poster. An examination of the field made it possible for us soon to produce posters thirty by forty-six inches in size and in four colors for seven cents apiece.

You, if you expect to be the communicative sort of artist, ought to set yourself the task of learning the possibilities of every form of reproduction. You should know what can be done with silk screen, what should be done in offset, what in letterpress. You should know papers, their cost, weight, and standard sizes. You should know the degree of accuracy that can be expected of the various media, the average pressrun for this or that process. You should be alert to every means of duplication, even to the multilith and photostat.

Just now the National Foundation for Infantile Paralysis is conducting a limited competition for posters in which some twenty artists will participate. Invitations have been extended mainly to persons who have had experience in poster design. But even so there will be those who, having completed the pictorial end of the poster will be at a loss as to how to proceed with legend and completed design.

For some curious reason the art schools have ignored these very real techniques. There seems to be some embarrassment concerning them, as though they were not within the province of true art. But such techniques are as important to the communicative artist as are his canvas, his colors, and his brushes.

Now let us consider form. I see no reason why the artist who seeks to communicate need banalize the images which he employs. They must be readable, yes, but within that limitation ingenuity in the use of form, freshness of observation, and impact of shape and color will add distinction and interest to his work. I really believe that "readability" does not present too great a problem to such an artist because his most compelling desire is to make himself clear.

Ben Shahn

My own personal definition of form is that it is the shape taken by content. Its potentialities are as varied as those of content itself.

If the content of a painting is soul-searching, then the forms will be highly personal, possibly vaguely allusive.

If the content is the establishing of space and color relationships, then, of course, form and content are one, and we call it abstract painting.

If the content is of the humanistic variety, that content will dictate forms which are revealing of human moods and relationships.

But, since art is visual its forms ought to present their content in the richest visual terms. There are certainly no rules to be applied to form—and, of course, that covers composition—because the content will in each individual case have its unique set of needs, thus providing a cue to more interesting form than rules could ever give.

Before leaving the question of the self-schooling of the communicative artist and returning to that of the purely expressive one, I think that there is one more point to be made, which is that the communicative artist ought not to reject from his equipment any visual factors whatever. It often puzzles me to note in a painting—in which careful attention has been given to detail—that a bit of lettering on a sign or a building will be carefully blurred so as not to be legible. At the same time, the detail of a molding beside it may be depicted with perfect clarity. I wonder why a line of lettering should be less significant than an equal length of molding, and it occurs to me that this may be a little instance of that art-school snobbery which minimizes the practical techniques of artistic communication.

For my purposes, lettering has a place in and around pictures both as communication and as design. In another direction, a poster composed of lettering alone can be both beautiful and memorable. I would recommend to the student that he master the styles of lettering and that he also know type faces and sizes and how to order them from the printer.

As the audience of the communicative painter is, theoretically, everybody, so that of the self-expressive artist is, theoretically, only himself. Of course, in truth the self-expressive artist does have an audience. It is one of connoisseurs, of highly perceptive people which, if it does discover the artist at all, is likely to give him enthusiastic support and to buy his work. But certainly one of the rigors of expressive art is that the artist must be prepared, if necessary, to be sufficient unto himself.

I think that if I were beginning to paint as a young artist and my intent were purely expressive, I would try to develop early a high degree of sensitivity to form, studying it constantly for its most subtle suggestive powers. I would explore the craft of painting with a view to discovering its utmost potentialities. And I guess that I would attempt to equip myself personally with as substantial an intellectual and cultural gear as I could achieve.

I might put in at this point that I am rather impatient with the theory that a high degree of intellectual activity is incompatible with good art. A few of our great artists have been ranking intellectuals. The curious myth about pure emotion—and what is that, anyway?—being all that the artist needs besides his paintbrush is a part of those canonical writings about which we've spoken. Believe me, the completion of any very involved piece of painting requires some very intensive cerebration. Were there nothing else present but emotion, the work would probably simply fly out of the window.

By now, you are probably asking yourself, "But how am I going to live as a painter?" And you may be familiar with the figures on the average income of artists gathered by Elizabeth McCausland some time ago. This thoughtful critic conducted a survey of artists who live primarily from the sale of their paintings and came up with the distressing information that their yearly income averages somewhere between eight and eleven hundred dollars.

One can hope that this figure is somewhat improved just now, but there is no indication that the gallery outlet can furnish either a decent living or security beyond tomorrow.

A year or so ago I had a discussion on this subject with Beardsley Ruml. For purposes of discussion, he divided modern society into three forces: Business, Church, and Labor Unions (that's his division, not mine!). He thought that the artist ought to be able to look to one or all these segments of society for that kind of patronage which, in the Middle Ages, was afforded by the Church. He felt that, of the three, business was the most suitable and most likely patron of the arts, that it might well adopt the role once played by the Church. . . .

The concepts of Christianity, its personalities, its episodes are of so spiritual a character that, accompanied by faith, they could and have furnished content close to the artist's heart—an incomparable kind of inspiration.

To compare this to the concepts of business seems to me—well, let's say, shortsighted! The usefulness of art to business lies in its ability to sell merchandise, or, on a somewhat higher level, to

Ben Shahn

create about business a dignifying atmosphere. This sort of purpose has no relation to—and can do nothing but abuse—the inner preoccupation of the expressive artist, or the convictions and intent of the communicative one. Commercial art can adopt, as a shell, the imagery and manners of noncommercial work, but it can never have its meanings, which are the primary reason-for-being of creative art.

As to teaching as a means of livelihood, I can only say for it that it is a worthy occupation. I note that increasing numbers of artists turn to it. However, I'm afraid that after they have become teachers one no longer hears of them as artists. I think that the artist as teacher pours so much of his thinking and so much of his energy into other people that he saps his own creative springs at the source. At least I know that in my own case, during the few periods in which I've taught, I have lost a great deal of the impulse to paint.

Most artists muddle through with a little of all these activities, augmenting what they earn through painting by an illustration job here and there, a competition from time to time, a commercial job which they feel they can accept, or a period of teaching now and then.

What, then, is a proper solution for the artist's economic problems?

In the *Saturday Review of Literature* of August 6 [1949], James Soby discussed some of the potentialities of a Federal Department of Fine Arts. Let me quote him. "Organizing painting and sculpture exhibitions"—he is here discussing a recent ill-fated effort of the State Department—"should be the concern of the Federal Department of Fine Arts. The Department of Fine Arts? We have none. And here I think"—he says—"we come upon a notable failure of American art over the past twenty-five years, for all the progress made. The steadily increasing interest in the visual arts in this country has not yet resulted in the appointment of a Secretary of Fine Arts, whose first responsibility would be the elevation of the status of American art, past and present."

And again, Mr. Soby says, "One of the functions of a Secretary of Fine Arts would be to encourage the revival of Federal projects such as those [of the thirties]. Another would be to promote an exchange of exhibitions with European countries. The benefits from these two activities would be very great. But even greater good might be in the gain in dignity and standing for artists."

I suppose that every artist who experienced the amazing phenomenon of the thirties—federal subsidizing of the arts—will agree

that, however much inferior art was produced, still there was also the greatest volume of good art ever produced at one time in this country.

Many people will argue that such a program would soon fall into quagmires of political patronage or of censorship and there is certainly a danger of that sort of thing. But the fact that the art programs were once administered fairly, that they were then free from censorship and favoritism shows that it could be done.

Now there is one more point I want to bring up before ending this talk. This takes us back to the functions of art—to the native impulses of artists. You have all observed, I daresay, the growing mechanization of our contemporary society, the gradual submergence of the individual into mass processes. You have possibly observed the complaisant manner in which the latest death-dealing inventions are received. All this indicates not only the submerging of the individual, but the gradual melting away of our human values. I believe that there is, at this point in history, a desperate need for a resurgence of humanism, a reawakening of values. I believe that art—art of any kind—can play a significant part in the reaffirming of man. I know a number of artists, and I might include myself among them, who now seriously dedicate themselves to such an objective. If I were a young artist beginning my career today, whether my bent were expressive or communicative, I would endeavor to relate it to the reawakening in man of his human concepts and values.

The Education of an Artist *Ben Shahn*

I am going to begin this discussion with a brief outline of a course of education which I would recommend to a young person intending to become an artist. And then I will move on to some of the reasons for this somewhat unusual course of study.

One's education naturally begins at the cradle. But it may perfectly well begin at a later time too. Be born poor—or be born rich—it really doesn't matter. Art is only amplified by such diversity. Young people of both origins may or may not become marvelous artists. That depends upon factors having little to do with circumstances of birth. Whether they will become significant

Reprinted by permission of the publishers from Ben Shahn, *The Shape of Content* (Cambridge, Mass.: Harvard University Press, copyright, 1957, by the President and Fellows of Harvard College).

Ben Shahn

artists seems to depend upon a curious combination of biology and education working upon each other in a fashion too subtle for the eye to follow.

But there is a certain minimum program. There are, roughly, about three conditions that seem to be basic in the artist's equipment: to be cultured, to be educated, to be integrated. Now let me be the first to admit that my choice of terms is arbitrary; many words could be substituted and mean approximately the same thing. This odd choice of terms, however, has a reason which will perhaps emerge as I proceed.

Begin to draw as early in life as possible. If you begin quite early, use any convenient tool, and draw upon any smooth uncluttered surfaces. The flyleaves of books are excellent, although margins of text-books too have their special uses, as for small pictorial notations upon matters discussed in classes, or for other things left unsaid.

My capsule recommendation for a course of education is as follows:

Attend a university if you possibly can. There is no content of knowledge that is not pertinent to the work you will want to do. But before you attend a university work at something for a while. Do anything. Get a job in a potato field; or work as a grease-monkey in an auto repair shop. But if you do work in a field do not fail to observe the look and feel of earth and of all things that you handle—yes, even potatoes! Or, in the auto shop, the smell of oil and grease and burning rubber. Paint of course, but if you have to lay aside painting for a time, continue to draw. Listen to all conversations and be instructed by them and take all seriousness seriously. Never look down upon anything or anyone as not worthy of notice. In college or out of college, read. And form opinions! Read Sophocles and Euripides and Dante and Proust. Read everything that you can find about art except the reviews. Read the Bible; read Hume; read Pogo. Read all kinds of poetry and know many poets and many artists. Go to an art school, or two, or three, or take art courses at night if necessary. And paint and paint and draw and draw. Know all that you can, both curricular and non-curricular—mathematics and physics and economics, logic, and particularly history. Know at least two languages besides your own, but anyway, know French. Look at pictures and more pictures. Look at every kind of visual symbol, every kind of emblem; do not spurn sign-boards or furniture drawings or this style of art or that style of art. Do not be afraid to like paintings honestly or to dislike them honestly, but if you do dislike them retain an

open mind. Do not dismiss any school of art, not the Pre-Raphael-ites nor the Hudson River School nor the German genre painters. Talk and talk and sit at cafés, and listen to everything, to Brahms, to Brubeck, to the Italian hour on the radio. Listen to preachers in small-town churches and in big-city churches. Listen to politicians in New England town meetings and to rabble-rousers in Alabama. Even draw them. And remember that you are trying to learn to think what you want to think, that you are trying to coordinate mind and hand and eye. Go to all sorts of museums and galleries and to the studios of artists. Go to Paris and Madrid and Rome and Ravenna and Padua. Stand alone in Sainte Chapelle, in the Sistine Chapel, in the Church of the Carmine in Florence. Draw and draw, and paint, and learn to work in many media; try lithography and aquatint and silk screen. Know all that you can about art, and by all means have opinions. Never be afraid to become embroiled in art or life or politics; never be afraid to learn to draw or paint better than you already do; and never be afraid to undertake any kind of art at all, however exalted or however common, but do it with distinction.

Anyone may observe that such an art education has no beginning and no end and that almost any other comparable set of experiences might be substituted for those mentioned, without loss. Such an education has, however, a certain structure which is dictated by the special needs of art.

I have been curious and have inquired from time to time about the objectives toward which the liberal education is pointed. I have been answered in different ways—some say that it hopes to produce the cultured citizen, or some hold that it simply wants its graduates to be informed—knowledgeable. And I think that the present ideal is to produce the integrated person. I myself can see no great divergence between these objectives and the ones necessary to art.

I think we could safely say that perceptiveness is the outstanding quality of the cultured man or woman. Perceptiveness is an awareness of things and people, of their qualities. It is recognition of values, perhaps arising from long familiarity with things of value, with art and music and other creative things, or perhaps proceeding from an inborn sensitiveness of character. But the capacity to value and to perceive are inseparable from the cultured person. These are indispensable qualities for the artist too, almost as necessary as are his eyes—to look and look, and think, and listen, and be aware.

Education itself might be looked upon as mainly the assimilation

Ben Shahn

of experience. The content of education is naturally not confined to the limits of the college curriculum; all experience is its proper content. But the ideal of the liberal education is that such content be ordered and disciplined. It is not only content, but method too, the bridge to further content. I feel that this kind of discipline is a powerful factor in any kind of creative process; it affords the creative mind means for reaching into new fields of meaning and for interpreting them with some authority. The artist or novelist or poet adds to the factual data the human element of value. I believe that there is no kind of experience which has not its potential visual dimension or its latent meanings for literary or other expression. Know all you can—mathematics, physics, economics, and particularly history. As part of the whole education, the teaching of the university is therefore of profoundest value.

But that is not to dismiss self-education as an impressive possibility, and one illuminated by a number of the greatest names in literature, art, and a good many other fields, not excluding the sciences. There is no rule, no current, about self-education any more than there is about advantages or disadvantages of birth. It is historically true that an impressive number of self-educated individuals have also been brilliantly educated: widely read, traveled, cultured, and thoroughly knowledgeable, not to mention productive. The dramatist who has had perhaps the greatest influence upon the contemporary theater stopped school at the age of thirteen. The painter who has set world taste in art is almost entirely self-educated. That does not mean uneducated, for each of these two people is almost unmatched in versatility of knowledge.

And that brings us to the third item in our minimum program for the education of an artist: to be integrated. (My sixteen-year-old daughter takes issue with this term. Whatever she may be she does not want to be "integrated." Perhaps I can persuade her.)

Being integrated, in the dictionary sense, means being unified. I think of it as being a little more dynamic—educationally, for instance, being organically interacting. In either sense, integration implies involvement of the whole person, not just selected parts of him; integration, for instance, of kinds of knowledge (history comes to life in the art of any period); integration of knowledge with thinking—and that means holding opinions; and then integration within the whole personality—and that implies holding some unified philosophical view, an attitude toward life. And then there must be the uniting of this personality, this view, with the creative capacities of the person so that his acts and his works and his thinking and his knowledge will be in unity. Such a state of being,

curiously enough, invokes the word integrity in its basic sense: being unified, being integrated.

In their ideal of producing the person of integrity—the fully integrated person—colleges and universities are somewhat hampered by the very richness and diversity of the knowledge content which they must communicate. Development of creative talents is allowed to wait upon the acquisition of knowledge. Opinion is allowed to wait upon authority. There may be certain fields in which this is a valid procedure, but it is not so in art. (Draw and draw, and paint, and learn to work in any media.)

Integration, for the person in any of the creative arts, might be said to be the organic relating of the thousand items of experience into form, for the poet, into tonalities and cadences and words with their many allusive senses and suggested images. The thinking of the poet must habitually be tonality and cadence thinking, as with the artist it is color, shape, image thinking. In each of these cases the discipline of formulation is inseparable from the discipline of thinking itself.

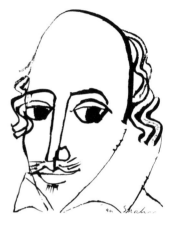

I hope that I have not too badly stretched these commonly used terms, to be cultured, to be educated, to be integrated. In any case, in the sense in which I have used them they are and have been the basic equipment of artists.

I sometimes find myself viewing with great nostalgia the educational procedure by which such artists as Leonardo were initiated into art. When the young man of the Quattrocento decided to pursue a career of art, he simply put together his most impressive pieces of work, showed them to a number of people, and ultimately became apprenticed to one of the known masters. There he began his service and education by grinding colors and mixing them, by preparing surfaces, and probably even making brushes. (What a fundamental kind of training that seems to us today when so many of us do not even know what our paints are made of!) The young artist probably was permitted first to paint in backgrounds. He was no doubt advanced in time to skies and landscapes, draperies, a face or so, and ultimately matriculated into angels. As he learned the use of his hands, and how to see things in shapes and colors, other changes were taking place in him. Perhaps his rustic manners were becoming a little more polished so that he could take part in the conversations of the atelier, even venture an opinion or so. He gradually became acquainted with the larger problems of the painter: composition, construction, qualities of spirituality or beauty, meaning in pictures. There was constant talk about art, about form; and there were the great

Ben Shahn

artists who came in and out of the atelier (those who were on speaking terms with his employer). The young painter gradually mastered iconographies—Christian and pagan and personal.

But then there was music, too, and poetry read and discussed, and the young artist not infrequently became both musician and poet. There was the conversation of learned men, talk of science, the excitement in the revival of ancient learning, mastery of the humanities. Of course there were the new buildings, too, palaces and fountains, and always the interest in the great spaces to be filled by paintings, the open courts to be occupied by sculpture, the façades and domes and bridges to be ornamented with beautiful shapes.

The day came, of course—the famous day—when the young painter executed a foreground with an angel which far surpassed in beauty the work of the master. Then, of course, he was very much in demand, the master of his own atelier.

How integrated indeed was the growing artist of that time, and cultured, and educated!

There have been efforts to revive the apprenticeship system, but not very successful ones. I believe that if such a revival ever is accomplished it will be preceded by integration of a different sort from that which I have been talking about—by the integration of art itself into the common life of the nation, as it was so integrated during the Renaissance in Italy. Since there is such rising interest in the setting and the look of the new great buildings—not just in their size, but also in their beauty and their placement—it seems not impossible that there may take place a resurgence of art upon a vast scale, of mural painting and mosaics, great out-of-door sculpture, and the ornamentation of public places.

The artist of the Renaissance had no great problems of style comparable to those which plague the young artist of today. He might simply follow the established manners of painting as most artists did. If his powers were greater or his vision more personal he expanded the existing manners of painting to meet his needs. But the artist today, and particularly the young one, feels challenged to be unique.

Such a condition, such a challenge, strikes at the security of the painter; it may sometimes press artists to exceed the bounds of good sense, simply to be different. But such a challenge has much to do with the character and the function of today's art, and despite its hazards it is also an advantage and an opportunity.

It is in the nature of today's art to draw upon the individualness of the painter and to affirm the individualness of perception in the

audience or viewer of art. The values of art rest in the value of the person. Art today may be as deeply subjective as it is possible for man to be, or it is free to be objective and observant; it may and it does examine every possible human mood. It communicates directly without asking approval of any authority. Its values are not those of set virtues, but are of the essential nature of man, good or bad. Art is one of the new media of expression which still remains unedited, unprocessed, and undictated. If its hazards are great, so are its potentialities magnificent.

It seems to me that this particular function of art—to express man in his individualness and his variety—is one that will not easily run out. It may have its low points, but the challenge and the potentiality remain high. The accomplishments of modern art in this individualistic direction are already impressive, of course. There have been quite remarkable psychological probings and revelations in painting; there are a dozen or so schools which one might mention—the Surrealists, the German Expressionists, and so on. There have been the sociological efforts—Social Realism and some others. The poetic sense has been brilliantly exploited—by Loren MacIver and Morris Graves and so many contemporary artists. We have the love of crumbling ruins in one painter, [Eugene] Berman, the return to myth in others, many others. Art has probed the mysteries of life and death, and examined all the passions. It has been responsible and irresponsible, and sympathetic and satiric. It has explored ugliness and beauty, and has often deliberately confused them—much to the perplexity of an often lagging public. . . .

All such probing and testing of reality, and creating of new realities, may result from different kinds of educational focus, different kinds of content, but they always require the three basic capacities: first, of perceptiveness, a recognition of values, a certain kind of culture; second, a capacity for the vast accumulation of knowledge; and third, a capacity to integrate all this material into creative acts and images. The future of art assuredly rests in education—not just one kind of education but many kinds.

Some years ago when the painter Max Beckmann died suddenly, I was asked to take over his class at the Brooklyn Museum School. I did so—reluctantly. On my first morning with the students I looked over their work and it appeared to me that the most conspicuous fault in it was a lack of thinking. There seemed to be no imaginative variety or resourcefulness. It was mostly just Beck-

mann. I certainly was not going to go on teaching more Beckmann, however greatly I may admire his work—and I do. I remember sitting on the edge of the model stand to have a sort of exploratory talk with the students. It seemed to me desirable to uncover some long-range objective, if there was any, and to find out what sort of people they were. We talked about all sorts of things, and I probably talked quite a little—I usually do.

In the midst of our discussion one of the students walked up to me and said, "Mr. Shahn, I didn't come here to learn philosophy. I just want to learn how to paint." I asked him which one of the one hundred and forty styles he wanted to learn, and we began to establish, roughly, a sort of understanding.

I could teach him the mixing of colors, certainly, or how to manipulate oils or tempera or watercolor. But I certainly could not teach him any style of painting—at least I wasn't going to. Style today is the shape of one's specific meanings. It is developed with an aesthetic view and a set of intentions. It is not the how of painting but the why. To imitate or to teach style alone would be a little like teaching a tone of voice or a personality.

Craft itself, once an inexorable standard in art, is today an artist's individual responsibility. Craft probably still does involve deftness of touch, ease of execution—in other words, mastery. But it is the mastery of one's personal means. And while it would be hard to imagine any serious practitioner in art not seeking craft and mastery and deftness, still it is to be emphasized that such mastery is today not measured by a set, established style, but only by a private sense of perfection. (Paint and paint, and draw and draw.)

I have mentioned our great American passion for freedom. And now, let me add to that the comment that freedom itself is a disciplined thing. Craft is that discipline which frees the spirit; and style is the result.

I think of dancers upon a stage. Some will have perfected their craft to a higher degree than others. Those who appear relatively more hampered and leaden in their movements are those of lesser craft. Those who appear unimpeded, completely free in all their movements, are so because they have brought craft to such a degree of perfection. The perceptive eye may discern the craft in many varieties of art. The nonperceptive eye probably seeks to impose one standard of craft upon all kinds of art.

Last year I visited the painter [Giorgio] Morandi in Bologna. He expressed to me his sympathy with the young art students of

the present day. "There are so many possible ways to paint," he said, "it's all so confusing for them. There is no central craft which they can learn, as you or I could once learn a craft."

. .

As to its degree of professionalism, art is, I suppose, as professional as one makes it. Some painters work very methodically, observing an eight-or-more-hour day, dispensing their work through galleries, placing pictures in every current exhibition, and having representatives in many parts of the country. Others are very haphazard about all this detail, and paint when the mood strikes them. But I suppose that almost any artist today whose major occupation is art has some more or less business-like connection with a practical world through one or another kind of agency or individual. Perhaps it is not customary to hang out a shingle as the lawyer is supposed to do, but it might be an interesting experiment.

. .

The sense of reality and meaning in any person's life and his work is probably vested in a community of some sort wherein he finds recognition and affirmation of whatever he does A community may, of course, be only the place in which someone lives; or a community may consist in a circle of admirers . . . or again it may be some area of self-identification, the place of one's birth, or some way of life that appeals to him. There is a considerable loss of the sense of community in present-day life. And I think that one of the great virtues of the university lies in its being a community in the fullest sense of the word, a place of residence, and at the same time one of personal affirmation and intellectual rapport.

The young artist-to-be in the university, while he may share so many of the intellectual interests of his associates, and has a community in that respect, is likely to be alone artistically. In that interest he is without community. And as a result he suffers keenly the absence of the sense of reality in art. Even though his choice of a life's work may meet with complete approval among his fellows, he still is without the give-and-take of well-informed, pointed, and experienced conversation pertinent to what he is doing. But then it is not at all unlikely that his ambitions may be looked upon by some of his friends as a sort of temporary derangement. Almost all the other young people around him will be turning their energies and conversations toward work of a seemingly more tangible order, toward professions or toward the business world.

One's future intentions are intangible things at best; they have

Ben Shahn

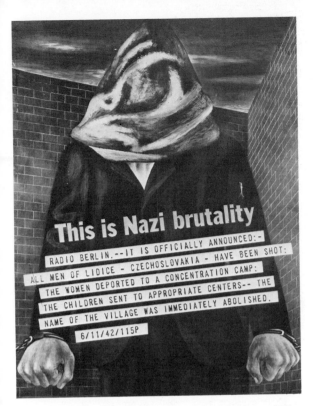

16. *This Is Nazi Brutality*, 1943. (Poster for the Office of War Information.) Offset lithograph, 40⅛" x 28¼". Collection of The Museum of Modern Art, New York. Gift of the Office of War Information.

17. *Gasoline Travels in Paper Packages*, 1944. (Advertisement for the Container Corporation of America.) Photograph courtesy of The Container Corporation of America, Chicago.

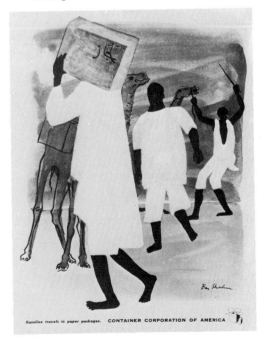

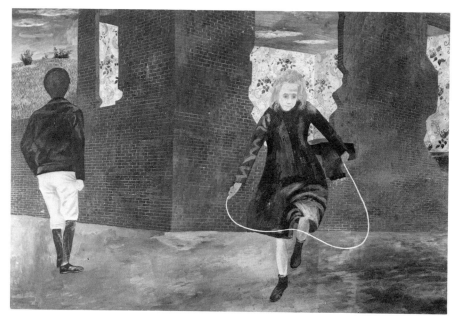

18. *Girl Jumping Rope*, 1943. Tempera, 16″ x 24″. Collection of the Museum of Fine Arts, Boston. Photograph courtesy of George Braziller, Inc., New York.

19. *Italian Landscape*, 1943–44. Tempera, 27½″ x 36″. Collection of the Walker Art Center, Minneapolis.

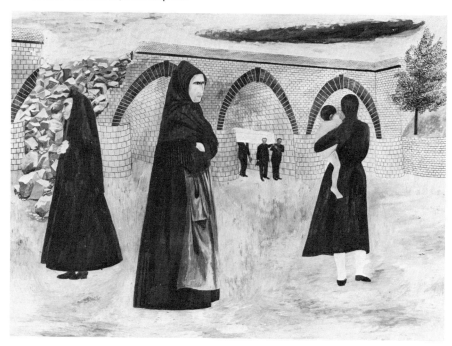

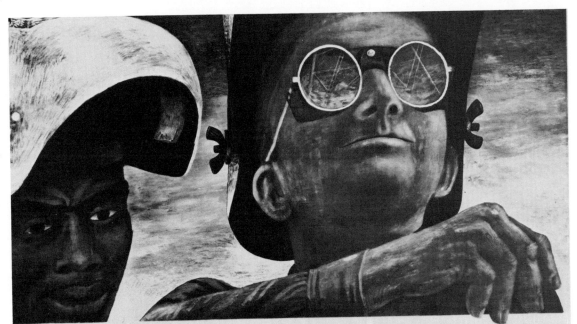

for full employment after the war
REGISTER VOTE
C I O POLITICAL ACTION COMMITTEE

20. *For Full Employment After the War, Register—Vote,* 1944. (Poster for the CIO Political Action Committee.) Offset lithograph, 30" x 39⅞". Collection of The Museum of Modern Art, New York. Gift of the CIO Political Action Committee.

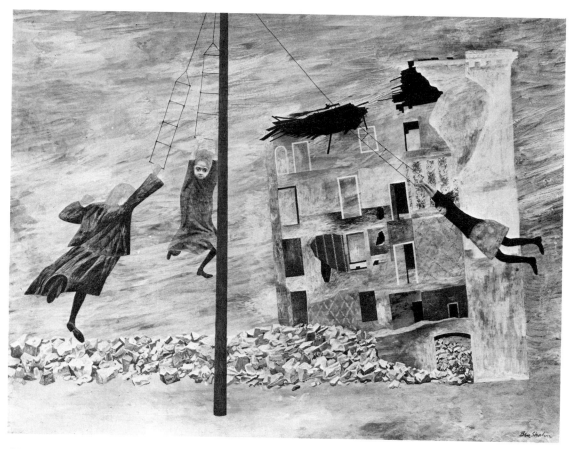

21. *Liberation,* 1945. Tempera, 20¾" x 39¾". Collection of James Thrall
Soby. Photograph courtesy of The Museum of Modern Art, New York.

22. *Pacific Landscape,* 1945. Tempera, 25¼'' x 39''. Collection of The
Museum of Modern Art, New York. Gift of Philip L. Goodwin.

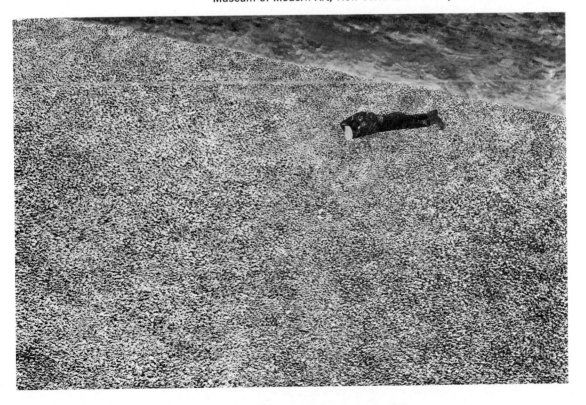

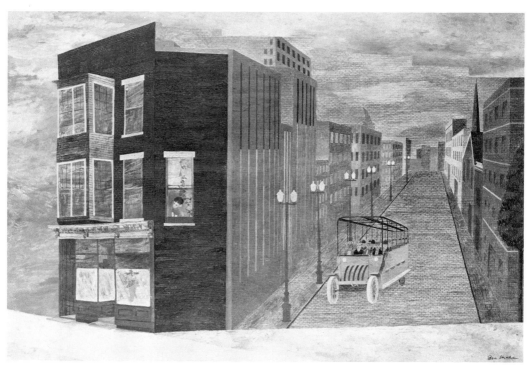

23. *Ohio Magic,* 1946. Oil tempera, 26'' x 39''. Collection of the California Palace of the Legion of Honor, San Francisco. Mildred Anna Williams Collection.

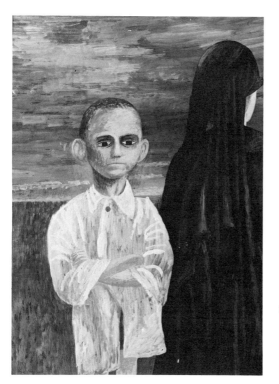

24. *Boy,* 1944. Tempera, 26¾'' x 18⅛''. Collection of The University of Michigan Museum of Art, Ann Arbor.

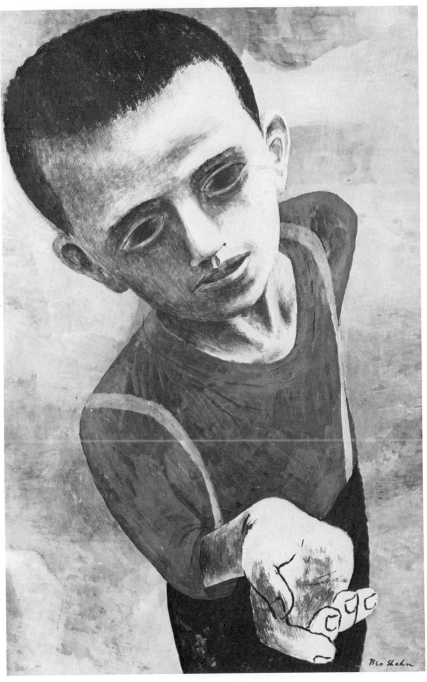

25. *Hunger*, 1946. Tempera, 40″ x 26″. Collection of Auburn University, Auburn, Georgia.

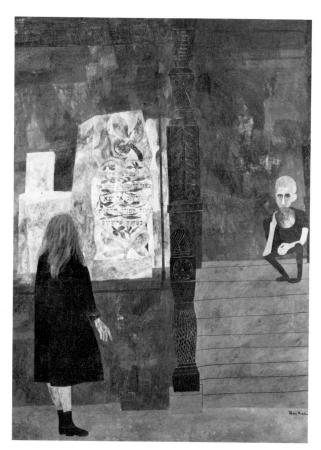

26. *Sound in the Mulberry Trees*, 1948. Tempera, 48" x 36". Collection of Smith College Museum of Art, Northampton, Massachusetts.

27. *The Violin Player*, 1947. Tempera, 40" x 26". Collection of The Museum of Modern Art, New York. Sam A. Lewisohn Bequest.

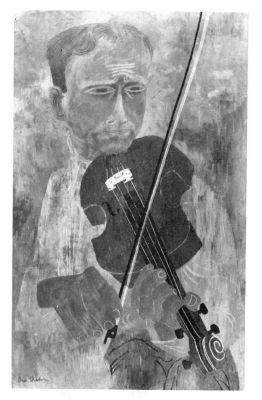

always some flavor of unreality. There are few college students who would presume to look upon themselves as Presidential candidates or Nobel Prize winners. The writer who has not written or the painter who has not yet painted seems, even to himself perhaps, to be grasping at wisps of smoke or to be deluding himself with romance. For such a person, there are as yet no such certainties. Artistically speaking, he does not yet know who he is or will be. More than anyone else, the young person embarked upon such a career needs a community, needs its affirmation, its reality, its criticism and recognition. (Or, as I put it a little earlier in that highly compressed description of an artist's education: Know many artists. Go to an art school, or two or three. Look at pictures and more pictures. Go to all sorts of museums and galleries and to the studios of artists.)

In the case of an older artist, one who has done a great deal of painting, his own work may in a strange sort of way come to constitute for him a certain kind of community. There is some substance and affirmation in what he has already done. It at least exists; he has found that he can cast a shadow. In relation to what he has done the new effort is no longer an unreality or an uncertainty. However small his audience, he has some sense of community.

The public function of art has always been one of creating a community. That is not necessarily its intention, but it is its result —the religious community created by one phase of art; the peasant community created by another; the Bohemian community that we enter into through the work of Degas and Toulouse-Lautrec and Manet; the aristocratic English community of Gainsborough and Reynolds, and the English low-life community of Hogarth.

It is the images we hold in common, the characters of novels and plays, the great buildings, the complex pictorial images and their meanings, and the symbolized concepts, principles, and great ideas of philosophy and religion that have created the human community. The incidental items of reality remain without value or common recognition until they are symbolized, re-created, and imbued with value. The potato field and the auto repair shop remain without quality or awareness or the sense of community until they are turned into literature by a Faulkner or a Steinbeck or a Thomas Wolfe, or into art by a Van Gogh.

VI commercial art

*Shahn found commercial art challenging, gratifying, and reward-
ing. The list of his clients is long and impressive, including the
Container Corporation of America; the Columbia Broadcasting
System; Capitol Records; Columbia Records; The Singer Com-
pany; Random House; Little, Brown; the Harvard University Press;
and The Museum of Modern Art. Among the magazines he made
illustrations for were* Charm, Scientific American (*for an article by
his friend and neighbor Albert Einstein*), Seventeen (Ill. 35) *and*
Harper's.

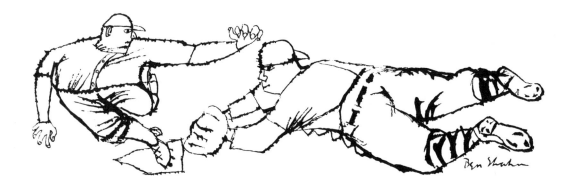

Some Revaluations of Commercial and Fine Art
Ben Shahn

Shahn's approach to commercial art is best stated in the follow-ing talk he gave in 1950 to the students of the Franklin School in New York City.

I daresay that a number of you here in my audience are busily trying to figure out how a so-called long-haired artist has hap-pened to stray inside your portals—whether I've gotten lost, or am here intentionally, or which of us is out of bounds.

It so happens that I have done a good bit of the kind of art that's generally classified as commercial. Thus, having a foot in the stirrups of both horses, so to speak, I feel fairly free to ride which-ever one the occasion requires. The difficulty is that I am loath to regard any work that I do as commercial, and that's confusing.

It's my hope that I may succeed in infecting all of you with a similar confusion, and that you also will be unwilling to regard any of your work as being of an inferior order or unworthy of your best effort—so that your standards will *not* be the standards of any particular client, or be affected by the size of your paycheck—but will be your own at all times, and never under any circumstance abridged.

In the series of discussions that we will have here, I hope to cover a number of subjects that are equally of interest to fine artists and to commercial artists. Some of the matters that we will touch upon will be "Communication in Art"; the great old theme of "form" and of course under that we can slip in "content" if no one is looking; and all the other great bones of contention: abstract art, non-objective, socially oriented, and perhaps socially dis-oriented. We will discuss the "Artist's Audience," "The Education of an Artist" and ultimately, "Humanism in Art."

Before we go into any of this, however, I think it will be fitting to re-examine some of the distinctions between fine art and com-mercial art that are current among us, and that seem to me to be erroneous. Such distinctions, I believe, are usually made to the detriment of commercial art. They place upon it limitations that aren't, by the nature of things, necessary. So I've chosen for the subject of this initial talk "Some Revaluations of Commercial and Fine Art." And I hope that together we may shed some light on the subject.

If you were now to go out into the street and ask the first

passer-by for a definition of commercial art he might well answer, "Oh, commercial art is art that gets paid for." You would probably protest, "Well, fine art gets paid for, too." But by that time your passer-by would be halfway down the block, and wouldn't hear you. The next pedestrian might well tell you that commercial art isn't as good as fine art. A third might even say, "Commercial art is drawing."

Or if, conversely, you were to ask for a definition of fine art you might get such answers as, "Fine art is in museums." Or, "It's something crazy that no one can understand." Or, "Fine art is made in garrets by starving artists." Or someone might tell you that fine art is nobler than commercial art.

Such distinctions are by no means confined to laymen. Among the so-called fine artists who do some commercial work, for instance, there is that sort of artist who saves part of himself for his "important work." He never lets his fine-art hand know what his commercial-art hand does. He has one set of standards for "my own" work. But he will accept anybody's standards for his commercial work.

Then there is the professional commercial artist who longs to paint. (A second drink will usually wring a confession from him.) He was plunged by misfortune, or by too good fortune, or simply by a taste for forty-two-dollar shoes, into the maelstrom of commercial art. Once in it, he could never wrest himself free. Isn't it odd that had he not made so vast a distinction between commercial art and fine art, in the first place, he might have gone along all this time enjoying a rich and rewarding career?

There are some artists—and I might say that they are the top ones in either field—who approach a piece of commercial art with the same interest and standards which they apply to their fine art. There is no line of demarcation where the one ends and the other begins. A pertinent sidelight to this is that the commercial pieces of this handful of artists are bought by collectors as often as their non-commercial ones.

We may deduce from this a moral—namely, that *one's own* concept of one's work actually operates to make it better or worse —on a higher or on a lower plane. It operates particularly to create the standards which a good artist will not violate. And that applies equally to fine or commercial artists. So, if we can rule out intrinsic standards as a distinction between fine and commercial art, let's go on to the related subject of craftsmanship.

Last summer I taught painting at the University of Colorado, and I found, at an early stage of my teaching, that I was making distinctions between my students. They weren't, however, distinc-

Ben Shahn

tions as to whether the student was preparing for fine or commercial art. They were simply distinctions as to the seriousness of the particular student. Whenever I found one who was merely pursuing a hobby, I let it go at that. With the abler students, I was much harder. On several occasions my criticism was met with this curious rejoinder (which illustrates again some misconceptions about commercial art): "But Mr. Shahn, I'm only going in for commercial art anyway." Of course I would answer, "Oh no you're not— at least not until you learn to draw!"

The students seemed to be under the impression that in commercial art one needs only to be abreast of a current set of tricks. It was my painful duty to point out that if one is painting for oneself alone, for one's own pleasure and no one else's, he might get on without craftsmanship. But in commercial art it is a *sine qua non.* Without it the young aspirant may as well put down his pens and brushes and try something else. Commercial art, contrary to the general conception, is an unyielding taskmaster, a hard school. It is also an excellent school for any artist, *provided it is not abused.*

I want to burden that point—*provided it is not abused*—because I believe that the most serious handicap that commercial art suffers, is its abuse. Just where the point of abuse begins ought to furnish us material for some pretty lively discussion.

But before we go into the matter of abuses, about which I feel pretty strongly, I think we might put in a word for some of the outstanding virtues of commercial art. I don't want you to think that I share the rather prevalent fine-arts snobbery about it. I don't.

One of its first virtues I have already mentioned—that is, craftsmanship. The commercial artist learns very early in his career that he either knows exactly what he is doing or that he might as well not bother. He knows his tools, his media, and the methods of reproduction. He understands the limitations of various media and how to turn them to advantage. He usually is an expert letterer. He knows production problems and costs. He is more often than not familiar with typefaces and with all the interesting resources of the printer. *And he can draw.*

On its highest level, advertising art may approach the achievements of fine art. Here and there, there is a business concern or perhaps an art director with broad enough scope to want the finest kind of art available for his advertising—or perhaps to put it more accurately, public relations.

The Container Corporation of America, of course, is the outstanding example of this civilized outlook, but there is a growing

number of firms—and may their tribe increase—that purchase really fine work. The artist, in such cases, is handsomely paid and is free of the usual commercial-art restraints. What is, I daresay, of greatest importance to him is that his work is wonderfully reproduced and circulated the length and breadth of the land. Since this fine-art form of public relations seems to enjoy tremendous practical success, one can hope that the attitude behind it may increase.

That commercial art is not inferior art is demonstrated in an amusing way by the fact that advertisements of another era become collector's gems in this. Thousands of lithographs and woodcuts of the last century (used then as advertisements) are now prized, not just for their quaintness, but for their technical excellence, and for the fact that they reveal to us so much of the mood of their time.

Now let's talk about some of the abuses. Returning to the matter of standards, every artist, commercial or otherwise, has his own set of standards, his own *ethic*. This governs his attitude toward his own work as well as his relationship with art and artists and with the concerns with which he deals. An ethic implies, or ought to imply, that the artist's work stems out of himself and is the product of his own resources. We are all influenced to some extent by the work of other artists, and even more by the prevailing art of our age. But there is a clear point at which influence becomes lifting—and any one of us knows exactly when he is purloining the fruit of someone else's toil.

I hope that you will immediately protest that lifting is not confined to the commercial art field. It certainly is also a vice of fine artists. But there is a difference, because the fine artist who lifts will soon be pounced upon by critics and he will lose whatever standing he may have. In the commercial field, lifting is a pretty well-established practice. Let an ingenious commercial artist evolve a new style or invent an amusing cast of characters for himself, and behold! Overnight his characters will begin to emerge from drawing boards, the length and breadth of the land, not his own, and will usually reappear sans original grace and humor.

This may be due partly to some of the misconceptions about commercial art that we have talked about before—the undervaluing of it, as a lesser art. I think that it is also partly due to the vast iron curtain of anonymity that has been imposed upon commercial art by advertisers—seemingly as a most cherished item of their advertising mythology.

There is a great deal of talk these days about the artist's integrity. I think it is pretty generally assumed that an artist cannot

Ben Shahn

do much commercial art and keep his integrity. Perhaps that is true, but it is another assertion that will bear a little scrutiny.

In the first place let us readily admit that art directors and art buyers more often than not tell the artist just what to do. The procedure is to call upon the artist *after* an idea has been pretty well mulled over by people who are often greatly distinguished for their lack of visualizing genius. The artist is presented with a layout including pictures done by someone else. Then he may be told, generously, "Just do this any way you want to." He is likely to mutter to himself, "If this is what you want, why don't you use it?" But to the art director he is more likely to say, amiably, "When do you want it?" The art director can't be entirely blamed for this misuse of human energies. There is a great deal of compliance on the part of the artist, too, however much he may complain about it afterward.

One of the greatest frailties of art directors is an over-willingness to demand that artists make the most destructive changes in their pictures—sometimes to appease a client's whim, too often in anticipation of a client's whim. The art director is just a little prone to regard the artist as a talened and expensive servant that has no vested interest in his pictures and no real right to think and feel about them. And of course this process turns *art* into commerial art.

Charles Coiner, art director of N. W. Ayer, and I recently touched upon this business during a radio session, and he asked me whether I thought the art-director system responsible for loss of integrity on the part of the artists. I answered that I thought that what "was wanted" was less a matter of lofty integrity than sheer old-fashioned stubbornness. I should like to see the artist simply refuse to allow his work to be cheapened or debased. For it is *his* role (whether he be a commercial or a fine artist) to be innovator, inventor, and originator. An art director can always know what other artists have done; or can know what they could do. But he cannot foresee the new symbols, new devices, new interpretations that an artist can devise to meet any given situation.

The European commercial art system—if it could be called a system—involves the artist at the outset. He usually originates the advertisement simply by visualizing it on a page. The initial interpretation of an idea is likely also to be his. This simplicity of operation is probably due more to shortage of man power than to deliberate foresight, but it is interesting to note how fresh and sparkling is the advertising result.

I think the commercial artist ought to set for himself a harder

standard of realism—or let's call it a search for new truth—than he now maintains. I doubt that there is a living individual who does not respond more readily to a bit of brilliant observation than he does to the most saccharine prettification of fact. Of course this assertion is heresy and contrary to the general belief. But surely by now our nation has become surfeited with sweets!

Advertising art is often accused of spoiling the public taste for the more substantial fare that fine art has to offer. What I believe it has really accomplished is to immunize the public against anything it has to say. I'm speaking now of the forever beautiful, forever sweet, forever smiling, forever untrue kind of advertising art. Or let's put it this way—a beautiful smile coming out of the toothpaste ad in the subway isn't going to uplift the heart of the weary subway rider.

I think we might conclude, if you are with me at all, that some of the misconceptions about commercial art have grown out of abuses such as those we have touched upon above. And that they have in turn placed upon commercial art, limitations that seem unnecessary. The question remains: What may be the real distinctions between fine and commercial art, if indeed there are any? In the first place, I do not think that there is any one point at which it can be said fine art begins or commercial art ends. There is a basic distinction, however, between the two orders of art. And that is mainly in *intention*. Commercial art *intends* to sell. It may sell ideas. It may sell on the very high level of merely associating the name of an establishment with a sophisticated or elegant work of art. Ordinarily, of course, it sells directly.

I find no fault with selling, understand. Indeed, I love to buy. And within the area of selling I think that art can be beautiful, resourceful and highly stimulating. Its potentialities are tremendous. Its function (to sell) is enhanced by all the virtues of any art, by craftsmanship, by new imagery, by wit, and wisdom, and adherence to truth, and especially by fresh observations of people and things. That is its scope—and a considerably wider scope than commercial art has yet availed itself of.

But the intention of fine art may be as broad as human experience. It may create beliefs, or destroy them—or at least try. Its level is philosophical rather than practical. It may be what commercial art may never never be—and that is controversial. (I sometimes believe that easel painting is the securest haven of free speech left to us.) Craftsmanship is essential to either commercial or fine art. But in fine art, craftsmanship may be, to a much greater degree, subordinate to the idea or feeling content of the work.

126 Ben Shahn

Beardsley Ruml once said to me that he believed industry today to be potentially as great a patron of art as the Church during the Renaissance. He spoke particularly of the use of art in advertising. I tried to point out to him (I don't know how successfully) that the Church during the Renaissance was the very center of morality, the focal point of man's beliefs and of his noblest emotions.

Business and industry are practical, at best amoral. They are concerned mainly with the problems of acquisition. The artist is a curiously moral person, anachronistic though that may appear to be. Whether in belief or in disbelief, he is likely to have a moral bent. He is, more than the next fellow, concerned with man's fate, and that forms perhaps his greatest creative impulse.

Therein, I think, lies almost the only basic distinction between fine and commercial art. As to the artificial distinctions that have been imposed upon commercial art, I should like to see them give way to higher standards, to a more original and observant commercial art, that would be a source of increasing pleasure and value to the public.

Ben Shahn *Russell Lynes*

The following excerpts from the "After Hours" column in Harper's *epitomize the feelings of Shahn's publishing clients about his commercial art. They appeared in the issue for which Shahn did the cover and the illustrations for the first installment of "The Voyage of the Lucky Dragon," an article by Ralph E. Lapp.*

It is nearly ten years since *Harper's* published "The Blast in Centralia No. 5" by John Bartlow Martin with illustrations by Ben Shahn. It was the first time that Shahn's work had appeared in *Harper's* and it appeared in profusion. When the editors asked him if he would like to illustrate the article, no stipulations were given. "Here's the piece," one of them said to him. "If you like it we hope you will illustrate it. We have just so much to spend on illustrations and if you decide you want to do one drawing only that's all right with us. We leave it to you."

Several days later Mr. Shahn called the editor at home on Sun-

day morning. "I think this is wonderful," he said. "I'll be in next Thursday with some drawings."

He arrived on Thursday with sixty-four drawings. "If you can't find what you want here," he said, "I have thirty-five more at home. I got started and I couldn't stop."

He didn't, in fact, stop for a year or more. Out of the drawings for "Centralia" came not only a close friendship (and future collaboration) with its author, but a number of paintings.

A year or so later much the same thing happened again. This time it was a Martin report on a tenement fire in Chicago. The article was called "The Hickman Murder Case." Again there was a raft of drawings, and distilled from them a painting called *Allegory*. . . . *The Biography of a Painting* is his account of how this picture grew out of the illustrations for *Harper's*. . . .

Shahn seems to approach each new problem not in the terms of his own style but in the terms that the problem demands. His intelligence guides his hand and he rejects mere facility as dangerous; the economy of his line and statement is the reward of endless study, endless observation, and an always personal point of view. His perception always relates the object he looks at to the world in which it exists, and sentiment does not frighten him. His line can, and often does, draw blood but it can also draw tears. He is fiercely disrespectful of the pompous, the phony, and the unjust, but he is moved to tenderness (not sentimentality) by the simplest human situations. . . . Several weeks ago I complimented him on how well-written his lectures are. "I hate it," he said. I asked him why; was he displeased with them?

"No, not that," he said, "I hate the process of writing. I really sweat."

He sweats over his drawings too, but to him it's more honest sweat. "Finally last night at nine I had to quit working on the *Lucky Dragon,*" he said. "I'd like to go on working on it for a year."

The chances are, of course, that he will.

[*He did, and a number of the paintings and prints reproduced in this book are the result.*]

Statement *Charles Coiner*

The following statement, made to the editor of this book in 1971, by the former art director of N. W. Ayer & Son sums up the feelings of Shahn's advertising clients about his work.

Ben Shahn

One of the problems in commissioning fine-arts painters to paint for advertising is that they find it hard to believe that the advertiser really wants fine art and not the usual advertising illustration. Their attempts to perform in the unfamiliar field of advertising are usually deplorable. This posed no problem for Ben Shahn, for he had always considered art as a form of communication. He also gave the average reader credit for being more intelligent than the advertising surveys indicated. This honesty in interpreting the advertising message came through to the reader. Beyond that, these advertisements had about them a memorable quality which cannot be said of most advertising.

With N. W. Ayer he worked for such diverse clients as Hawaiian Pineapple, Capehart, and Container Corporation. We found in the very beginning that the fewer instructions given to Ben, the better the result. The usual procedure in constructing an advertisement is for the agency sketch-artist to rough out a layout showing how the text is to be illustrated. This is submitted to the client for approval before negotiations begin with the artist who is to do the final work. If approved, this artist "finishes" the art, not deviating from the basic idea of the sketch.

In the case of Shahn we submitted the *artist* to the client, saying that it would be ridiculous for him to follow a sketch-artist's work. The idea was well received, and Shahn then made a finished work. He said that if his work was not approved he would like to have it back, and there would be no charge. (We paid Shahn his going rate at the time—$750 to $1,000 per painting.) This happened only once, and later I saw the rejected work hanging in The Museum of Modern Art. [*Peter and the Wolf, 1943.*]

Shahn usually made several interpretations of any one idea. I have seen several of these variations in exhibitions, notably the drawing of hands used in the Container Corporation series: Great Ideas of Western Man, "You have not converted a man because you have silenced him."—John Morley.

Shahn's approach to advertising art was similar to that of some of the great French painters. If the price is right and they are given carte blanche on execution, most will accept a commission for painting or design for industrial use—display advertising, posters, or even fabric design. Shahn proved that in this country, too, fine art can be used in advertising to the advantage of both the advertiser and the artist.

VII photography

If he had not been a painter by preference and inclination, Ben Shahn would be well known as a photographer. He liked to tell the story of being introduced to someone as "Shahn the painter" and being asked if he were any relation to "Shahn the photographer." His photographs illustrate the WPA guide to Ohio, have appeared in leading European and American photographic magazines, and are in the collection of The Museum of Modern Art in New York and the Fogg Art Museum in Cambridge, Massachusetts.

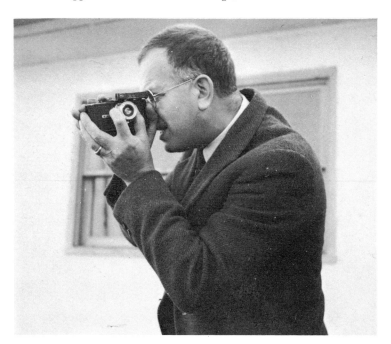

Photography *Ben Shahn*

The camera people ought to photograph the obvious. It's never been done. What the photographer can do that the painter can't is to arrest that split second of action in a guy stepping onto a bus, or eating at a lunch counter. That's what we tried to do for Roy Stryker and the FSA [Farm Security Administration]—Dorothy Lange, Walker Evans, and the rest of us. Of course we had a special job of selling to do—helping the underprivileged. Maybe that's why we were pretty austere about our job. We had only one purpose—a moral one, I suppose. So we decided: no angle shots, no filters, no mattes, nothing but glossy paper. But we did get a lot of pictures that certainly add something to the cultural history of America.

We tried to present the ordinary in an extraordinary manner. But that's a paradox because the only thing extraordinary about it was that it was so ordinary. Nobody had ever done it before, deliberately. Now it's called documentary, which I suppose is all right. But somehow I don't like putting such things in pigeonholes with a label on them. We just took pictures that cried out to be taken. When you spend all day walking around, looking, looking, looking through a camera viewfinder, you get an idea what makes a good picture. What you're really doing is abstracting the *forms*.

Photographs give those details of forms that you think you'll remember but don't—details that I like to put in my paintings. There's a good example of that in the picture called *Sunday Football*.

You remember the picture—two little guys looking through the cracks of a high wooden fence, all dressed up in their Sunday best, one with a cap and the other with a new hat on. Well, the composition called for some kind of accent in the middle, and I knew there'd be an election poster on that fence, so I looked through my photograph files to find one. I've got about three thousand. I picked out this particular one and copied it just as it was. I sent the painting off to the Academy show in Philadelphia, and the next thing I knew I got in the mail a deputy sheriff's badge from Sheriff Campbell, whom I didn't know from Adam. He was the man in the election poster. He'd seen the picture reproduced in a Philadelphia paper because it had won a prize, and must have figured that somehow I'd helped him win the election. So he sent me a gold-plated deputy's badge. I've never used it.

Excerpt from "Ben Shahn: An Interview," *Magazine of Art* (April, 1944).

Henri Cartier-Bresson *Ben Shahn*

You suppose technique in a photographer, just as you suppose it in a musician, or a painter. Lots of people have it. But technique is not what makes Bresson's photographs memorable. Bresson likes people. That's really all there is to it. That's why he photographed the onlookers at the coronation, when everybody else was photographing the coronation itself.

Or the Mexico series. Most people photograph the picturesque —the markers, the costumes, and so on. Bresson photographed the girls in the red-light district, not as Mexican practitioners of the oldest profession, but just as people. His genuine sympathy for people is what makes these photographs memorable. He is never mean. Even in the picture called *Picnic,* the one with the fat woman on the sand, he is sympathetic. Most people would have made fun of her.

Of course his photographs have form—composition, contrast, and all that. Bresson is also a painter, so that's what you'd expect, or what you might presuppose, as I said. But the thing that makes them memorable is their content. To me, he is supremely the artist when he is looking for his subject. The rest is mechanical. The feeling for the subject and the ability to know just when to press the shutter—that is not mechanical. To find the extraordinary aspect of the ordinary—that's what Cartier-Bresson does.

The emphasis among most photographers in this country has always been on form. Our first photography club called itself "The Circle of Confusion." Its members talked about lenses, scope, speed, print quality, and I don't know what all. I still don't know the language very well.

There are any number of conditions under which you take a picture—the place, the people, why you were there, why you stood where you did instead of on any of a thousand other spots. But in the Annual published by *U.S. Camera* the only questions asked of the photographers are: camera? aperture? speed? (Shahn confessed that since he never keeps an account of these details, he once made up some completely impossible figures, which were solemnly published—ed.)

Because concern with content has been so rare among our photographs, a show that has nothing else but content, and such human content as this one, is bound to be a memorable experience.

From *Magazine of Art* (May, 1947).

Ben Shahn

Interview *Ben Shahn*

Following are edited excerpts from an interview with Shahn in his home in Roosevelt, New Jersey, April 14, 1964, by Richard Doud for the Archives of American Art.

I became interested in photography when I was sharing a studio with Walker Evans, and found my own sketching was inadequate. I was at that time very interested in anything that had details. I was working around 14th Street, and a group of blind musicians was constantly playing there. I would walk in front of them and sketch, and walk backwards and sketch, and I found it was inadequate. So I asked my brother to buy me a camera because I didn't have money for it. He bought me a Leica and I promised him—it was kind of a bold promise—I said, "If I don't get in a magazine off the first role, you can have your camera back." I did get into a magazine, a theater magazine [*Theater Arts,* October, 1934].

Now, my knowledge of photography was terribly limited. I thought I could ask Walker Evans to show me what to do, and he had made a kind of indefinite promise. One day when he was going off to the Caribbean and I was helping him into his taxi, I said, "Walker, remember your promise to show me how to photograph?"

He said, "Well, it's very easy, Ben. F9 on the sunny side of the street. F45 on the shady side of the street. For 1/20th of a second hold your camera steady"—and that was all. This was the only lesson I ever had. Of course, photography is not so much the technical facility as it is the eye and the decision that one makes about the moment at which one is going to snap. I was primarily interested in people, and people in action, so that I did nothing in the way of photographing buildings for their own sake, or a still life, or anything like that. To me it was just to make documents for my own work.

Then, in the fall of 1935 someone came down from Farm Security. (It was called the Resettlement Administration then.) I had been recommended by Ernestine Evans, who was on the planning board and had recommended Walker Evans earlier that year. I was brought in, not in the photographic department at all, but on a thing called "Special Skills." I was to do posters, pamphlets, murals, and propaganda in general.

It was suggested that I first take a trip around the country in the areas in which we worked—to see what it was all about. And I tell

you that was a revelation to me. My experience had been all European. I had been in Europe for four years. I studied there, and my knowledge of the United States came via New York and mostly through Union Square.

I took my camera along, as I felt there wouldn't be enough time to draw the things I wanted to do. I did some drawing and a lot of photography, but I was not part of [Roy] Stryker's outfit at that time. I presented the photographs to him as a gift, with my negatives, and for that reason I had the facilities to print them.

I still want to speak of the revelation that the country became to me as compared with what I knew of it. Frankly, I'd never traveled in the United States at all. I had traveled all over Europe, you know, and Africa, but not the United States. When I had the desire to see the United States, I didn't have a penny. It was in the middle of the Depression, and I couldn't get as far as Hoboken at that time. It was really a very serious time. I thought I'd never get out of New York again, and so when this thing came along with the idea that I should wander around the country for three months, I nearly jumped out of my skin with joy. And not only that, they were going to give me a salary, too! I just couldn't believe it! Anyway, I went, and I found things that were very surprising to me.

For instance, I remember the first place I went to on this trip where we were active, one of the resettlements that we built. I found that as far as I was concerned, they were impossible to photograph. Neat little rows of houses. This wasn't my idea of something to photograph at all. But I had the good luck to ask someone, "Where are you all from? Where did they bring you from?" And when they told me, I went on to a place called Scott's Run, and there it began. From there I went all through Kentucky, West Virginia, down to Arkansas, Mississippi, and Louisiana—in other words, I covered the mine country and the cotton country. I was terribly excited about it, and did no painting at all in that time. This was it, I thought. I'm sort of a single track guy, anyway. When I'm off on photography, photography is it, and I thought this would be the career for the rest of my life.

In 1938 I went on Stryker's payroll, at about half the salary I was getting before, to cover what he called "The Harvest" in Ohio. It was so completely different from the South and from the mine country. It was neat and clean and orderly, and I didn't think it had any photographic qualities for me. At first I said, "Well, I can't do anything about it." Then one day it sort of came to me. I

Ben Shahn

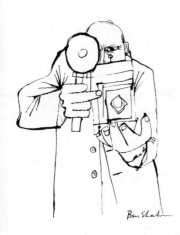

Ben Shah

felt it after about two weeks, so I called Roy and I said, "I'll take the job." I stayed about six weeks with this, and worked just day and night on the scene. It was an entirely different thing. In the South or in the mine country, wherever you point the camera, there is a picture. But here you had to make some choices, you see.

There were nice orderly farm houses, nice orderly roads, and so on—without sharecroppers and without the mine shacks. It was a little more difficult, but I think I did what I call a nice job. Not only was it the actual harvest. I wanted to know what they did on Sundays, and I covered a lot of church activities. I wanted to know what they did on Sundays to amuse themselves, and I went out to a place called Buckeye Lake. Then there was the auction of a home which had its tragic overtones—a baby carriage. The children for whom that baby carriage was bought were now grandparents themselves. You see, all those overtones. I looked at it almost like a movie script, except they were stills. I'd first go out and photograph all the signs on telegraph poles and trees announcing this auction, and then get the people gathering, and all kinds of details of them, and then examine the things, and the auctioneer, and so forth.

I used what is called an angle finder. You know, in an ordinary Leica, the lens is here. The angle finder lets you look off in another direction when you focus, so it takes away any self-consciousness people have. So, most of my pictures don't have any posed quality. This was a very helpful thing in my work, this angle finder. I remember traveling around in Arkansas with Senator Robinson and I told him what this little trick was. He felt very much a part of it. He had me take pictures of people unbeknownst to them. On another occasion, when I was in Kentucky, the sheriff came along and just took me by the arm. No photographs in post offices. A post office has been held up in Paducah, and someone had come in with a camera and sort of cased the joint. Well, I was very amused by this. I had credentials which I had not shown. I wanted to see how far this would go. So, the sheriff took me to a justice of the peace, and I showed him my credentials, and while he was reading me the riot act I kept photographing him with this angle finder.

The things that I photographed I did not take so much as photographs as documents for myself. A lot of paintings came out of them over the years. I thought of photography purely as a documentary thing, and I would argue rather violently with photographers who were interested only in print quality. All that bored

Photography 137

me. I felt the function of a photograph was to be seen by as many people as possible. I felt that the image was more important than the quality of the image—you understand?

I was really quite a purist about it, and when some of the people came in and began to use a flash I thought it was immoral. I'll give you a reason why. You know, you come into a sharecropper's cabin and it's dark. But a flash destroys that darkness. It is true that a flash would actually illuminate the comic papers that they used to paste on their walls, but this wasn't the impact it had on me. It was the darkness, the glistening of the eyes, the glistening of a brass ornament on top of a big bed, a glass, a mirror that would catch light. I wanted very much to hold on to this, you see.

I have a strange inability to read a guide book before I go anywhere. I can read it after I've been there, and by the same logic I refuse to accept any technical hints from anybody. In those days I refused to learn more about photography than I knew, and I confess I missed a great deal. (I missed a great deal also when I traveled by not reading the guide book.) What I did I did with absolutely simple facilities. I used a camera that did not have an interchangeable lens, so it was much flatter. I could put it in my back pocket. I got to be fast enough to work from a moving car. My wife would do the driving. She was very understanding through the whole thing, and just as enthusiastic about it as I was. Sometimes we'd retrace our steps up to 500 miles: I needed something to fill in, I'd missed it, and back we'd go. We had a little Model A Ford that we knocked around in. It gave us no trouble, but it didn't have much speed, so going back 500 miles meant almost three days.

The 35-mm. camera I was using cost all of twenty-five dollars at that time. It was a secondhand one. I did not even use a light meter. I used my own judgment on it. So, I missed a lot of things. I remember spending the whole evening at some dance hall and not getting a single thing. If I had used a faster film, I probably would have got it. Sometimes I got things that I never dreamed I'd get. There was one photograph that I'm very proud of. It's been reproduced a lot. A little girl, very meager looking, tragic eyes, walking through the hallway of her home, and there was a huge reproduction of a Raphael Madonna on the wall. I held the camera in hand for about ten seconds, and I got it! My hands are pretty steady, so I was able to get it. That was a lucky thing.

My negatives I know were very uneven, and a real trouble for the printer. I would insist in the beginning on printing my own stuff, and then when I did so much, they had to bring in some

printers. I would give them the quality of the thing I wanted and they would put it in the file, so when they had a call for it, they could reproduce it. They were much better printers than I was. They could reproduce it exactly.

The fact that one of the newspapers, AP or UP, began to borrow stuff and make boiler plate of it and send it around the country was one of those weird accidents. Because normally the average photo editor is not going to go to a government agency for a good photograph. But our pictures were used a great deal. Archibald MacLeish was then an editor of *Fortune,* which was doing an enormous study on the use of the land. Someone suggested that he might look at our photographs. I don't think he was very excited about the idea. But when we sent down a big portfolio, he said, "I'm abandoning my text. I'm just using your photographs, and I'll write a sound track for it, a single line." The book is called *Land of the Free* and this, I think, was the first book that came out of our photographs.

I think our work revolutionized photography—at least one aspect of it. To me there are two areas of photography. There is the kind of thing Paul Strand does or Walker Evans does, with an 8 by 10 camera, getting on the scene and divulging textures and details the human eye almost misses. Then there is the thing that Cartier-Bresson does, of people in movement. Those are the two great directions for me. A third one has come up now which is kind of abstract, but it doesn't move me very much. I'm not surprised that we had a revolutionary effect upon photography. As a matter of fact, Margaret Bourke-White and her husband did a book called *See Their Faces,* or something like that, and they were inadequate copies of our work, really. It did not have that particular dedication that ours had. It was a commercial job.

Roy Stryker felt that the photograph is an adjunct to the written word. I don't think so at all. I don't think one is an adjunct to the other. It's like saying that the cello is an adjunct to the orchestra or the other way around—the orchestra is an adjunct to the cello. It depends on how you use them and how you put them together.

In 1959 my wife and I went to Asia, and I took a camera along. I began to do what I had done years ago—photograph people. I could not get interested in it. I took hundreds of photographs of details of sculptures and monuments. We were in Indonesia. We were in Cambodia, and I did endless photographs of details—the temples and so on. But no more people. I found it was gone. I still love to look at photographs of people, but I couldn't make them myself any more.

VIII graphics

This section contains the complete text of Love and Joy About Letters, *written and illustrated by Shahn. The bibliography at the end of the book lists four other books that he wrote and twenty-eight publications that he designed or illustrated. No record was kept of the many jackets he designed for books such as* The Road to Miltown *by his friend S. J. Perelman (Ill. 40) or of all the magazine articles he illustrated, or of the posters he contributed to various causes, or of the early prints he made.*

Shahn was drawn to the graphic arts for the same reason he enjoyed doing murals: a large audience. Also, he loved to give presents to his friends, and he could not afford to give away his drawings and paintings. They paid his rent and fed and clothed his family. So he made serigraphs and lithographs and kept a supply on hand to offer a selection to visiting friends. When the editor of this book was offered such a choice, he chose the print reproduced as Illustration 15 and asked Shahn what he called it. "Oh, I call it something different every day," Shahn replied. "Today I'm calling it 4½ out of 5 Businessmen. *He planned, but never executed, another version of this picture, to be entitled* Let Us Prey.

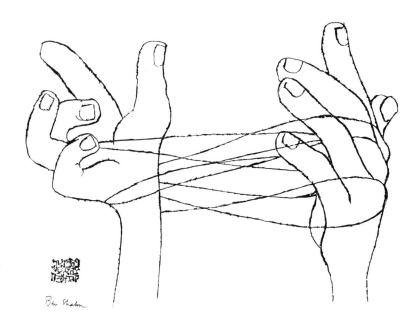

Ben Shahn

Love and Joy About Letters *Ben Shahn*

"The strings touched by the right or left hand move, and the sound is sweet to the ear. And from the ear the sensation travels to the heart, and from the heart to the spleen, and the enjoyment of the different melodies produces ever new delight. It is impossible to produce it except through the combination of sounds, and the same is true of the combination of letters. It touches the first string, which is comparable to the first letter, and proceeds to the second, third, fourth, and fifth, and the various forms combine. And the secrets, which express themselves in these combinations, delight the heart which acknowledges its God and is filled with ever fresh joy."

So wrote the great mystic, Rabbi Abulafia, who believed that in letters were to be found the deepest mysteries, that in the contemplation of their shapes the devout might ascend through ever purer, more abstract levels of experience to achieve at last the ultimate, ineffable abstraction of union with his God.

When I was very small I had a famous uncle. He was famous to me, anyway, because I had never seen him, and my mother and my father and my grandfather talked about him with so much respect. He was Uncle Lieber, who was great because he belonged to the Russian cavalry, rode a horse, and was very far away somewhere.

Once I drew a picture of Uncle Lieber. Since the only military installation that I had ever known was the striped sentinel box at the *caserne* at the end of our street, I drew my uncle sitting on his horse in front of that. The stripes were nice, but the horse troubled me because it looked like a cow—at least it looked more like a cow than a horse.

Like Rabbi Abulafia, I had learned first of all the Hebrew alphabet. Like him, I loved to draw and to contemplate the big flowing letters; I was most at home with them and could make them long before I could do anything else with my hands. It was such a pleasure to copy them from the prayer book, because in each letter there was some subtle part of the others, and as one learned to make the new ones he discovered those familiar parts that he already knew. So with my drawing, I retreated to what I knew best and lettered under it, "Uncle Lieber Sitting on his Horse." That gave the picture quite an air, and it impressed me very much.

At that time I went to school for nine hours a day, and all nine hours were devoted to learning the true history of things, which was the Bible; to lettering its words, to learning its prayers and its psalms, which were my first music, my first memorized verse. Time was to me then, in some curious way, timeless. All the events of the Bible were, relatively, part of the present. Abraham, Isaac, and Jacob were "our" parents—certainly my mother's and father's, my grandmother's and my grandfather's, but mine as well.

I had no sense of imminent time and time's passing such as was felt and expressed by my own daughter when, in 1951, under a drawing of her cat, she lettered first its name and then, ominously, in a small hand at the corner of the page added, "49 years till 2000."

But the immigration to America worked a cataclysmic change. All the secure and settled things were not settled at all. I learned that there was a history quite apart from the intimate Biblical legends; there was an American history and a world history that were remote and unreal and concerned people who were strange to me and had nothing to do with my family or with Abraham, Isaac, and Jacob. Time was moving toward me, and time was passing away. It seemed as though there wasn't enough of it for anyone—and of all the new friends that I made who were my own age, none could make letters or draw or carve. Then there was the new world of letters and print; it seemed to me there were thousands of letters in the American alphabet, all shapes and styles and sizes. They were intimidating, but also quite wonderful, and I was eager to learn them.

In 1913, when I was fourteen years old, I was apprenticed to a lithographer. By this time I had finished elementary school and, it was generally agreed, knew everything there was to be known. The problem now was to learn to do. To my family it seemed right and proper that I learn a craft; to my father, a woodcarver, to my mother's family who were potters, craftsmanship was the way of life, the natural means to earn a living. I was apprenticed to a lithographer, and if learning a craft was my ostensible reason and purpose, my private one was to learn to draw—and to learn to draw always better and better.

But people who drew were the aristocrats of the lithographic trade. First I had to learn the hard things, like grinding stones and running errands and making letters—thousands and thousands of letters until I should know to perfection every curve, every serif, every thick element of a letter and every thin one, where it be-

Ben Shahn

longed and how it related to the form of the letter to which it belonged.

I discovered the Roman alphabet in all its elegance and its austere dignity, and I fell in love all over again with letters. To make a perfect Roman letter—I suppose that I spent months just on the *A* alone; and then when I felt that I was ready to move on to *B*, the foreman of the shop, my boss and my teacher, would not accept the *A*, but condemned me to more work and more making of *A*'s.

As I learned the alphabet, and then many alphabets and many styles of alphabet, and ornamentation and embellishment of letters without end, I found here, too, the wonderful interrelationships, the rhythm of line as letter moves into letter. There is the growing insight—there are, after all, only two basic kinds of letter, the severe unornamented Gothic without serifs and the Roman with serifs. And there is the pondering: Out of what tools and what materials have the styles of letters emerged? Were serifs first used to accommodate the chisel that carved letters in stone? Or were they, on the other hand, a hangover from some original cursive or painted kind of letter in which each element ended with a flourish of a brush? Did Hebrew letters, with their slight reminiscence of wedge shapes, derive from some even earlier cuneiform writing?

All letters, of course, were once pictures. Can one still discern the head of the ox in Aleph and Alpha and A? Can one see the house in Beth and Beta and in B? Why does every Greek letter so resemble the Hebrew equivalent in its name—was that its origin? Have they a common origin? All this while one works painstakingly, almost painfully, the lip fixed between the teeth, contemplating, wondering about the mysteries, the mystic relationship of the letters growing under one's hands.

And then there is spacing. When I had begun to achieve assurance and mastery over the letters themselves, there was still something missing. Even to me, the line seemed awkward and glaringly imperfect. And again the foreman criticized my work with that inexorable perfectionism of the true letterer. He made me look past the letters at the spaces around them—a minor theme, one might call it, of shapes and patterns carved out of the background by the letters themselves. How to determine these spaces? I tried measuring, I tried allowing for curves and angles, but no formula that I could devise provided for every shape, so that all the letters might emerge into a perfect line.

Then he shared with me the secret of the glass of water. "Imag-

ine," he said, "that you have a small measuring glass. It holds, of course, just so much water. Now, you have to pour the water out of the glass into the spaces between the letters, and every one has to contain exactly the same amount—whatever its shape. Now try!"

That was it; letters are quantities, and spaces are quantities, and only the eye and the hand can measure them. As in the ear and the sensibilities of the poet, sounds and syllables and pauses are quantities, so in both cases are the balancing and forward movement of these quantities only a matter of skill and feeling and art.

As a lithographic engraver, I had learned to work in a precise way, literally to cut the lines that I made, working always against the resistant material of the stone. Then, when I studied art more formally and drew extensively, I found that this chiseled sort of line had become a necessity, a sort of temperamental fixture, so that even when I drew with a brush the line retained that style. Again, in my painting, I found the influence of my early experience very strong, for I loved—and still love—the clear patterning of forms, the balance and movement of shapes and the sense of major and minor themes of which I had become so conscious during my early youth.

The world of type had so far escaped me. In my kind of rigorous training, a line of letters had to be more than just a communication or a mechanically perfect sequence of words; each line of letters had to be a unit, to form a single and not a scattered silhouette, to be balanced by the eye. All this seemed to be precluded by the simple fact that type is mechanical.

Sometimes during the thirties I designed my first book, and I undertook the project as a chore. But then I began to discover the delights of type: fitness, elegance, tradition, humor, the color of pages, the vast panorama of choices, each with its own peculiar flavor which added so much to the words said. I enjoyed a year or so of complete infatuation with type; I set everything that I could in types with which I was beginning to be familiar; I did posters all in type—a strange turn for an artist—or posters in which type boldly predominated; I found old wood-engraving houses in Baltimore and Philadelphia that still owned drawers full of dusty, long-abandoned letters. I hunted down a few small-town newspapers that had never thrown away their drawers of Brandon and condensed Cheltenham, Clarenden, Girder and nameless types that no one could any longer identify. If my enthusiasm cooled, that was because I began to realize that the uses and the understanding of type are a life's work, and that I would never be much more than

Ben Shahn

a dabbler. I returned to the lettering that I love, but not without a vastly increased admiration and respect for the type designer.

It was during the thirties too that I first became aware of hand lettering by amateurs. Here was a folk art of great quality, and one that was extremely amusing as well. I really made no effort then to copy or reproduce that kind of lettering. But I did take innumerable photographs of whatever I found along the highways and in the small towns: the gas-war signs—"6 gals, 1 dollar," "Last Gas Before Bridge"; the restaurant and diner signs—"We Don't Know Where Mom Is, but We Got Pop on Ice," "Don't Criticize our Coffee, You May Be Old and Weak Yourself Some Day!", "In God We Trust, All Others Cash!", "Ladies," "Gents," "EAT," and the all-too-frequent sign, "Closed." In those days the slogans were not yet supplied by printing houses. The lettering was laborious and of an impressive variety. On a good day, one could count as many as twenty different versions of the figure 2 alone.

I loved using these signs as parts of paintings. Not only is there a certain structural character in letters—any letters—but there is also flavor and a sense of place. I suppose that had something of the visual meaning for me that "Le Journal" once had for Picasso, Braque, or Juan Gris. I incorporated them in paintings as an integral part of the work, not as something separate.

In my own lettering I was still, at that time, a perfectionist. But gradually, and probably as a reaction against the mechanical perfection of type, I began to free words and letters from the set line. I still felt strongly the rhythms of balance and weight, the distribution of color in a line or an area of lettering, but a new concept of letters in and with pictures was growing for me.

I began to use letters now, not as local color, and not as subordinate parts of paintings, but for their own sake, for their beauty and their own meaning. Words and letters may amplify and enrich the meaning of a painting. They are at the same time independent and integral to the painting, a contrapuntal element. They lend force and structure to the work, but they must be fully developed; they must, I think, be knowledgeable in themselves. A badly done letter is a pitiful thing in a painting and degrades it as a fully understood letter may enhance it and complement it.

All kinds of letters that exist—and that includes type letters and amateur letters—have their own intrinsic moods and meanings. Lettering is, for all its perfectionism, an expressionistic art. There is a sort of decorative joy in those seemingly simple, but not at all simple Greek characters that interweave with and underline the figures of the great Byzantine mosaics. There is the glory of the

Hebrew that I had sensed so deeply as I had first learned to make the letters. Now I did not hesitate to register my own feeling; the prohibitions of art must melt before one's own authority, one's sure knowledge of what he feels and what is right for him. I made many paintings using the Hebrew letters or the more ancient Aramaic in gold or red or black, realizing with Rabbi Abulafia their mystery and their magic.

Who can fail to respond to that beauty informed with religious ecstasy that unfolds across the richly ornamented pages of the medieval gospels, the books of psalms, the breviaries? There, no time spent could be lost time or wasted time, no degree of care too much; there, no ornament could be too rich or too elaborate, for to the inspired monks who labored over the rich pages and the magnificent uncials, all ornamentation was to the greater glory of God.

And looking at the elegance of a page of Khmer script, at the handsome square Sanskrit, or the Arabic, at stones carved with the mysterious runes of the Anglo-Saxons, at early Greek tablets, the cuneiform stelae of the Sumerians, or at the majestic lettering on some Roman monument, who can fail to find there an immediate sense of the hand that made the letters? There is a joy of workmanship that no time or weathering can erase. We may never know who dictated the words written, or under what circumstances they were made. But the skill remains there, the elaboration of shapes and rhythms, the understanding that must reside in the workman and in him alone. Small wonder that so many people have attributed the origins of the alphabets to their gods!

One of the noblest legends concerning the divine origin of letters comes from the *Sefer Ha-Zohar,* the Book of Splendor, written by Moses de Leon, a thirteenth-century Spanish scholar. He claimed to have the story from a second-century manuscript that had fallen into his possession, this work of Simon ben Yohai who, in turn, had received it by revelation. The story begins:

"Twenty-six generations before the creation of the world, the twenty-two letters of the alphabet descended from the crown of God whereon they were engraved with a pen of flaming fire. They gathered around about God and one after another spoke and entreated, each one, that the world be created through him.

"The first to step forward was Tav. 'Oh Lord of the World,' said he, 'be it Thy will to create the world through me, seeing that it is through me that Thou wilt give the Torah to Israel through the hand of Moses. For it is written, "Moses commanded us to keep the Torah." ' The Holy One, blessed be He, made answer

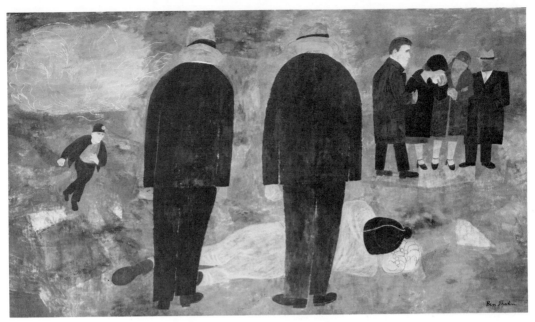

28. *Death of a Miner*, 1949. Tempera, 27" x 48". Collection of The Metropolitan Museum of Art, New York. Arthur H. Hearn Fund, 1950.

29. Ave, 1950. Tempera, 31" x 52". Collection of the Wadsworth Atheneum, Hartford.

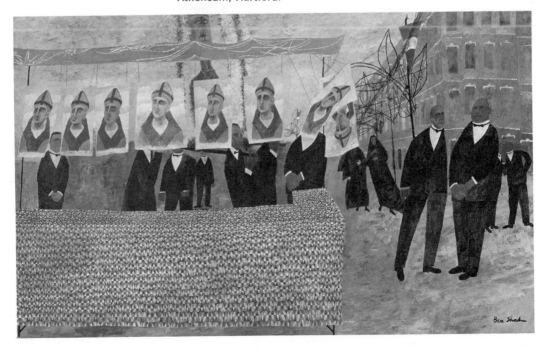

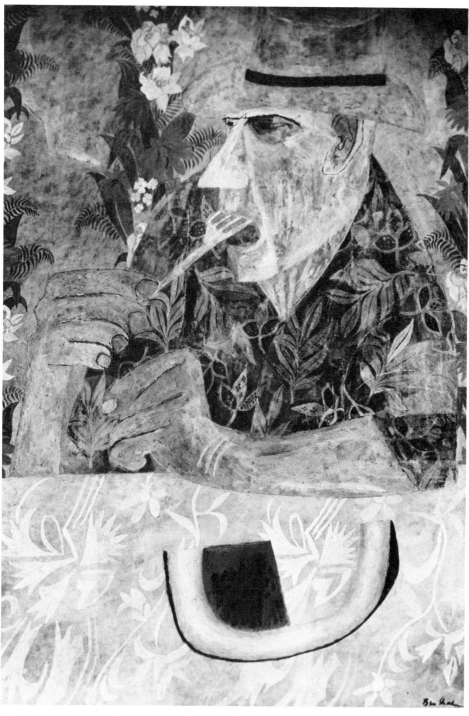

30. *Summertime*, 1949. Tempera, 39¾" x 27". Collection of the Addison
Gallery of American Art, Phillips Academy, Andover, Massachusetts.

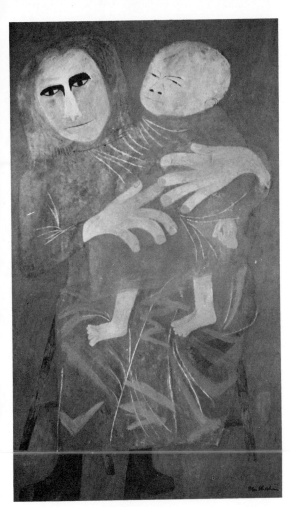

31. *Lullaby,* 1950. Tempera, 52" x 30¾". The Santa Barbara Museum of Art. Gift of Wright Ludington.

32. *Second Allegory,* c. 1950. Tempera, 53⅜" x 31⅜". Collection of the Krannert Art Museum, University of Illinois, Champaign. Purchase, 1953.

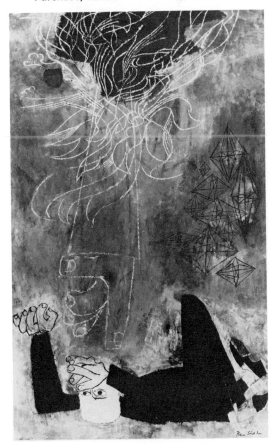

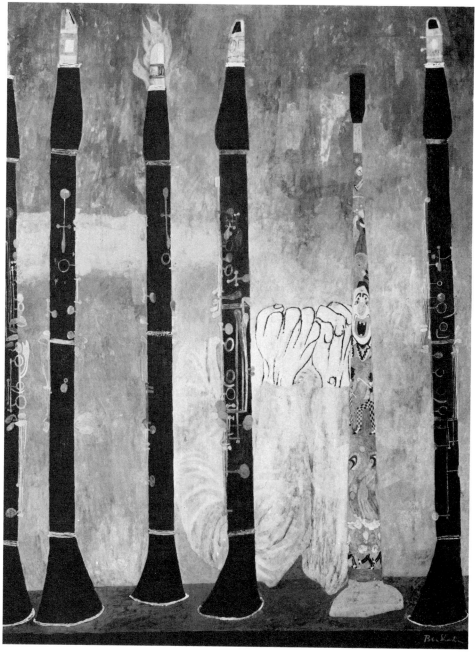

33. *Composition with Clarinets and Tin Horn*, 1951. Tempera, 48" x 36". Collection of The Detroit Institute of Arts. Gift of the Friends of Modern Art.

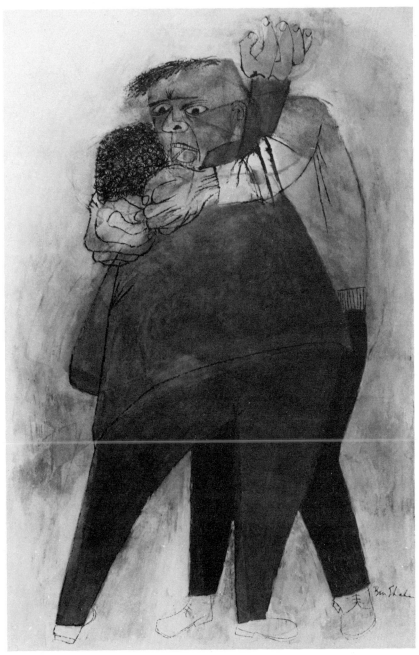

34. *Discord*, 1953. Watercolor, 38⅛″ x 25¼″. Collection of the Cranbrook Academy of Art, Galleries, Bloomfield Hills, Michigan.

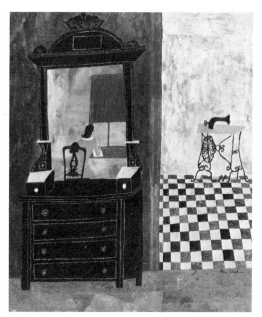

35. *Inside Looking Out*, 1953. (Painted for *Seventeen* magazine.) Gouache, 17" x 15". Collection of The Butler Institute of American Art, Youngstown, Ohio.

36. *The Blind Botanist*, 1954. Tempera, 52" x 31". Roland P. Murdock Collection, Wichita Art Museum.

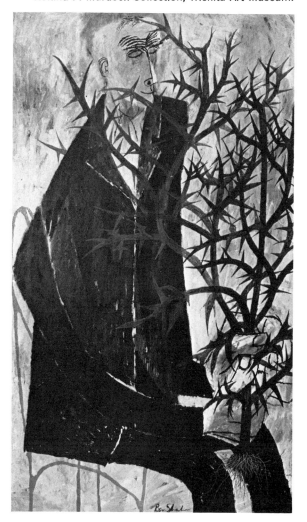

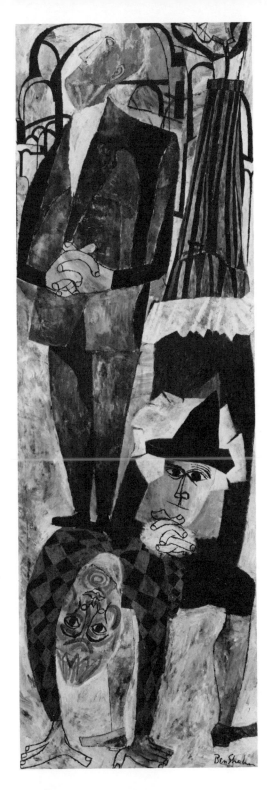

37. *Everyman*, 1954. Tempera, 72''
x 24''. Collection of the Whitney
Museum of American Art, New
York.

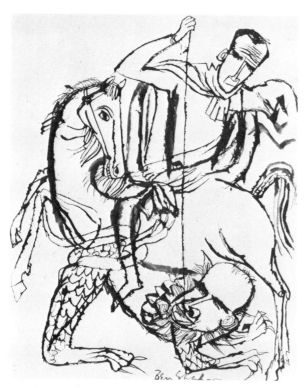

38. *Ed Murrow Slaying the Dragon of McCarthy*, c. 1955. Brush drawing, 12¼'' x 9½''. Collection of Kennedy Galleries, Inc., New York.

39. Goyescas, 1956. Watercolor, 39½'' x 26½''. Collection of Kennedy Galleries, Inc., New York.

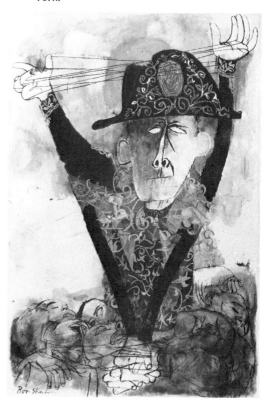

and said, 'No, because in the days to come I shall place thee as a sign of death upon the foreheads of man.' And Tav retired. Shin then stepped forward. 'Oh Lord of the World, create Thy world through me, seeing that Thine own name, Shaddai, begins with me.' But Shin was rejected because it was his ill fortune to stand at the beginning of the words, Shav, lie, and Sheker, falsehood."

Thus all the letters of the alphabet come before the Lord, each making its claim; and each in turn is rejected because of some shame connected with its name. At last Beth presents itself before the Lord. The legend goes on, "When the letter Beth left the crown, two hundred thousand worlds, as well as the crown itself, trembled. Beth stepped before the Holy One, blessed be He, and pleaded, 'Oh Lord of the World! May it be Thy will to create the world through me, seeing that all the dwellers of the world daily give praise unto Thee through me. For it is said, Baruch, blessed be the Lord forever: Amen and Amen.' The Holy One, blessed be He, immediately granted the petition of Beth, saying, 'Blessed bc he that cometh in the name of the Lord.' And He created the world through Beth; as it is said, 'Bereshith—in the beginning, God created the Heaven and the Earth.' "

But the most touching note of the legend is at the very end where the Lord addresses the letter Aleph, saying, "Oh, Aleph, Aleph, why have you not presented a claim before Me, as have the other letters?" Aleph replies, "Master of the Universe! Seeing that all these letters have presented themselves before Thee uselessly, why should I present myself also? And then, since I have seen Thee accord to the letter Beth this precious honor, I would not ask the Heavenly King to reclaim that which he has given to one of His servants." The Lord, blessed be He, replied, 'Oh, Aleph, Aleph! Even though I have chosen the letter Beth to help Me in the creation of the world, you too shall be honored.' And God thereupon rewarded Aleph for her modesty by giving her first place in the Decalogue."

In 1954 I made a book of this legend, rewriting it from several fairly conflicting accounts and creating at the same time my own version of the Hebrew alphabet. This reverts, I suppose, to an early time in the evolution of the Hebrew letters, a time when the letters were free, and when, as with the Chinese and Japanese calligraphy, each letterer created his own variation of the basic forms. The invention and use of type seemed to set the forms of the Hebrew letters, and to discourage somewhat their further evolution.

Perhaps it was the sense of freedom and the highly personal

quality of the figures that first attracted me to Chinese and Japanese calligraphy. (And who isn't attracted to them?) An incident that determined me to master at least a few of the Chinese ideograms took place in Singapore in 1959.

Walking along a narrow, teeming river of a street, I saw a sign painter's shop before which long black and white banners of undecipherable signs flapped and waved with the passing crowds of people. I stood and looked at the signs for a long time, eager to go into the shop and searching my mind for an excuse. Finally I found one; I went inside, pointed to one of the most stunning of the immense calligraphs, and asked the sign painter whether he could make my name in such a way in Chinese. Nodding happily, he assured me that he could, and we went into a long conference about how to interpret the words *Ben Shahn* in Chinese. *Shahn* is easy enough; it is one of the common Chinese words and means "mountain." *Ben* was not so easy but we worked it out with great laughter and agreement on both sides.

On the following afternoon I returned to the shop. The sign was finished, the immense size just right, but I was profoundly disappointed by the image. The ideograms were stilted, hard and seemed to possess none of that rather violent and very fluid quality of the signs that I had most admired. As I seemed hesitant, my friend became quite crestfallen. He could not understand why I was not pleased; he had executed the words so carefully. I didn't want to hurt his feelings, but at last I took him to one of the original signs and pointed out the rough edges and the fiery calligraphy, explaining that it was all that that I liked so much.

His face cleared. Now he understood. He himself could not make such signs. He had them made by a special sort of person, a friend of his.

Well, could the friend make such a sign for me? That depended upon when I would have to have it. Tomorrow? No, tomorrow would not give him enough time. The friend could not make such a sign at just any time; he had to be in the right mood. Sometimes it would be days or even weeks before he would be in the right mood. He had to prepare himself and work up to it, and then sometimes he could make any number of them, one right after another.

I told the sign painter to let his friend take all the time he needed. I came back the following day; no sign. No sign the second day. On the third I began to think I was being hoaxed, but I returned to the shop anyway. My friend was all smiles; the sign

Ben Shahn

was ready. We looked at it together and agreed that it was perfect. To me it was a revelation.

On that night I bought some writing materials and several books of instruction, and I began to try to make the ideograms, to learn how to combine them and to read a few. My calligraphy, for all my vanity, looked like a lame man hobbling on crutches among dancers. I resolved that I would try just one figure, and work on that for a year, if need be, until I knew it so well that I could execute it with my eyes shut. As with the other kinds of letters that I had learned, I began to know some of the common elements, to learn their characteristic turns and flourishes, and to combine them. I am still not master of a great many ideograms, but those few that I know, I love to repeat. And in them more than in any other letters or figures that I have seen, I have sensed the element of timing, of the fast movement and the slow, the deliberate and the rash—that wonderful progression of time and movement that continues to reside in the figure after it is made.

Oriental calligraphy is highly honored even in the West, and has exercised a very strong influence upon Western art. In the East, where esthetic and religious principles are so highly fused, calligraphy is a very real factor in the public sensibility. Every household displays one or more scrolls of writing, and such scrolls are not passed by as anonymous items of furniture, but are treasures greatly admired and much discussed.

The ritual procedure of guests arriving at a Japanese home, after greetings have been exchanged, is to move immediately to the niche were the flower arrangement has been set, to examine and admire this and the calligraphic scroll which inevitably will hang there. Such scrolls may vary widely, some being ancient and priceless, and often undecipherable to the owner. Others may be relatively contemporary, but all are beautiful, and all display the magic deftness of the Japanese hand.

This art is, of course, action painting par excellence. It is amusing to trace the curious, I should say ironic, migrations of this wonderful esthetic principle. Japanese calligraphy produced its first effect upon Japanese art itself (or vice versa). Indeed, the two expressions are so close as to merge often into one art. I have a scroll that comes from the sophisticated collection of the artist Tetsuo Yamada. This is a small poem concerning someone's birthday and three cranes. The paintings of the cranes and the words of the poem are quite indistinguishable; all are calligraphic, and cranes become words, and the words, cranes.

In those nature paintings, so slight and yet so evocative, birds in the wind, reeds in the wind, are presented not as careful studies of objects, but rather are painted with the motion that the wind makes. Water coming over stones is much more the motion of water than it is a study of water. The hand long practiced and deft at calligraphy turns naturally toward calligraphic drawing and painting.

When Oriental art first began to appear in the West, artists were strongly affected by it, and sought to emulate the fluid forms. The hand and wrist were not there; Western imitations of Oriental art were only embarrassing. But as art in the West freed itself of academic restraints, a new understanding arose. We could never emulate the lightning-fast and yet controlled hand of the Oriental, but we could achieve fast and slow movements, rhythms in which control was not a factor. We could and did; Pollock, Mathieu, particularly Franz Kline have created memorable images in such motion.

The Japanese are today unstinting admirers of the West. Whatever we do seems to them interestingly modern, and if I use the word "ironic" in connection with the migrations of calligraphic art, it is because the Japanese are today emulating a kind of action painting which is indeed our own adaptation of their brilliant calligraphs. They have renounced the control that introduced the element of pure magic into the older work, but even so they are honorable heirs to action painting, however greatly they may have been influenced by the West. (As they are also natural heirs to abstractionism and the textural modes in art, both of which are old in the Japanese tradition.)

A wholly different calligraphy that is pleasant and interesting to ponder over is the often erratic calligraphy of various friends. I always put away for further perusal a letter from Robert Osborne, who is one of our most calligraphic draftsmen. I come across these Osborne letters everywhere—in the glove compartment of the car, on top of a row of books, in drawers, almost anywhere. Re-found, they are likely to be re-read and moved to a new place. I cannot imagine throwing away such a letter. Written in a big exuberant hand, profusely illustrated, these letters are incredibly expressive and a joy to have. I have other letters that I am inclined to treasure too; one from [Abe] Rattner that is highly rhythmic and has a painted quality, and letters from [Leonard] Baskin, minuscule and mysterious.

Then there is the poem that William Carlos Williams once wrote for me on a mouse-eaten piece of paper that had been made by

Ben Shahn

Maillol, the poem in that scrappy hand that poets are so likely to affect (or to practice unwittingly) but that is, to say the least, highly personal.

I often wonder how many poets write in longhand; it would be interesting to know. One might surmise that verse written to the staccato clack-clack of the typewriter might differ enormously from that written in the noiseless and rhythmic movements of the hand. Ogden Nash claims to have broken the sound barrier in his verse. But I wonder, after all—was it he, or was it the typewriter?

I know a novelist who has written several long works in longhand, and this seems quite a feat until one recalls that prior to the present century, or a little earlier, everything that was written at all was written so. I myself like very much to write things in longhand; in this form they seem to me more intimate and more real. If I come across a passage in a book, or a piece of verse that I want to make my own—as some people make such things their own by memorizing them—I sometimes write it in longhand. And I like to incorporate such script in paintings.

I realize that such a practice tends to roil the people who believe that painting should remain strictly within the confines of its own parish. But I believe that sensitivity is not departmentalized, and that art itself is not to be confined within hard boundaries. The inclination to see, to feel, to hear, to apprehend and understand form, to make new shapes and meanings out of the materials at hand, is simply a human capacity, and it appears in all sorts of unpredictable ways. I am sure that before Calder, few scholars would have included motion in sculpture. And before Hindemith, I feel sure that the non-instrumental sounds he first used would have been rejected as being outside the scope of music. The young artist Tony Schwartz has begun to create an entirely new art form out of the incidental sounds of city life. There are no barriers here; there are no defining walls around the perceptions of the imaginative and creative person.

Letters and lettering, too, are circumscribed by rules, departments, and even hierarchies. These may be the principles of shapes and spaces developed over long periods of time by the individual letterers, discoveries that later became written into the rules. Or they may only fix the traditional use of letters, determine appropriateness, often outlawing certain forms as being gauche or having an improper flavor for certain uses, sometimes going so far as to prescribe a certain style for a given use—the inevitable script of the wedding invitation, the inevitable girder for the circus advertisement. To develop some new style is a challenge to ingenuity

Graphics 161

and to mastery of the basic principles. But any such style is likely to be well within the accepted boundaries of lettering.

In the casual roadside signs I spoke of earlier, which are the work of amateurs (they might be called "the unlettered letters"), one can see the violation of every rule, every principle, every law of form or taste that may have required centuries for its formulation. This material is exiled from the domain of true lettering; it is anathema to letterers. It thins letters where they should be thick; it thickens them where they should be thin. It adds serifs where they don't belong; it leaves them out where they do belong. Its spaces jump and its letters jump. It is cacophonous and utterly unacceptable.

Being so, it is irresistibly interesting. I had first used it long ago, somewhat humorously, for color and sense of place. Inevitably, one begins to study the relationships in any lettering one uses. For all its freedom from the rules, there appeared to be certain consistent patterns in such lettering. It seemed to me that perhaps this was a sort of folk alphabet, and that one might do well to study it more carefully.

I first used the amateur or folk alphabet very seriously in making a print concerning Sacco and Vanzetti. I wanted to use the entire text of the historic statement of Vanzetti, the tragic words ending with ". . . that agony is our triumph." I wanted the words to be pictorial in their impact rather than to have a printed look. And I wanted them to be serious. The folk alphabet seemed appropriate to the halting English as well as to the eloquent meaning of the words. Furthermore, this alphabet, with its unfamiliar structures, halted the reading somewhat and produced a slower effect, and all this seemed to me desirable.

I found the alphabet appropriate again in a big poster that I made for the Jazz Ballet [Jerome Robbins's "New York Export—Opus Jazz"]. I had always sensed in it a jazz rhythm, broken and staccato. Often, I used it simply to pique the experts, but only if I felt it right for the given space. I used it increasingly and then, to my amazement, began to see it used by others. An editor friend of mine, speaking at an American Institute of Graphic Arts affair, said, "Shahn is a subversive! He has subverted you all. You all used to have some sense of letters and lettering; now you are all using *that* alphabet!"

From time to time, I return to the older forms of lettering, the medieval church letters, or the classic Roman, perhaps just to show myself that I can. Thus, the German letters that I made recently for the "Dreigroschenoper," the cover and title page for an

Ben Shahn

Ecclesiastes that I've been working on. These were a return to perfectionism.

For, as Rabbi Abulafia continued, "Cleanse thy clothes, and, if possible, let all thy garments be white, for all this is helpful in leading the heart toward the fear of God. If it be night, kindle many lights until all be bright. Then take ink, pen, and a tablet to thy hand and remember that thou art about to serve God in joy of gladness of heart. Now begin to combine a few or many letters, to permute and to combine them until thy heart be warm. Then be mindful of their movements, and of what thou canst bring forth by moving them. And when thou feelst that thy heart is already warm, and when thou seest that by combinations of letters thou canst grasp new things which, by human tradition or by thyself thou wouldst not be able to know, when thou art thus prepared to receive the influx of divine power which flows into thee, then turn all thy true thought to imagine the Name, and His exalted angels in thy heart as if they were human beings sitting or standing about thee. And feel thyself like an envoy whom the king and his ministers are about to send on a mission, and he is waiting to hear something about his mission from their lips, be it from the king himself, be it from his servants. Having imagined this very vividly, turn thy whole mind to understand with thy thoughts the many things which will come into thy heart through the letters imagined. Render them as a whole, and in all their detail."

IX aesthetics

"Artists are people who make images," Shahn once told the convened members of the American Society for Aesthetics. He continued, "Aestheticians are people who tell other people why artists make images, and what the images mean. They also tell people why they—the people themselves—either like or do not like the images that artists make. For reasons best known to themselves, artists and aestheticians rather sedulously avoid each other's paths." The aestheticians, however, did not avoid Shahn. He was constantly in demand as a speaker. Following are four of his most important talks.

Paul Klee *Ben Shahn*

A week or so ago I sat with a jury for the Pennsylvania Academy show. There came before us a number of what might have passed for Klee paintings; Klees, except that the hand was heavier; Klees, except that one's face didn't brighten, somehow, when one looked at them; Klees, without the unfaltering innocence of Klee.

Aside from the embarrassment which one must feel at such times, I felt also a deep regret that Klee, the painter who had so much to give to other artists, should have had to be robbed!

What I should like to accomplish in this discussion is to make clear somehow what the gifts were (or are) that Klee has passed on to us—what he ought to mean to other artists.

Looking at his paintings and drawings should, I think, do more than merely enrich us with *his* images, *his* amusing devices, his gently mischievous interpretations of ponderous classical things, it should serve as a sort of preachment for artists—well, for other people, too—to open the doors upon some of our own inner vistas, that mysterious scenery from which so many of us are shut off by some sense of humbleness, or unimportance, or possibly by the devious workings of our inhibitions.

For Klee, I think, more than any other artist, has given us the depths and reaches of his subjective life. Whoever knows his work well, knows him; knows what he thought and felt about life. Therein, of course, lies the preachment. For every artist, if he has nothing else—not even an Eames chair—has that thing; a wholly separate and individual self with his own dreams and passions, its unique landscape unmapped and unexplored—peopled with shapes and forms unknown to others. And that private, unknown self, wherever it has been realized well, in paint, sculpture, music or words, has been of unceasing value and wonder to others.

The Klee-influenced submissions for the Pennsylvania show did not, unfortunately, reveal new personalities seeking new ways of expression. They were the old personalities who, this year, had abandoned Picasso, or Mark Tobey, Tamayo or the other great innovators, and had, as you might put it, "gone Klee." There were, I guess, about thirteen such paintings. Some affected the styles of Klee; some rearranged his characteristic mannerisms; some lifted passages outright from his work.

What kind of miscalculation lies behind such painting I can't

From a symposium at The Museum of Modern Art, New York, Spring, 1950.

Aesthetics

guess. But in each case one may know that the artist has rejected his most valuable asset—himself—to ape whatever artist he believes to be man-of-the-hour.

He has repudiated the gift that Klee might have given him—that is, a reassurance of the worth of his unique personality. Klee might have told him that style and form are secondary, and that the artist's *first* need is to communicate, or just merely realize, that which moves him.

Nobody ever painted like Klee before, and it seems to me unnecessary that anyone ever paint like him again. His styles of painting grew out of the necessities of mood and imaginative content. More than anyone else he reaffirms an old heresy of my own—that form is merely the shape taken by content. Where content is highly subjective and highly personal *new forms* will emerge. That is the unceasing wonder of really good art. And that (and not a trick of weaving ribbons of color) is what Klee ought to mean to other artists.

Another facet of Klee's work—which, incidentally, must have been part of the development of many painters—has to do with certain unexpected areas of paint which appear during the working of almost all pictures. These areas, although they combine the artist's own color and workmanship, are still *unplanned,* and are sometimes almost mysterious to him. When such an area is good the artist is likely to guard it carefully—whatever other changes he may make. If it is a poor, atonal spot, he may say to himself, "Now, how the hell did I come to do that?" and quickly obliterate it.

Not many artists give serious thought to such accidental areas. I think that Van Gogh, for instance, did. In his earliest works there is little either of light or of movement. But as these qualities appeared he retained and developed them—at first slowly and painfully—to achieve finally the tremendous fire of movement and color which was necessary to his intensely emotional nature—and by which we know him.

To Klee, I believe that such unexpected areas—not only the good ones, but also the discomfiting ones—were matters for great exploration. He studied their pattern and their look to find out why they affected him as they did. He was vividly alert to the sense and mood of such forms and shapes, and their meaning never escaped him. Out of such areas he evolved his thousand-and-one styles, so unlike in texture and yet so unmistakably stamped with his personality. Herein, again, I feel that he has much to give to other artists—in that all his styles emerged *out of his own work.* None

168 Ben Shahn

reflects to the slightest degree a coveting of the eminence or achievement of other artists.

Klee lived at a time when Europe was swept by more "isms" than most of us could catalogue. A highly sophisticated painter, he was aware of them all. Yet his work bears the stamp of none of them. If they affected him, and I daresay they did, to some extent, it was not to deflect the course of his own work nor to make him doubt the validity of his own feelings. Such art currents were, instead, absorbed in Klee's work, enriching it, giving it a turn here and there, but never rendering it spurious. They say that the invading armies have never succeeded in taking China, but have only themselves been absorbed. I think that the invading art ideas had about that effect upon Klee.

Another preachment that we can make about Klee is his want of pretentiousness. Any survivor of art jurying will tell you that his most desperate moments have been those when he was confronted by one of the outsized oeuvres which dwarf everything else in the room and the emptiness of which is heightened by sheer acreage. I obviously have no quarrel with large paintings, if they have some purpose other than to impress, but imitation is triply disconcerting when it is triply sized, its emptiness increasing with the square of the area. The thing that we aspiring artists ought to note about Klee is that, given his admitted stature as an artist, his paintings are small, intimate and unpretentious. I believe he once said that he never painted pictures that couldn't be done within the radius of an elbow! Yet there is so much of amazement, surprise and wonder in these small works of his!

Now let's invoke Klee in opposition to the great modern search for Formula. Artists come to me—as I know they do to other painters—looking for secrets in paint-mixing, secret procedures, secrets of materials and design. This attitude reflects, I know, our present-day belief in technical processes, our abiding faith that American know-how makes us a better people.

I always try to point out, in answer to such queries, that technical processes in art (in life, too, for that matter) must remain subject to intuitive and humanistic ends. That the failure of this principle is the curse of the world today (and that goes for *both* sides of the apocryphal curtain) I won't go into. But wherever technical processes do become paramount, society—or art, since that's what we are talking about—becomes deranged. Klee was certainly the most intuitive of artists. And the great technical skill which he had was solely this: a deft means of realizing his inner visions.

I imagine that Klee must be the bane of the truly professorial mind because he defies classification. His surrealism antedates Surrealism proper while such work of his as might be called "Cubistic" is, at the same time, Surrealist. Precursors of all the "isms" which we spoke of may be found among his early drawings and paintings. The Maze, The Monster, and The Order are all there, but *out* of order. Before Futurism exalted the machine, Klee had turned it into a fairy tale. Before the Dadaists had proclaimed themselves as a cult, Klee had exploited such ideas as theirs with a subtlety which they never achieved. Although he was allowed to join Kandinsky and Marc . . . in 1911, he had painted such Expressionist pictures as the *Musical Dinner Party* as early as 1907. Of course it's my private belief that any good art evades classification; Klee gives particular comfort to that belief. I want to finish with some emphasis upon still another gift which Klee might pass on to other artists—that is what may be called "innocence of vision."

It's one of the odd contradictions of life that considerable sophistication is necessary to seeing with a truly naïve eye. By that I mean that all of us, though we may have been born with "pure" vision, have, by the time we've reached adulthood, acquired such a confusion of handed-down values, prejudices and visual habits that we have no notion of how we would see things if we could look at them naïvely.

In 1902 Klee wrote: "I want to be as if born again, knowing nothing of Europe . . . " and so on. I think he achieved this artistic summum bonum as few others have. And whatever we may admire of his wit and poetry, however much we may be delighted by his ingenious images, the one attribute of his we should really seek to acquire is this ability to see with a fresh eye.

Realism Reconsidered *Ben Shahn*

An artist about to undertake any discussion of art immediately places himself in a poor position strategically. The scholar of art, the critic, the aesthetician, the historian, bears no personal responsibility for the work of art which comes under his purview. He investigates and makes judgments from a position of Olympian hindsight. He may enjoy his dinner, sip a brandy or so, smoke a cigar, and then, looking backward over the eras, tell us what realism has been, and what art has been.

Talk given at the Institute of Contemporary Art, London, February, 1956.

Ben Shahn

Or he may move on to drawing room or atelier where the work of art awaits—a fait accompli, to be vindicated, or destroyed. It belongs to this aesthetic—or to that; it has too much realism—it hasn't quite enough. It is art—no, it isn't art!

No such ease of mind attends the artist. He has only uninstructed foresight to guide him. He looks into a blank vista where no work of art exists; his is the responsibility to create one there. He has to create an aesthetic, too, and to create reality where none now is. Whatever opinion he offers about art must be based upon a future perspective, not a past one. He may be in doubt about his dinner, too, or, if he has one, not be able to eat it.

An artist, then, must have some rather burning reason for his interest in political art. His reason cannot be very materialistic—obviously—for it is quite unlikely that his pictures will bring him much material gain. Apparently he has a mission of some sort when he undertakes to paint a picture. He will no doubt have considerable struggle with it. Certain effects or elements will have appeared in the half-finished work which he will not want and which must be done away with. No one but he can know what elements must be discarded. A corps of scholars could not instruct him; a roomful of aestheticians would prove barren. And yet the artist does know, and has always known.

So, if we may recapture for the artist himself some small beachhead off the vast continent of art, perhaps we may go on to consider the realities and realism not only in a past, but somewhat in a future perspective.

First, let us make this clear, that when any painter has wrestled with a canvas for hours—or days—or even weeks—and has finally won through to a finish, there is only one reality for him, and that is his picture. All other things have faded back into the periphery of consciousness; there is the vividness of paint itself; the wonderful presence of color. There are the shapes, figurative or non-figurative, with which he has lived with such intentness that he knows them better than his most intimate companions. Perhaps he has doubted some area—let us say, three small figures in a background. He has painted them out, repainted them, moved them, altered their color or form. Finally, perhaps he has rendered them half-transparent or fragmentary, and now they are right. Now they provide just the proper play between foreground and background. Now also, they have become unaccountably dear to him; they are even himself; they are the very essence of reality.

But that of course is reality; real-*ism* must be something more; the profession of reality; reality as an objective in painting.

Aesthetics 171

Let us, with Puritan honesty, try to find out just what realism is. We might begin with Webster (that is, the American version of the *Oxford Dictionary*). Webster defines realism as "fidelity to nature, or to life." Both life and nature, of course, have myriad aspects—a complication which Webster doesn't touch upon, but I shall.

Perhaps I might make a painting of this present room with all its people, precisely as I see it from here. That would constitute realism for a great many people. But what egotism! For that would be only a perspective view—perspective, the strictly personal, limited, one-sided view of reality!

The Cubists attempted to probe that kind of realism. Dissatisfied with the half-truths of academic art—with the half-woman, the half-vase, the roomful of one-sided objects—they sought to pictorialize the fuller view, thus introducing the era of segmented forms—objects in section, light and shade, the realism of the whole.

Let us say that I paint a tree—conscientiously—from my perspective view; that would be one aspect of truth, I suppose. Or I might paint it from several views, combining them; that might be another.

A botanist and a physicist may well challenge me: "Come now, that's an incredibly superficial account of a tree!" The botanist: "You must give some indication of how the tree functions—how sap is carried to the leaves—how chlorophyll is manufactured—some sense of growth!" The physicist: "You've given us nothing of its complex atomic structure. Can you ignore photosynthesis?" Truth! Realism!

Perhaps patiently, like the man who carried the donkey, I will try to please everybody, and attempt to create the new versions of reality. But I must do so at the expense of true perspective or even of Cubism.

If there is a physicist among you, he is likely to say, "It all depends upon your frame of reference." Let us now examine "fidelity to nature or to life" in that light.

We now have quite a series of paintings. We have the perspective view of our room, with people. We have one tree *à la Cubisme,* one botanic tree, one atomic one, and so on. We now exhibit them to a Marxist friend who promptly comments, "What's that got to do with the class struggle!" He goes on to set me right: "This art may bear some resemblance to real things," he says, "but art is a weapon. The only truly realistic art is that which promotes the cause of the proletariat."

172

Ben Shahn

I turn to a psychologist who disagrees with such a view. He applauds the art of Dali, or Ernst, or Yves Tanguy, "because," he explains, "the realities, those that actually exist—that affect our behavior and our lives—lie in the subconscious surrealism, another level of realism.

Still seeking enlightenment, I carry my pictures to a philosopher who studies them and offers the following opinion: "Your pictures may show reality in its parts, but they contain no sense of underlying meanings. I see in them no search for any ultimate truths; I cannot determine by looking at them what you yourself think about anything! And now about values? They seem to create none; they assume none on the part of the observer. Do you exclude value as a reality?"

A priest (who has come to offer extreme unction) adds his comment: "Your paintings are mechanistic; they provide no hint of the grander scheme of things, the unfolding of Divine Law. That is reality!"

A critic comments briefly: "The trend is toward non-objectivism in art. Where have you been for the last fifteen years?"

I have a chat with a fellow artist who appraises the work thus: "Your color is not bad. Some of the forms are original, but not organized at all—that *is* bad. Texturally, your work is dull. In the final looking at a picture," he goes on, "no matter what you are driving at, the only thing you can achieve is *visual*—colors, shapes, design, paint—impact. If you haven't got that, you have nothing!"

I certainly cannot disregard what the artist has told me. It is quite true. But, then, so is there truth in the comments of the other advisers. We might move on to consider some professional views of realism.

Within the last decade or so, realism, as a part of art terminology, has suffered a rather seedy existence. As the new aesthetics of the isms gained popularity through the most prolific and passionate body of exegesis that art has ever known, the once unassailable catchwords of the academy fell low, and were ostracized from the society of the polite and the well-informed.

Such academic axioms, for instance, as the concept of verisimilitude (sometimes called realism) or truth-to-nature, was now ousted from its high place in gallery or museum to go begging about in country lanes or other remote places, never making a reappearance in informed circles except in some quaint and rustic guise as that of primitivism, or folk art.

Beauty itself—another of the cast of the once-great, now re-

duced to rags—has gone begging from door to door, sometimes taking refuge within some such alien art as mathematics or medicine, reappearing only in company with some more acceptable companion, as in a "beautiful equation" or a "beautiful incision."

Academism itself came to mean, not the circumscribing of art by a series of rigid precepts, but rather a particular kind of aesthetic, having realism as its objective. I have somewhere—in an incautious moment—suggested another word, "pedantism," to indicate the same sort of academic rigidity as it applies to art today—dictating the modern aesthetic—proscribing from art any deviation from the present convention. But of that I will have more to say a little later.

So realism too has fallen from its position of high esteem, carrying today some slight innuendo that perhaps everything isn't just as it should be.

Today realism is used mainly *about* artists rather than *by* them. We had several years ago in New York an exhibition which was assembled under the title "Magic Realism." The term is thus used in a kindly way to designate that supernaturalistic sort of art which may sometimes project ambitiously forward out of its frame, or that kind which brings every detail of a picture into sharpest focus, so that every point seems to be the high point. The term "magic realism" seems to allow that the artist did well within his limitation, but that neither critic nor sponsoring museum will betray an undue enthusiasm for the product.

Then there is "moral realism." I am not at all sure as to what is the distinguishing feature of moral realism. It has a solemn sound like the "Stern Daughter of the Voice of God," and somehow doesn't sound at all like art. But it is a noose in which I have been hung from time to time, and with all my struggles and protests of "not guilty!" it seems they will not let me out.

Once the charge is in print, I gather, there is no redress.

An even more marked note of opprobrium attends the term "social realism." This designation is for artists who betray an unbecoming interest in politics, or who make pictures of the undernourished, or men wearing overalls.

It may mean that the artist conceives of people as a mass, or that he feels that no subject is worthy unless it has some mass application; or it may mean that the artist has no personal private convictions—that he is a pictorial functionary for bloc thinking—to which he is perfectly willing to bow.

The complicating factor in the evaluating of social realism,

Ben Shahn

however, is the fact that so much art is relegated to that category without the acquiescence of the artist. Social realism is a term much more popular with critics than with artists. It is frequently used to write off the intransigent movements in art, and it is not infrequently used to disparage all art which shuns the abstract-nonobjective aesthetic.

As the authorized aesthetic of Russia, social realism has been singularly unproductive. A recent piece in the *New York Times* quotes a number of complaints about art from the Russian press. One of these assails "Scholastic formulas by which all forms of Soviet art have been made to reflect the Communist Party's social-historical line" and goes on to say, "Few monumental artistic works of universal importance have been created in the postwar period. . . . We still have mediocre inartistic works that prove their authors are trailing behind events. Knowing life only superficially, and unable to understand its laws, they gild reality, minimize our difficulties, and do not show our shortcomings truthfully."

One can observe sadly that the seeds of the new mediocrity lie within the criticism of the old. That, until the Soviet artist is free to seek truth and create wherever he happens to see it—whether he happens to find it in the love-life of the cricket, in the inner soul of the social maverick, or in how many angels can stand on the head of a pin—until he has that degree of freedom, his art will present the same degree of emotional grayness and unconvinced socialism as it does today.

If social realism seeks to impress upon art a rigid aesthetic of subject matter and point of view, there also exists another opposite camp which seeks with equal rigidity to exile from art all meaning—to keep it free from any content whatsoever.

That is the camp of pedantism.

The pendants are the masters of category. (They are usually Masters also—or Doctors—of the Fine Arts.) It is their distinguished task to pass on to the young and the uninitiate understanding and appreciation of art. While they do not themselves paint extensively, they have usually done some painting—either through a youthful impulsiveness, or the better to get the feel of their subject, or the better to prepare themselves for teaching, criticism, or holding some sort of museum job.

To do well, to advance properly, the art historian, or pedagogue must be highly knowledgeable, know the trends, be a pace-setter, and must necessarily publish. For as we say, "publish or perish."

It is often said in America that education is our leading industry.

That is, to my mind, good. And it is also good that in that enormous educational activity, the teaching of art holds an honored place.

But, to be taught, it is necessary that art be highly departmentalized. Thus it is thrust into all sorts of classes and categories—of meaning, of era, of place, of good and bad, of aesthetic persuasion, and often of the finer points of scholarship. Such categories, at first devised, no doubt, merely to provide some sort of geography by which the student or art lover may find his way about, tend to become fixed—to be regarded as fact rather than theory.

Thus a very handsomely turned-out book which, I think, was not written in too much seriousness some five or six years ago, has now become canonical. It departmentalizes a few of the (then) latest trends as follows:

First, it gives us Expressionist Biomorphic, which is described as "irregular-shaped forms and calligraphic interlacings bearing, if any, a relation to organic or anatomical forms; composed, usually, in dynamic, symbolic, or emotively suggestive relationships; often showing an automatist, or 'doodling' origin."

Category two is Expressionist Geometric, and not at all to be confused with category one, being "Space usually treated three-dimensionally and often in a vibrant and pulsating manner, reflecting the inward and outward tensions and thrusts of the forms within the space."

But we have hardly begun. There is Mechanical Geometric, which is "Space treated two dimensionally"; then on to category four, which is Pure Geometric, and then we have Naturalistic Geometric. And thus we begin to get something that can be taught, something that the student can get his teeth into, something upon which he may be examined.

Looking over our catalogue, I observe that we now have a fine new set of categories, and that such individualistic old-timers as Charles Sheeler, Demuth and Niles Spencer (perhaps unknown in England, but well-known to Americans) have now earned themselves a category and an "ism"—Precisionism. One gathers that time has been saved, for while the several styles of work of these men seem to have nothing in common, and would thus require individual scrutiny, now obviously, they may all be lumped into one category, thus practically eliminating the need to look at the paintings at all.

And we go on to new mysteries; abstractionism has broken into waves: One, Two and Three, which only the hopelessly confused would mistake for Geometric Abstraction or Abstract Expression-

176 Ben Shahn

ism. Then we have Realists, Romantics, Pure Painters, and something called Social Content—not to be confused with social contentment.

I cannot think of any sensible reason why pedagogy, and scholarship, should lean preponderantly toward the non-objective forms of art, but that does seem to be the case. And, as journalism follows the lead of scholarship, there seems to be a growing espousal of non-objectivism, along with a collateral (and sometimes highly emotional) repudiation of art with meaning or content.

I don't believe that tendency is confined to any single country; it seems to be fairly universal.

Perhaps the literary plasticity of non-objective art lends it an irresistible appeal. No piece of art in which meaning was stubbornly embedded in symbol could, for instance, possibly lend itself to the following bit concerning the painter George Mathieu: This, from New York's *Art News:*

> George Mathieu lives completely in the abstract insofar as it is worthy of that name, twenty-four hours out of twenty-four. I think I can say that, outside of certain problems of logistics and long research, and meditation on the culture of the Capetian Monarchy, Mathieu regards everything as totally absurd and shows this continually in his behavior, which is characterized by the most sovereign of dandyisms. He understands with complete lucidity all the dizzying propositions in the inexhaustible domain of the abstract on which he has staked his whole life, every possible type of Humanism having been rejected. Carried to this degree, to this power, if I may use the precise terms of mathematics, the act of painting has become for him a means to knowledge.

Not only does non-objectivism invite colorful rhetoric, but it also provides interesting material for scholarly speculation. I have been assured by one avant-garde critic that the austere horizontal-vertical discipline of Mondrian's painting might be attributed to the celibate's aversion to the roundness of a woman's breasts. Another critic, frequently read in the little magazines, proposes the theory that the entire gamut of emotions has been exhausted in art, and that there is nothing left but pornography. A very serious art historian has explained to me that the real significance of such work as that of Jackson Pollock lies in a space-time continuum— of which the work is a manifestation. "Any effort of will on the part of the artist," my historian explained, "any exercise of thinking or intention would interfere with the free flow of cosmic forces."

Another inviting aspect of such art may be its dependence upon

the critic and theorist. My space-time historian has also assured me that it is not within the scope or function of the artist to understand the meaning of his own work. He merely paints—he does not know why—and the more capacious mind of the scholar is left to cope with the work.

Many visually exciting, even intellectually exciting works have emerged from the great volume of non-objective art, but today it has reached what might generously be called a plateau. Despite the best efforts of its artistic horticulturalists, the fruit hangs limp upon the branch.

But non-objectivism, too, makes its claims upon realism. One summer day I sat in the garden behind New York's Museum of Modern Art and eavesdropped on a sad little conversation between a young man and his girl friend.

"You simply don't understand what realism is," he was saying, "Abstract art doesn't just slavishly copy outside reality; abstract art creates reality!"

The girl was quite annoyed by the conversation, and tossed a coin onto the metal table. "Reality!" I heard her say, "That's reality!"

Reality is no doubt that which impinges most forcibly upon an individual. I am sure that to the banker, the world of finance is vividly real, while to the poet it scarcely exists at all. To the shoemaker, reality must be a wholly different matter from the reality, let's say, of the salmon fisherman. To three-quarters of the earth's population, I am sure that reality is the eternal cry for food, whereas to diplomats, who should be deeply concerned with such a situation, reality consists in notes and cautious language, meetings and maneuvers for positions of strength.

For, whatever the realness and stability of the outside world, man has only one access to it, and that is through the mind and the senses. We recognize objects and assess circumstances in the light of those impressions of experience which are retained in the imagination. Thus reality, whatever its outside life, is for the individual *subjective* and *interpretive,* its *meanings* residing within the whole context of his experience.

But there are constant meanings—meanings that are held in common by great sections of the population. Such constant meanings must necessarily exist in symbol form—that is, in objects or sounds or images which have been formulated around fixed meaning. Such are the symbols of mathematics, the images and sounds of words, certain edifices—the bank, the church, the schoolhouse —the written language, and, like money, the meaning of which is

Ben Shahn

also symbolic, such meanings or symbols may be passed from person to person as common tender, retaining substantially the same significance for all who use them.

It is to this order of reality that the images of art belong. Direct impressions of nature and events may be evaluated differently by all people who experience them. But a value is implicit in any work of art, which might be called a symbol of this sort of an emotion, of that sort of an attitude. And while I would concede that the public estimate of the work of art varies greatly, still the work itself remains constant. It is formulated around a belief or an intention, and persists as the symbol of that intention.

So it is through the arts, through the symbolizing of the great legends, the religious stories, the images of compassion and great emotion created in painting, sculpture, literature, and other arts that civilizations have acquired and retained values in common.

Reality then, we must own, leads many lives. Reality exists objectively in things and events, and subjectively in man's imagination. It fluctuates in the interpretations of things, and remains constant in the symbols of things. In the world of art, reality includes classifications as well as works of art. For the art historian, it is the entire panorama of existing art. For the artist himself, it has still another dimension—a future one.

Then there are two different attitudes toward reality which I think have some pertinence for art, and which I would like to discuss somewhat. The first might be called the *realistic* attitude, the second, the searching, or *truth-seeking* attitude.

The realistic individual, as we all know him, is inclined to take a somewhat laissez-faire view of life. He is not given to self-deception, is likely to be honest with himself even as to where his own interest lies. He does not plague himself with vain fancies of how things ought to be, or might be. He takes a hard and honest view of reality as it appears to him; he makes it his business to cope with it as it is.

The truth-seeking individual is one who must needs see within reality an implicit deeper reality. He cannot be content with the surface appearance of things, but must probe beneath the surface to discover *why* they are so, and indeed often *whether* they are so.

The truth-seeker has from time immemorial been a thorn in the side of the realist. Never content to let well-enough alone, he continually probes, examines, explores and so undermines the existing state of things. The truth-seeker is thus always on the outs with the better-entrenched elements of society. He has been crucified—exiled—thrust into dungeons—burned at the stake—pilloried—os-

tracized—and finally subpoenaed. But nothing seems to cool his ardor; his probing of reality continues.

The truth-seeker, once he begins to discover those underneath the surface, perhaps implicit truths, once he has gained some sense of enlightenment will not feel impelled to formulate that enlightenment into some sort of reality. Perhaps he will want to communicate his meanings by oratory or leadership; perhaps he will preach a gospel; perhaps he will write a *Republic,* a *Principe,* a *Wealth of Nations.*

Perhaps such an individual may be a builder, and envision as a possibility a sculpture of the dimensions of a temple; his vision may be so insistent that he will throw into its realization the lives of thousands of men—and create a *Sphinx.*

Or the sculptor himself may be restless and dissatisfied with the gods and heroes produced by his fellows. In his mind's eye he sees a very perfection of human form. He creates a *Hermes,* and imparts to later generations an inerasable value—a sense of beauty in the human form.

Or let us consider a decorator of churches who lived in the thirteenth century. He feels the presence of personality, feeling and humanness in the individuals of the religious legend—something more than the rigidly abstract symbols of saints that dogma has passed down to him. The artist may be Giotto, who would introduce into art just that careful observation of character and humanness which contemporary art is at such pains to abolish.

Then, of course, there is the reverse side of the coin, the intolerable presence of non-truth, of falsity, of debasement. The truth-seeking individual must needs formulate what he sees into some action or image. Perhaps he will only become a hermit. Or perhaps he may go into politics; or he may write *The Hollow Men,* or paint *The Entry of Christ into Brussels.*

Jacques Maritain makes a distinction between the truth-seeking individual and the practical man, grouping all the creative kinds of man under the latter—the practical. It seems to me that the differentiation lies elsewhere. For truth-seeking is an essential aspect of creativity. It is through that restless dissatisfaction, that seeking for realities below the reality, the questing for principle, for the true way of things, that the artist gains that sense of personal enlightenment which, in turn, becomes the compelling force in art. I believe that it is just that sense of urgency which constitutes what we call motion in art.

But that is not to imply that art must fulfill some appointed task, or bear some unwanted torch. Truth in art—even as in the sciences

—is unqualified; it is above expediency, or prior commitment, or special ends. It is only where the free intelligence finds it. Whether such truth is on the most trivial level of existence, or on the most humanly profound level, its artistic discipline is confined to its own intentions—not to irrelevant social aims—not to irrelevant aesthetic strictures.

The significance of truth-seeking either in or outside of art does not lie in the finality of principles or truths discovered, but rather in a kind of dedication, an ability to be attached wholly to objectives outside any self-concern; to be devoted to an idea for its intrinsic merits, for what appears to be its worth. I am sure that many of the truths of one century—the economic ones—may be invalidated by the events of later centuries, but the character of artistic truth with its thorough dedication does not change. It remains innate within the work of art.

What kind of truth, then, we might ask, does art actually discover? What truths does it symbolize?

Truth in art, first, consists in those qualities which are not immediately discernible in things. It may consist only in a fresh evaluation of the familiar; it may imbue a face, for instance, with unwonted intensity—as Rouault creates of his own self-portrait an image of introspection, imbues it with the surprising religiosity which one might expect only in a Christ face. Or, consider Morris Graves's painting of a bird singing in the moonlight. Graves has made much of what might seem a trivial moment, and has captured a sense of infinite solitude, returning man to his inner self, concretizing an inner truth.

But how much of art is fantasy? And doesn't all fantasy display irreverence for truth? Again, one might contrast reality with truth; fantasy displays irreverence for reality only. Fantasy takes on its meanings in the light of underlying truths and belief. Iconography has given us a thoroughgoing account of the life-history of all those symbols which appear in the fantasies of Pieter Breughel. And yet iconography cannot capture their meaning. The truth of those strange and tortured landscapes does not lie in the single meaning of any creature or object depicted. The truth, rather, infuses it. It is the cryptic language of violence and degradation during the years of the Reformation in the Low Countries. It is the language of agony, suppression, burnings-at-the-stake, the abuses of religious absolutism and its equally fanatic Protestant enemy.

Truth in the art of the "isms" lay in intense exploration of the means of the painter—in materials, structure, space and form.

Truth in art during the Renaissance lay in the very tide of humanistic resurgence of which art was only one manifestation.

But the notable fact about all truth in art is that it is never content with mere surface realities. To reiterate that which has already been created is only eclecticism. To reproduce without new evaluation would be meaningless. Art is always visionary. Art always disturbs present realities, however satisfactory they may seem to the rest of the world.

The merely realistic point of view is incompatible with the creative. And yet the realistic point of view does characterize a great deal of professional scholarship, which likes to arrange its world as neatly as possible so that it will operate satisfactorily, and not require any painful readjustments in established theory—that this year's curriculum may be substantially the same as that of last year, and the even flow of intellectual life remain undisturbed.

Perhaps it is for such reasons that scholarship turns such a kindly eye upon eclecticism in art. If, in a gallery of paintings, the critic or aesthetic expert finds certain paintings which he may vaguely recognize—which have some faint, and more often blatant, look of something somewhere that he has known as good and worthy—then I believe that he will make his way toward that work of art much as he might make his way to the side of a friend at a cocktail party.

(Let me interject at this point that I do not, in this particular view of scholarship, mean to include those worthy and intense researches which have meant so much to art—which have preserved its treasures—which have brought such tremendous enrichment to practicing artists, as well as to the public. I speak here of that curious kind of scholarship which is parasitic rather than dedicated, which finds in art some sort of basis for self-arrogance.)

But if art is today in a becalmed state—and I think it is—I believe that the condition may be attributed in part to the leadership of art scholarship and its follower, art criticism. The critic is almost the only link between artist and public—a lamentable situation, in itself—and his power over the artist is heliotropic; whatever his aesthetic position, the artist turns that way. For among artists, as among the public generally, there will always be those who are more realistic than visionary in their outlook.

Perhaps another reason for the becalmed state of art may lie in the fact that truth-seeking itself has become a somewhat archaic practice in our contemporary civilization.

For, while art has often appeared in desert places, its great periods have been those of universal enlightenment. One needs to

Ben Shahn

cite only the period of the Renaissance in Italy or that of the so-called Golden Age in Greece to note that at such times humanistic curiosity was at high tide, and penetrated every possible field of endeavor. Science advanced equally with the other arts; philosophy dared to be creative, formulating those concepts which we now hold as the most staid realities. Art, during such times, has taken stimulus and inspiration from its surroundings.

May I quote a few lines in this connection from one of the essays of Erwin Panofsky. Mr. Panofsky says:

> Content, as opposed to subject matter, may be described as . . . that which a work betrays but does not parade. It is the basic attitude of a nation, a period, a class, a religious persuasion—all this unconsciously qualified by one personality, and condensed into one work. It is obvious that such an involuntary revelation will be obscured in proportion as one of the two elements, idea or form, is voluntarily emphasized or suppressed. A spinning machine is perhaps the most impressive manifestation of a functional idea and an abstract painting is probably the most expressive manifestation of pure form, but both have a minimum of content.

"Content," in Mr. Panofsky's terms, it seems to me, parallels what I like to think of as implicit truth in art, with its sense of enlightenment and emotional urgency. Academic art, on the one hand, and non-objectivism or abstraction, on the other, constitute those opposite extremes of subject matter and functionalism from both of which content has been excluded.

Realism as an aesthetic in art can be accepted or rejected only by the working artist himself. Any effort made to ban realism from art would, I am sure, promptly inspire some dozen or so artists to set out to prove its incomparable worth; any effort to establish realism as an indispensable ingredient of art would no doubt prompt another—possibly the same—dozen artists to show how well art could do without it.

If there is something to be learned from a reconsideration of realism, it seems to me that it is simply this: that the formulation of an aesthetic is peculiarly and exclusively the task of the artist—and that is, the artist in any field. Only he can possibly know what sort of plastic means will realize his own peculiar kind of enlightenment. There are the implied truths, the deeper-than-surface meanings in every possible facet of reality whether grave or trivial, and only the man behind the eye can determine which way the eye shall see.

In Defense of Chaos *Ben Shahn*

As a guest and interloper during the past week of enlightenment, I carry with me a heavy sense of guilt. I have heard and seen my environment being built around me and above my head; I have seen the doors closed and the windows locked. I have faced my diet of plankton; I have seen my linens replaced by paper—all to be well-ordered for me by benign and unseen forces—and I have said not one word in defense of Chaos!

I love Chaos; it is the mysterious, unknown road. It is the ever-unexpected, the way out; it is freedom; it is man's only hope. It is the poetic element in a dull and ordered world!

I am sure you think that I'm only amusing myself; well, that too, but I am serious. And I would like to communicate to you some little notion of what I conceive Chaos to be, and why I think that it is our unsung and uncelebrated human friend.

Insofar as I know, Chaos is utterly disallowed by science. The very notion of Chaos runs counter to any acceptable logic. Every object upon which we place our hands is part of some physical order; every object has its evolutionary history and its future existence either of long endurance or of predictable decay. And every part of this process is orderly. Every act of ours and every notion of the mind has also its history of impulses, exposures and connections. And all this is order. The macrocosms and the microcosms obey their proper physical laws. Where, then, is Chaos?

Even as any order of being—including me as an order and you as an order—unfolds through space and time, absorbs and reflects and digests its environment—as any such order pursues its own way, developing its individual shape and form, so are there other such orders, thousands and millions of them unfolding, too, wholly independently of each other. All are ordered within themselves and to their environment. But their courses through space and time may be completely unrelated, each one following and making its own rules. The disorderly element, the unpredictable, unforeseeable item is the moment of impact between two such orders. That is pure accident. It is the moment of Chaos. It may also be an act of Chaos. It may be deliberately undertaken by a conscious individual.

In nature, it is out of such conflicts between orders that the great changes have come about, the geologic upheavals, the earthquakes, the continental and celestial disturbances. In life, the

Talk given at the Aspen Design Conference, Aspen, Colorado, June 24, 1966.

Ben Shahn

mutations in species have probably been due to such conflicts between orders. In the processes of thinking, the great social changes, the revolutions, the overturns of tradition have been brought about by conflicts in order—between orders.

None of these episodes has any innate quality of being good or bad; they may be either beneficial or harmful to man; if they are sufficiently inexplicable we call them "acts of God."

But within the area of man's life and his thinking, there are fierce conflicts of orders, and there is fierce conflict between order and disorder. All such conflicts have what are called "value" aspects. Some prove to have been good; others prove to have been bad, and all claim to be good.

Among the thousand varieties of classification that might be applied to the fierce struggles between order and disorder in the human arena, there is one that I find especially interesting. That is the division, the conflict, between omniscience and/or tyranny on the one hand, and Chaos, or the-breaking-out-to-freedom on the other. I have had to name this breaking-out-to-freedom "Chaos" for the simple reason that a break for freedom is always a disruption of established order.

(I am certainly not condemning order as such; we could not live or breathe for a day without it. But neither can I accept it as an unqualified good. Sometimes we cannot breathe within it!)

However generous it may be in its intention, omniscience is a dangerous quality in us. Let us say that a designer has designed a living space so perfect in all its dimensions that no one takes issue with it. It has everything; extreme thoughtfulness and understanding have provided for every one of the dweller's needs. There are the conveniences; there is beauty everywhere; there is equipment and ministration to the sick; food is provided, and entertainment; there is paper for the writer and paint for the painter, and aphrodisiacs for the poor in spirit. Nothing is wanting. The occupants move around, function smoothly, time glides along.

No one wants to break out of this perfect place, there is no reason to. Through the days and the nights the bolts gradually slide into place along the windows; the locks rust on the doors. All exits, unused as they are, become sealed.

But no one actually notices this condition until the ever-restless poet exclaims, "Let's let a little air into this place! I'm suffocating!"

He is roundly condemned. Isn't the place air-conditioned? Who wants the hot, humid outside air? The poet insists; he begins to wrestle with the doorknobs; he tries all the windows. He is a troublemaker, a dissident element. He picks up a chair and throws

it through the window and makes his break for freedom. A few people follow but "The Society" stays inside. Not until he comes back with a bouquet of mountain flowers clutched in his hand do the occupants of the living-space begin to question their condition. (The planner, through an oversight, had forgotten to install mountain flowers.)

The people go out; they look around themselves—what a heavenly world! They are refreshed; they think of all sorts of things that they can do in the newly revealed world. They have broken out of the perfect place; they can grow. The poet dies, of course; he has fulfilled himself. He isn't really much mourned, he was such a chaotic element!

I said somewhere before that Chaos is not, even to my mind, an unqualified good. Certainly the poet is not the only deliberately chaotic element among us; so is the criminal; and psychologists, omniscient as they are, have frequently aligned the two elements in our society as being essentially the same individual, sharing the same characteristics of temperament.

But there is a difference so profound as to put them at opposite ends of the social scale of good and evil forces. Each one is, within himself, an order, evolved, predetermined and self-determining. The criminal strikes society with the impact of an order—an organism—built around and out of cruelty and hatreds. His vision is narrow; he is without compassion. His dreams and images are anti-human. He strikes only against, not in behalf of the other person.

The poet is motivated—I think almost always—by pro-human visions. These may not be acceptable to the society within the closed room; they may not even be particularly good for it—not necessarily at all. But the poet seeks freedom, fresh air; he has to breathe; he cannot stand suffocation; he cannot be shackled either by bad design or by good design, he just cannot be shackled. And, in seeking freedom for himself, he sees in his own act liberation for other people and for his society.

There is a very antique legend; it is the oldest one known, that holds Chaos to be a dragon named Tia-mat. According to this legend a certain god, Marduk, was chosen to destroy the dragon of Chaos. There was an historic battle and Chaos/Tia-mat was vanquished. But, most significantly, she was not actually destroyed. She was chained by Marduk, who then proceeded to place the north star in the Zenith, to arrange the heavens, separate the water from the earth, and create the planned society under which we have been living ever since.

Ben Shahn

Tia-mat reappears from time to time—almost anyone can see that —and she is quickly subdued again. But she is the dark genius of the artist and the poet, the musician, the dissenter and about three philosophers in every ten thousand. I don't propose to release Chaos and just turn her loose from the human race—we still must have banks and plane schedules. But I think it would be nice if we just made a pet of her and let her go free from time to time to get a breath of fresh air and romp around a little among the members of the Planned Society.

Imagination and Intention *Ben Shahn*

Whenever matters held to be ineffable come under review, it seems proper to call out the artists and poets, for surely this is their especial province. Imagination—so vague and impractical a human quality—seems to belong to that category. So we are here gathered to bear witness; and if we cannot add to the substance of the inquiry, at least we may lend it color.

I hope I will not be betraying my profession if I begin by saying that imagination is by no means ineffable. Imagination is equally shared by the bright and the dull, the flighty and the mundane. Imagination supplies the banalities of life as well as the inspirations. Imagination is the total conscious life of each one of us. Without it neither you nor I could make his way to his parked car, or recognize it when he arrived there. Without it we could not dress ourselves in the morning nor find our way to the breakfast table, nor know what we were eating, or what was said to us by our morning paper. Without it we would recognize nothing at all. This seems axiomatic.

For imagination is images, traces of experience, the residue of impacts made upon us by all sorts of forces both from outside and inside ourselves. It is such images retained, and the power to re-invoke them, the power to re-group them and out of them to create new images according to our uses and intentions.

But such images do not have hard edges and unalterably clear outlines. An image does not exist just as a visual, or just as a heard image; it is not just touch, taste, or motion—it is also emotion, frequently very compelling emotion. It is a frustrated hope with all its complicated visual and other dimensions; it is the image of a wrecked automobile with its implicit sense of horror. It is a

From *Review of Existential Psychology and Psychiatry* (Winter, 1967).

view of oneself sitting at an open café in Saigon, at ease, looking up the pleasant street so typically French with its even rows of trees, its pretty people—an image complicated by a subsequent sense of guilt and anguish in that war of which I am so inextricably a part. Not only do almost all images, to a greater or lesser degree, have some emotional coloration, but so do emotions exist in image form. And I believe that emotion cannot exist free of image.

To return momentarily to my assertion that we live totally within our imaginations, let me elaborate that somewhat. Let us say that we do return to our parked car; we can know it only because we carry its image within our consciousness; we have a mental image of the route by which we will reach it; we have an image of the motion of walking toward it, and of the look of the way; we recognize the keys in our hand because we have a tactile as well as a visual image of them. Our reading is images of letters, words, and the objects and situations that words represent. Habit itself is the image of action so often repeated that it no longer requires being consciously invoked in order to be acted out.

Thus, the common assumption that some of us have vast imagination while others have little or none seems to me quite untrue.

Some years ago, as I was laboriously planting a small maple tree in my front yard, cheering myself with visions of future cool drinks drunk in its future spreading shade, a neighbor of mine who was passing by stopped to watch me at work. He cleared his throat:

"D'you think it'll grow?"

I condemned him in my mind as a fellow with no imagination. But after some years of reflection I realize that he had just as much imagination as I. I am sure that, in his mind's eye, he could quite clearly see the tree a year hence standing dead in my front yard. Let's say that his imagination was other than mine—dour.

That brings us to the fact that imagination is selective. It is selective according to our intentions. But our intentions themselves are images—structures of images.

And here, all that is axiomatic ends, for I find this matter of intentions extremely provocative. I will talk about it somewhat according to my lights, which are oblique indeed.

Intention is a going-forward toward a goal, an aim, a conceived image of some sort. There are basic and fundamental intentions that are built around our temperamental needs and that set the general direction of our lives. Then of course, there are lesser, momentary intentions easily adopted, easily yielded. But

Ben Shahn

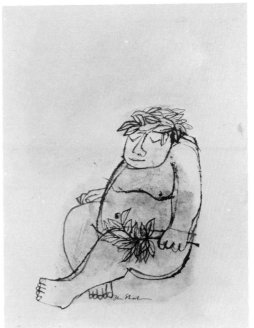

40. *Bacchus with Flower*, c. 1957. (Used as the jacket subject for S. J. Perelman's book *The Road to Miltown*.) Brush drawing, 13¾" x 9½". Collection of Kennedy Galleries, Inc., New York.

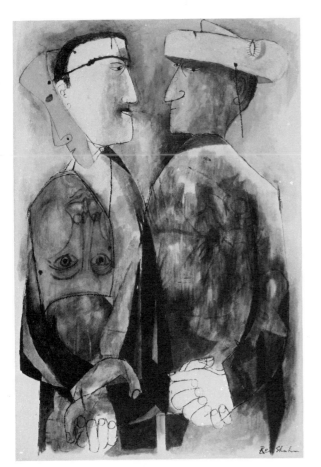

41. *Conversations*, 1958. Watercolor, 39½" x 27". Collection of the Whitney Museum of American Art, New York.

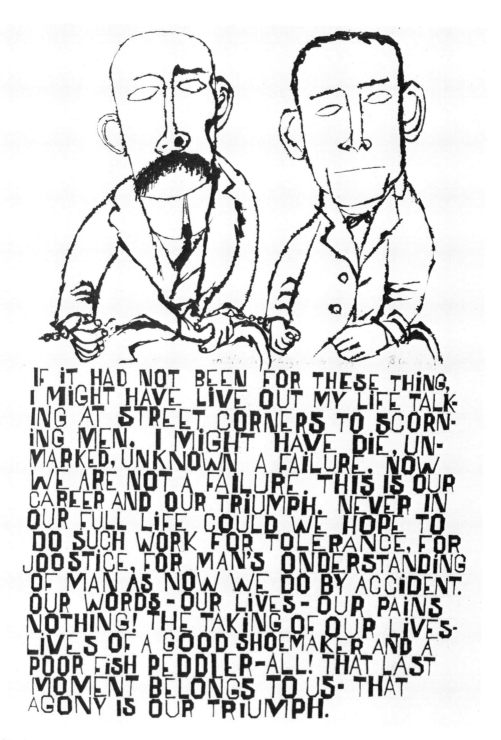

IF IT HAD NOT BEEN FOR THESE THING, I MIGHT HAVE LIVE OUT MY LIFE TALKING AT STREET CORNERS TO SCORNING MEN. I MIGHT HAVE DIE, UNMARKED, UNKNOWN A FAILURE. NOW WE ARE NOT A FAILURE. THIS IS OUR CAREER AND OUR TRIUMPH. NEVER IN OUR FULL LIFE COULD WE HOPE TO DO SUCH WORK FOR TOLERANCE, FOR JOOSTICE, FOR MAN'S ONDERSTANDING OF MAN AS NOW WE DO BY ACCIDENT. OUR WORDS-OUR LIVES-OUR PAINS NOTHING! THE TAKING OF OUR LIVES-LIVES OF A GOOD SHOEMAKER AND A POOR FISH PEDDLER-ALL! THAT LAST MOMENT BELONGS TO US- THAT AGONY IS OUR TRIUMPH.

42. *Sacco and Vanzetti*, 1958. Serigraph, 25¾" x 17½". Municipal Museum, Amsterdam.

43. *Triple Dip,* 1959. (Poster for an exhibition at The Downtown Gallery.) Gouache, 31″ x 23″. Collection of Kennedy Galleries, Inc., New York.

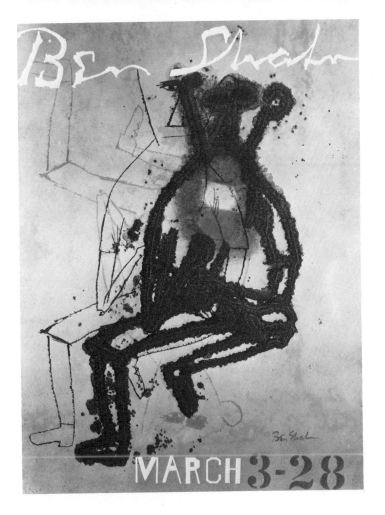

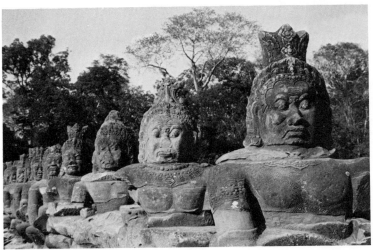

44. Untitled photograph of temple sculptures, Cambodia, 1960. Photography Collection, Fogg Museum, Harvard University, Cambridge, Massachusetts.

It is not the Soviet Union or indeed any other
big Powers who need the United Nations for their protection.
It is all the others. In this sense, the Organization is first of all their
Organization and I deeply [...] in the wisdom [...] I shall [...] o [...]

Ben Shahn

45. *Portrait of Dag Hammarskjöld*, 1962. Oil, 59½" x 47¾". National
Museum, Stockholm.

46. *Abstraction*, c. 1962. Oil, 82" x 14". Collection of The Newark Museum.

47. *Wast Thou There*, 1964. Gouache with gold leaf, 52" x 42". Collection of the Amon Carter Museum, Fort Worth.

48. *Peregrine Falcon—Mr. H. Falco Peregrinus*, c. 1965. Watercolor, 25″ x 19″. Collection of Kennedy Galleries, Inc., New York.

49. *Spoleto*, 1965. (Poster for the Festival of Two Worlds, Spoleto, Italy.) Watercolor, 26½″ x 20½″. Collection of Kennedy Galleries, Inc., New York.

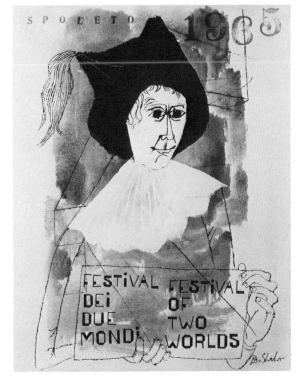

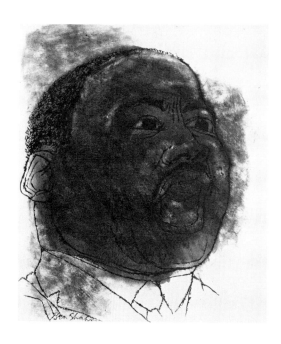

50. *Portrait of Martin Luther King*, 1966. Wash drawing, 26¼" x 10¼". Collection of Amon Carter Museum, Fort Worth.

51. *The Gestures of the Little Flowers*, 1968. (Original drawing for a lithograph illustrating "For the sake of a single verse . . . ," a paragraph from *The Notebooks of Malte Laurids Brigge*, by Rainer Maria Rilke.) Watercolor, 8¾" x 7½". Private collection. Photograph courtesy of Kennedy Galleries, Inc., New York.

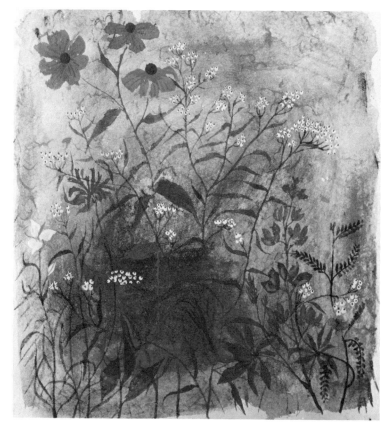

while intention does explain to a large extent the increasing selectivity of images and imagination, still, to understand the nature of intentions and of all images, it is necessary to look honestly at their very source—the self.

I am fully aware of just how rash an undertaking this is, this quest of self. The self has ever been the Abominable Snowman both of science and of philosophy, leaving its footprints on every slope of snow, leaving the signs of its presence everywhere, yet never appearing in person—eluding every chase and every scientific investigation until some have held that it doesn't exist at all. For when the self is approached as object it becomes subject, and when it is finally cornered and surrounded as subject, it teasingly dashes off and becomes object again.

But in the arts, and particularly in painting and poetry, the self is a content. It is perhaps both object and subject united in one image. It is the source of whatever truth art can discover. It is constantly invoked, consulted, conversed with. In deepest truth and fullest conviction I believe that the self has proved less elusive to art than it has to systematic investigation. Whatever the world knows of the self it knows through the arts and not through science.

The self, within its physical center, is an accumulation of images, known ones and many many unknown ones; and these images constitute its individual structure, its personality. I am sure that, in its initial stages, the self is only an awareness. But we must remember that awareness is not an abstract or intransitive state of being. Awareness is transitive; it requires an object. We are not just aware—we are aware of something. Then let me go on to an artist's definition: awareness is the absorption of images.

Since awareness must have its object to be aware of, I would hold that the self is a polarity between subject and object. No identification could be possible; no orientation could be possible without this inner-outer polarity. (And may I just note in passing that herein may lie the clue to an inconsistency that I have always felt in the statements of certain theorists on art—namely, that pure self-expression must be non-objective. The question would be: Can it be so?)

When images have been imprinted upon the awakening awareness, the first great human accomplishment takes place: recognition. Recognition of the original by means of the image—a face, food, an object, and I suppose that recognition may be the basis of knowledge. But that is not pertinent to our discussion.

What is pertinent is that images grow and increase, yielding

pleasure and displeasure; and willing and wanting arise vested in these images of experience. Willing and wanting—and many other such impulses—are the dynamics of intention; with them images spring to life, become active, and intention is born.

Intentions must be begotten by all sorts of accident, but they must also arise necessarily out of needs and of temperament. I am inclined to believe that there is a sort of temperament that characterizes artists—impatience, unwillingness to be led, fear of being trapped in stable situations—certainly one such quality is an arrogant belief in one's own authority; and another is an intense boredom with propriety and all its triteness. Whatever kind of aesthetic direction any artist may pursue, I think that we all of us tend to break out of traps and out of set situations.

We rather like to shake society out of its complacency. That may not be a worthy trait, but it's certainly a fairly universal one in artists. Thus, in the images that we invent there is not unlikely to be some element of shock. I do not think that such qualities could in any sense be called artistic temperament—there's nothing artistic about them; but it seems not unlikely that the sort of person who has such qualities may drift into art; for through art he may find the fullest satisfaction, the fullest freedom in the expression of his impulses.

There the resemblance among artists ends. The complicated imagery that accrues within the consciousness, that is so interacting and so unique, and that comes ever more highly polarized in us is the basis of the imagery that we create. It is the stuff of our intentions, but it is not necessarily the stuff of our art.

Art is a material thing; no picture, no sculpture is better than what meets the eye. No poem is better than its images realized in cadences. Whatever the intentions of the artist may be, they count for nothing if they are not implicit within his images. Intentions, what is more, may be an abuse of art, an enemy of art if they are pressed upon an unwilling material—in which case they create a duality, saying one thing in idea, another in material.

And it has been this schism between idea (or intention) and material that has given impetus to all non-objective art. For many artists believe, and with great validity, that idea has too often frustrated and suffocated the expressive powers of material.

But I myself believe that the material is equally senseless without the artist. The polarity that I have pointed out between subject and object is the essence of the art image. For between those levels of intention—the transitory, passing ones and the deep, life-dominating ones—it is possible to yield the one while maintaining

Ben Shahn

the other. One often finds that it is the more profound but less precise intention that emerges in his work and that gives it meaning.

The process of art is very much the discovery of images during work, the recognition of shapes and forms that emerge and awaken a response in us and that seem peculiarly of ourselves.

One wishes to communicate—and that does not mean to communicate to some select public. It means, rather, to communicate into some external object, some material, images that haunt and propel us. The images may be of many orders, of laughter-provoking figures, of mysterious, fear-laden shapes, or only of the act of painting. But one must impress the images into the material. I suppose that such a process might be called formulation; but I prefer the word communication because there is a constant interchange between subject and object.

Instances crowd into my mind. Not long after the war, I set about painting a general. I had feelings about the surface look of generals. I painted a uniformed man that was in the main, a surface of medals—just as I had envisioned the picture. No; it didn't work. I increased the number of medals. Still, no. I made each medal more precise and specific. No. I widened the shoulders and made the head smaller. No. More medals; no, no, no.

Finally, after some two weeks of work I dipped my brush in black paint and angrily defaced the picture with huge "X's." I looked at it with astonishment and exclaimed to myself, "Terrific!" In two seconds, literally, I had accomplished what I hadn't been able to do in two weeks. This was a direct, unequivocal statement. Recognition was instantaneous.

I have sometimes found myself beginning a picture with an image and coming up with an entirely different one—and I even like the trace of the first that may remain visible within the second —for search and dissatisfaction are real within us, and their shadow may be a telling image.

I recall a preoccupation with fires that was with me over a period of time. I tried to realize pictorially something of the panic that had remained within my nervous system as a result of a frightful childhood experience. I achieved the emotional impact that I sought not through an image of a burning house or of people wrapped in flames, but through the image of a dark red wolf-beast exuding flames and standing arched over a small knot of victims. I remember, too, that as I painted the insane eyes of the beast, that curious immediate recognition took place. I doubt that I have even actually encountered a wolf. But I believe that the wolf-terror

must be deeply embedded—almost archetypal—in those of us who are of Russian origin. Created images are not duplicates of experience but are always vestiges and fragments known and felt in many ways.

When such an image appears before us in our work, and when we are struck by its impact, by recognition of something almost unknown that we are searching for, such recognition is immediate, and there is a great joy in it. For one has communicated something of himself into a material object; and it remains there for his vast and unstinting admiration. He has imparted something of himself to the world.

The reason that lies behind all the notions and ideas that I have expressed here is to trace to its roots, if I can, my belief that the object is as necessary to art as is the objective world to the self. If the self is a relationship and a polarity with the outer environment; if the self could have neither location nor identity without such a relationship, then equally the art image must have object. It cannot be just subject.

And if all this paints for you a somewhat unfamiliar picture, perhaps you will accept it as just that.

Ben Shahn

X the artist and society

The key word in Shahn's attitude toward society was engagé. *His lifelong hatred of injustice would not let him stand aside when he beheld what he regarded as the wrongs of our social system. In action, words, and images he expressed his views fearlessly, as is revealed in his writing and in such pictures as* Ed Murrow Slaying the Dragon of McCarthy *(Ill. 38).*

Some Questions *Ben Shahn*

I have a very serious note here from Miss Macomber asking me to touch upon several specific points in this discussion. Most of them have, I surmise, been subjects of warm debate among the art students on your campus.

The over-all heading for the discussion is "The Place of the Artist in Modern Society." I'm inclined to tell you that, from my point of view, your title answers all the subjoined questions. In other words, "yes," the place of the artist *is* in modern society!

Of course there are artists who have reasoned that the artist's place is to be projected as an abstraction within time-space. And, in this atomic age, one must grant that there is some validity in such a position.

However, one of the great and tragic characteristics of the atomic age is that human values—morality, if you will—have not kept pace with scientific achievements. Thus we have the horrible spectacle of Hiroshima, accented by that of the ranking general who had his birthday cake baked in the shape of the bomb explosion.

It is my belief that the work of art is a product of the human spirit and that, conversely, the function of the work of art is to broaden and enrich the human spirit. Let us bring to man more of compassion and a little less of mechanical operations. Let's try to discover new truths and values pertaining to man himself rather than to the performance of his Buick or the surpassing excellence of the new bomb.

Yes, I believe that the artist in modern society is there, not only, perforce, by chronology and geography, but that he can be a significant factor in modern society just because he *is* concerned with the things of the imagination and spirit.

Your first specific question is as to whether the artist can make his ideals effective, and the answer is, "yes," if he has any.

The question goes on: "whether through 'erudite theories,' commercial art, or politics?"

The term "erudite theories" is, of course, a little loaded. Artists probably vary in the degree of their erudition, but I daresay that you will find it almost universally true that if you scratch the artist you will find the philosopher underneath.

Of course, I know that you refer particularly to those abstruse manifestos full of art gobbledegook by means of which a few artists

From a symposium at Smith College, Northampton, Massachusetts, 1949.

seek to mystify and awe their public. I would suggest that whatever fallacy exists here lies more in the *content* of the theory than in the mere fact that an artist has done some thinking and has attempted to systematize it into a theory. Emotionally (and because I, too, have been offended by a good many art theories) I'm with you in this. Yet I do think it's a little dangerous to start throwing taboos around.

As to commercial art, from the artist's own standpoint—from mine, anyway—I've made no distinctions in the work that I've done. If the piece of work happens to have some commercial use as its destination I don't see why that should alter the artist's attitude toward it. Let the buyer worry about that. Your obligation is toward your own work, and there's no reason why it should not be regarded as a further opportunity for you to do something good and something which you enjoy.

However, on the whole, I do not think that commercial work affords any sort of worthy outlet for a serious artist. Its uses are too circumscribed and, with rare exceptions, the buyer will always attempt to alter the artist's work.

As to the artist's involvement in politics, let me cite a Greek distinction. To the Greeks the word "idiot" was opposite in its connotation to the word "politic." The idiot was one without understanding of politics and unable to participate in political matters. I believe that helps clarify my position!

Do I think that the artist can synthesize his uncorrupted ideas of artistic truth with the qualified moral attitudes of the world? I believe that if the artist's ideas of "artistic truth" are really uncorrupted they will *include* the qualified moral attitudes of the world. I think that this is actually his grist, whether he acts toward it as critic, originator, priest, or iconoclast. I might reiterate that the artist's place is *in* modern society.

Here I would like to mention a tendency which I've noted among students or people still in the apprentice stage of art, to refer to themselves as "artists." It seems to me that the word artist, like "doctor," ought to indicate the person who, having mastered his tools and techniques, is now a practitioner capable of using his tools skillfully to communicate ideas. I mention this, not to belittle the student, but to point out that there are those who continue their research into techniques—their apprenticeship—into old age, making technique their chief concern and only content. To me this constitutes a curious negation of life; it is perhaps consonant with the degeneration of human values which I mentioned before.

Ben Shahn

Do I think it necessary for the artist to have "social significance" in his paintings to achieve contemporary greatness? Well, obviously, I do. But I also hold that whether the artist paints a bowl of pansies, or whatever, the "significance" of his work depends upon whether it expands the scope and perceptions of the people who behold it.

I'll qualify that by saying that *if* we were living in a stable and fairly secure society, it would not be incumbent upon the artist to emphasize any particular phase of the life around him. However, we're not. We now live in a time of turmoil, too susceptible to drastic and deplorable changes. I feel that the painter who can, under such circumstances, concern himself with a bowl of pansies is dodging issues and is afraid to participate in the life around him.

While I am certainly no existentialist, I find myself turning to their word, *l'engagement,* which implies the obligation and need of the individual (working in cooperation with others) to do something about the evils of his times. It might be noted, too, that they regard us Americans as "curiously disengaged."

I might sum up by saying, in answer to your very stimulating questions, I do my utmost to function as effectively in modern society as my powers permit. I think it incumbent upon the artist not to be disengaged. I am not.

The Future of Creativity *Ben Shahn*

Whoever can predict the course of art during the coming fifty years will be a valuable citizen, for he will be able to predict also the course of human affairs—whether we will have war or peace, whether we will live under civilian conditions or military, under dictatorship or democracy. He will be able to tell us whether the individual will still be free and sovereign.

This is in truth quite a modest claim. For where, better than in the art of any time, can we read the true spirit of that time. Art reacts as a sensitive needle to the society in which it exists, continuing after that society has vanished—an unerring record of how people lived, what they looked like and how they behaved.

As to the matter of what kind of art will survive into the future, let us first ask, to what end will the artist paint. And to what end does he paint now, since that, too, has its implications for the future. Will he operate on the highest intellectual and spiritual

From a symposium at the University of Buffalo, February, 1952.

level, comprehending the truths of his era, reinterpreting them, always addressing himself to that part of man wherein he is most civilized?

Or will he perhaps retreat into a smaller community of understanding intimates, growing ever more abstruse, ever more removed from the common human problems. Again, under other circumstances, will art become increasingly a "use" item—useful to some political regime, to industry, to sell goods, or ideas?

These functions of art are, I think, more a product of their times than the individual artist cares to admit.

During the last war, the work of American artists was effectively harnessed to the war aims. Indeed we felt our cause strongly, so much so that in some cases the art of war posters and illustrations rose above immediate use to achieve the universality and deep feeling of truly great art. But the main body of the work, once its use was served, failed to survive artistically. Its interest today rests in the accurate record it presents of the needs and the details of World War II.

During the same years we saw another kind of exploitation of art. The Hitler regime outlawed German Expressionism by fiat. In its place was substituted an art of *Kirche, Küche,* and *Kinder*—a bloodless representation of the kind of society that would best serve the Hitler aims. The soul-searching art of Kokoschka, the irreverence of Klee, the bitter truths of George Grosz—all that was too humanly revealing for Hitler; such art and artists were exiled. Communist doctrine, again, holds art to be a weapon, and has harnessed it to the uses of the state. Neither the formulae of commissars, nor inducements of honor, nor pretentious awards have yet succeeded in breathing life into Soviet art. Its deadly procession of overdrawn generals and overidealized proletarians bears sharp testimony to the fact that there is no conviction in the artists' hearts, and that the search for truth has been stalled.

Now I think we might examine American art, as of now, and in the light, too, of public attitudes, to see whether any of its present trends seem to have an assured future.

Quantitatively, the greater part of the American art product is strictly for use. It asks no embarrassing questions about aims and implications. It serves its business patron well, and will probably flourish as long as business does.

Of our fine art there are two main streams, one humanistic, necessarily asking the question, "to what end?", greatly concerned

Ben Shahn

with the implications of man's way of life; the other, the abstract and non-objective, absorbed in its own plastic problems, and not involved with the human prospect.

The latter has aligned itself with science to some extent. Like science, it greatly emphasizes "know-how," seldom asking to know why. Its literature has appropriated much of the time-space terminology of modern physics, and again, like contemporary science, it does not scrutinize its human implications.

Whether non-objective art will survive depends, of course, upon whether its plastic discoveries will hold enduring meaning for society. Presently it has several practical advantages—one, that since it is both socially and humanly noncommittal, it is not likely to tangle with censorship of any kind. Another is an advantage of trend, and still a third is the present wide acceptance of science, upon which non-objective art rests must of its rationale. I think that its great disadvantage lies in the fact that, having repudiated human content and the imagery of life, it is not likely to sink its roots deep into human soil.

As for the humanistic form of art, that art that necessarily evaluates things according to their human ends, it exists today in a somewhat inhospitable atmosphere, one complicated by the general fear of Communism. At first what was called "social content," then human content, and more recently, just content at all, have come under curiously bitter attack, as having some subversive connotation.

Yet if either art or society is to survive the coming half-century, it will be necessary for us to reassess our values. The time is past due for us to decide whether we are a moral people, or merely a comfortable people, whether we place our own convenience above the life-struggle of backward nations, whether we place the sanctity of enterprise above the debasement of our public. If it falls to the lot of artists and poets to ask these questions, then the more honorable their role. It is not the survival of art alone that is at issue, but the survival of the free individual and a civilized society.

I wish to reiterate the connection between public attitude and the status of the arts. I believe that they interact, that an enlightened public is the happiest circumstance for a full art expression, and that art, in its turn, is a factor in public enlightenment. They have always reached their heights in company. It is the mission of art to remind man from time to time that he is human, and the time is ripe, just now, today, for such a reminder.

The Problem of Artistic Creation in America Today *Ben Shahn*

It would be difficult, furthermore it would be presumptuous, for me or for anyone else to prescribe the environment that would be "right" for the artist, or "ideal," or even perfectly sympathetic. In thinking over the problem of artistic creation in America today, I've tried seriously to imagine just what would be a perfect environment or a perfect condition for artistic creation if one actually could make such a choice.

And each time that I've arrived at what seemed to be a good solution to the problem, it has mischievously presented me with its opposite. No one could doubt, for instance, that the completely free, uncensored, democratic environment is the most favorable one for art. Of course it is. And yet, think of Hieronymus Bosch working within an atmosphere charged with terror and persecutions; think of Pieter Breughel, painting amid the human burnings, the tortures and the various assorted nightmares of the Reformation; or think of David, surrounded by and fomenting revolution; or of the political corruption out of which Daumier sprang, and on which he thrived; think of the starvation and utter moral degeneracy of George Grosz's Germany. By some ironic contradiction, these murderous times became an essential element in the character and significance of each of these artists. Not even the most dedicated art lover would willingly revive any one of the above-named epochs; yet out of them, even in some cases because of them, we have had some immortal works of art.

I don't think we would be warranted in jumping to conclusions about how sweet are the uses of adversity, however. In contrast to the lives of the artists whom I've just named, we might think of that of Leonardo da Vinci, who worked in an atmosphere that would undoubtedly excite the envy of the most dedicated Sybarite. He was, as we know, surrounded by music, by poetry—some of which he wrote himself—by the conversation of the enlightened and sophisticated; he was the darling of dukes and popes and princes—not to mention their wives. He became rich in his own right through the skill of his hands and the fertility of his imagination. Still, curiously, his art remained unspoiled throughout his life—sensitive, powerful in concept, superb in workmanship.

One thinks of the Renaissance—of Leonardo's period—as having furnished possibly the most agreeable circumstances for

Talk given at a College Art Association meeting, Philadelphia, 1953.

Ben Shahn

painting of any era of which we know much. The gregarious-ness and fullness of life, its wealth of beauty, its fine individualism move through fifteenth-century painting in a rich and glowing procession. Patronage of the arts was openhanded, and public interest intense. The artist worked within a climate of perfectly free discussion—even free quarreling. There was a well-rewarded job for every painter or literary man or musician; for the artist, particularly, there were walls and triptychs and portraits, and there was ample opportunity to become known and honored. Art was able to explore new directions and new meanings, and thus it produced a vast and indestructible symbolism, created around the prevailing human values. The Renaissance symbolism was, and perhaps continues to be, one of the world's most civilizing forces.

Again, one may not deduce sweeping generalities from the fine life and relatively easy subsistence which the Renaissance artist enjoyed. One must consider such artists as our own Ryder, who worked in isolated loneliness, without sales and without honor; of Van Gogh, lonely, rejected by society, yet never wavering in his personal insight into nature, or in his own means of expressing it.

Nor is the freedom of opinion or of style that the Renaissance artist enjoyed an absolute sine qua non of great and significant art. The artists of the Byzantine school were, as we know, subjected to a rigid artistic dogma which dictated form, content, symbol, and ornament. Even the placing of a halo, or the position of hands and feet of the saint were set by convention and vested with religious sanctions. One might comment that the Byzantine mosaics certainly preserve and convey such a sense of rigidity, and then one must hastily add, "But that period produced a tremendously impressive art, full of austere beauty and religious grandeur." I know that there are many artists today who would like to capture something of the Byzantine austerity, but I cannot think of any artist who would willingly submit to the working conditions which produced it.

Then, returning to the problem of the really ideal condition for artistic creation, I am plagued by an exasperating notion: What if Goya, for instance, had been granted a Guggenheim; and then, completing that, had stepped into a respectable and cozy teaching job in some small, but advanced, New England college and had thus been spared the agonies of the Spanish Insurrection? The unavoidable conclusion is that we would never have had *Los Caprichos* or *The Disasters of War*. The world would not have been called upon to mourn for the tortured woman of the drawing inscribed, "Because She Was a Liberal!" Nor would it have stirred

to Goya's pained cry: "Everywhere it is the same!" Neither would it have been shocked by his cruel depictions of human bestiality, nor warned—so graphically, so unforgettably—that fanaticism is man's most abominable trait.

Perhaps our whole problem of artistic creation in America today might be focused upon through this instance of Goya. For life, seen and valued by the artist, emerges with new meaning. It is not just the artist's experience, but his values, his judgments, made with love, or anger, or compassion, that live in the work of art and make it significant to the public. For they change and modify the public's own values, and create value where there was none before.

So let us conclude that the artist, a thinking and feeling human being, must be where life is; and *here* is the most perfect set of circumstances for artistic creation. Or one might even reverse the proposition and say, wherever the artist is, life is, and here is the proper setting for artistic creation.

But I can readily anticipate the outcry which may rise from that art wing which holds that the artist must be "disengaged." For there is a new sort of monasticism growing among us, a bloodless, bodiless, even soulless kind of retreat from life which seeks to sterilize the artist from the common touch, and would remove him from among the people and events which are and always have been the very grist of art. And, while I am certain that such a retreat may be necessary to some artists, and indeed that some very profound painting may issue from that sort of monasticism, I hold that it is unthinkable to apply it as a rule for all art. Yet there is an increasing number of writers on art, of critics, of artists themselves, who hold that such a retreat from reality is an absolute and final condition for creativity.

No more would one insist that the artist settle himself on the corner of Broadway and 42nd Street, or try to get himself caught up in a revolution. There is neither a "right" background nor any given kind of subject matter that could be said to be especially appropriate for painting. Only that material is appropriate in which the artist finds meanings pertinent to his own beliefs, material out of which he can symbolize his own truths. It would not have made sense for Paul Klee to hang around the prize ring, nor for George Bellows to have explored the interior of his own mind, nor for Daumier to have retired to the MacDowell Colony. But that does not at all imply that some artist may not find in the MacDowell Colony just the right environment for the realization of his best abilities.

Ben Shahn

Wherever there has been human life at all, there has been an art of some kind. To examine the world's art is to gain intimate knowledge of its peoples. For within the whole story of art lies the most authentic history of humanity (if not the most widely accredited one), an account that reaches back to that Dawn Man who first was struck by the notion that certain materials about him could be molded into images of things that he saw or thought.

Since that time the artist has imitated, criticized, cajoled, mocked, and praised and even led his fellow men; not led them in the sense of a general or a statesman, but simply by making compelling symbols around his own, often very passionate idealism. Insofar as people think or act in terms of the symbols familiar to them, they have been affected and influenced by art.

On the whole I have always had some mistrust of special or contrived environments for the artist. I believe that they serve mainly to remove him from the common experience, and thus to rob his work of that authority and universality that comes of close and habitual observation; and that such environments tend also to produce art that has a special and limited, rather than a broad and universal meaning.

But I think that we might raise some question about the environment in which a public exists. Acting, appreciating, feeling, thinking, as it does, in terms of its familiar symbols, it seems that perhaps any public—to be healthy, to be civilized—must be constantly replenished with images of its own human meanings. It needs appraisal and reappraisal pictorially and otherwise, and here and there a dash of reckless criticism. It needs to be confronted with the new truths and the contemporary issues. It needs a little resurgence of belief from time to time, an honest passion or two, stated in contemporary terms. The predominant symbols of our civilization—the automobile, the bomb, the bathtub, the refrigerator—are not such as to stir a people to greatness, or to compassion for their world neighbors, or even to a sense of identity with the history and culture of the whole race. So it is my honest conviction that this problem of artistic creation with which we are here concerned is not so much a private one for the individual artist as it is a public one.

It is, I believe, the problem of the nurturing of civilized values. Thus, I believe that art—all the arts—should be widely subsidized, patronized, implemented in every possible way, not through motives of charity toward the artist, but in the interest of an advanced and civilized public.

Remarks to "The New Republic" on the Occasion of Its 50th Anniversary *Ben Shahn*

May I reiterate the words of Mr. S. J. Perelman, who some time ago wrote: "An old subscriber of *The New Republic* am I, prudent, meditative, rigidly impartial. I am the man who reads those six-part exposés of the Southern utilities empire, savoring each dark peculation. Weekly, I stroll the *couloirs* of the House and Senate with T.R.B., aghast at legislative folly. Every now and again I take issue in the correspondence pages with Kenneth Burke or Malcolm Cowley over some knotty point of aesthetics." *The New Republic* has, for more years than I would like to remember, but nevertheless do remember, been a careful student and judge of whatever aesthetic trends or aberrations have been dominant at any given period. It has, I must confess, from time to time been an intrepid spokesman for some of these aberrations, even though today its art criticism is the most astute that I know of anywhere. (An aesthetic aberration, I ought to admit in any kind of fairness is: any deviation from the clear, true path of aesthetic rightness—that is, someone else's opinion that goes counter to mine.)

But *The New Republic,* whether it may have been in a pro or con stage of aesthetic rightness, has consistently performed a great service toward art; that is, in its quiet recognition of the fact that art does belong on the pages of a mainly political journal. I am in fullest agreement with this point of view, believing as I do that artists are superb political theorists, and that if our service had been solicited, the country would have been many steps in advance of where it is today.

Consider Vietnam. Any dunce could see the folly of our tactics in that country. The people there have about as much will-to-power as a basketful of hungry kittens. They don't seem to care anything about freedom—even when force is applied, and that leaves us in a terribly embarrassing position. Why weren't the artists asked! What would we have done? Well, first we would have sent over a corps of Zen Buddhists of whom we have a good supply. They would have understood those recalcitrant wards of ours much better than has the military. We could have backed up the action by a fleet of battleships loaded with rice and thus have saved helicopters, men, ammunition, weed-killer, *and* face.

Indeed, our government might have taken a cue from the inter-

Talk given at a dinner at the Mayflower Hotel, Washington, D.C., March 5, 1964.

Ben Shahn

esting use made by the Vietnamese of the first technological aid that we sent them. That consisted, in part, of, I guess, some thousands of spools of many-colored nylon-wrapped wires of a highly specialized kind for electronic use. The people saw the possibilities in the wire and promptly set about putting it to use. They braided and twisted it with exquisite skill, turning it into hundreds of little dragons, tigers, demons, and gods of great beauty. These objects could be bought on the streets of Saigon for a few sous each. You might have thought that the artists had actually gotten in there and were already working with the people, but that was not the case; it was their own idea, and a very good one, too.

For some four or five years it has been apparent that trouble is brewing for Our Side in Indonesia, as well as in Saigon. And what will we do there? Of course we will follow in our own footsteps. That is to say that, having learned our know-how in Vietnam, we will proceed along the established lines in these islands and in other small, out-of-the-way places.

It is too bad that the artists will not be consulted in time to prevent bloodshed. We could wean the local folk away from any and all dictators without wasting a round of ammunition. How? It's simple:

First, we will set up in these steaming equatorial islands a network of frozen-custard stands from which we will dispense the icy delicacy free of charge to all comers, setting aside a decent amount for the gods. That strategem will not only remedy the immediate problem of starvation—which is, I am sure, the key to all Asiatic politics—but it will profoundly endear us to the carnival-loving inhabitants. We can then solidify our gains by the very practical measure of marketing the chief produce of the country, which is art. For nowhere in the world, I am sure, are there so many sculptors at work as there are in these islands. Nowhere on earth is wood-carving carried on with so much skill; nowhere is there such a profusion of paintings produced daily, such beauty of hand-dyed silks and cottons, such exquisite workmanship in objects of silver and gold. And nowhere, except in the immediately adjoining countries, is there so rich a tradition in dance and public story-telling and music. There is sufficient art produced in the Indonesian archipelago to supply a worldwide market—and perhaps even to remove from these gentle people the threat of progress—via heavy industry.

I submit this sample set of political notions to *The New Republic* in the utmost humility, and in appreciation of your fifty years of unflagging attention to our equally snarled aesthetic problems.

XI epilogue

Ben and the Psalms *Bernarda Bryson Shahn*

During the later years of Ben's life there was a certain resurgence of religious imagery in his work. It seemed to me that, since he had rather emphatically cast off his religious ties and traditions during his youth, he could now return to them freely with a fresh eye, and without the sense of moral burden and entrapment that they had once held for him.

He rediscovered myth and story and a holy spirit that had once offended him but that now held tremendous charm, even amusement, and that he could now depict with a light touch and with affectionate tenderness.

His reawakened interest was not confined to Jewish themes, although with his intimate knowledge of Jewish lore, he was able to present it in its most precise details and with all its natural color and variety. He was greatly moved also by Catholic forms and concepts. I remember a Mass that we once witnessed in the lower transept of the Church of Saint Francis in Assisi. Ben was spellbound by the scene, the kneeling monks, the dim light of the flickering tapers, the sonorous mumbling chant that rather softly filled the low stone galleries. Again, during another Mass in Palermo, we saw a child break loose from her mother's grasp and dance around in an open area in front of the altar. Ben whispered to me, "That's religion!" He so often quoted the principle by which medieval monks justified their continuation of graven imagery, which was, "Ornamentation toward the greater glory of God!"

He created several images of Martin Luther, but while he admired the stubborn freedom of conscience that begot Protestantism, he regarded the whole movement as being dry and antithetical to art. Heretically, he conceived of religion as being somewhat pagan in spirit and it was that spirit that he illuminated in his painting.

Very indicative of Ben's sense of religion is a paragraph from the writings of Maximus of Tyre of which he once made a beautiful book in large hand-drawn letters. The paragraph reads in part: "If a Greek is stirred to the rememberance of God by the art of Pheidias, an Egyptian by paying worship to animals, another man by a river, another by fire, I have no anger for their divergences. Only let them know; let them remember!"

Ben loved the Psalms, and above all the One Hundred and Fiftieth. He was deeply affected by its running cadences, its maj-

Foreword to *Hallelujah* (New York: Mourlot Graphics, 1970).

esty, its vivid imagery. He had done some small pieces around the musical instruments and figures of the Psalm, then conceived the idea of producing the book *Hallelujah*. He made the drawings and mounted them in book form. He then decided to do the drawings in larger dimensions with the dual purpose of rendering them on stone for an edition of lithographs and, in addition to that, creating a mural in mosaic to be based on the drawings. The mosaic design was not completed, but the lithographs for this book, *Hallelujah,* have been produced according to plan.

Ben Shahn

Bibliography

Writings by Ben Shahn

(In chronological order)

MILLER, DOROTHY C., and ALFRED H. BARR, JR., eds. *American Realists and Magic Realists*. New York: The Museum of Modern Art, 1943. (Catalogue of exhibition; statement by Shahn, pp. 52–53.)

"An Artist's Credo." *College Art Journal*, Autumn, 1949, pp. 43–45. (Condensation of paper read at the Second Annual Art Conference, Woodstock, New York, August 28–29, 1948.)

"The Artist's Point of View." *Magazine of Art,* November, 1949, pp. 266, 269. (Text of paper presented on Art Education sponsored by The Museum of Modern Art, New York, March 18–20, 1949. Balcomb Greene, Robert Motherwell, and Shahn participated in the session "The Artist's Point of View.")

"Aspects of the Art of Paul Klee." *Museum of Modern Art Bulletin,* Summer, 1950, pp. 6–9. (Speech delivered at the first of a series of symposia presented by the Junior Council of The Museum of Modern Art, New York.)

Symposium: The Relation of Painting and Sculpture to Architecture. New York: The Museum of Modern Art, 1951. (Typescript of symposium, in The Museum of Modern Art Library; includes remarks by Shahn. Published report in *Interiors,* May, 1951, p. 102.)

Paragraphs on Art. New York: Spiral Press, 1952. (The second in a series of brief personal credos prepared at the request of The Spiral Press. These paragraphs by Shahn gathered from speeches made at various times and places over the past few years.)

"The Future of the Creative Arts: A Symposium." *University of Buffalo Studies,* February, 1952, pp. 125–28. (One of several symposia on the theme "The Outlook for Mankind in the Next Half-Century." at the Niagara Frontier Convocation, December 7–8, 1951. Includes text by Shahn; remarks reprinted in Alfred H. Barr, Jr., ed., *Masters of Modern Art,* 1954, p. 162.)

"What is Realism in Art?" *Look,* January 13, 1953, pp. 44–45.

"How an Artist Looks at Aesthetics." *Journal of Aesthetics and Art Criticism,* September, 1954, pp. 46–51. (Paper presented at the annual meeting of the American Society for Aesthetics, East Lansing, Michigan, November 20, 1953.)

"The Artist and the Politicians." *Art News,* October, 1954, pp. 34–35, 67.

"They Can Rank with the Greatest Works of Art, But . . . Famous Painter Asks: Are Cartoons Now Among the Obits?" *Art News,* October, 1954, p. 50.

Alphabet of Creation. New York: Pantheon, 1954. Fifty copies, numbered 1–50, on Umbria paper, including an original drawing; 500 copies, numbered 51–550, on Rives paper, all signed, in slipcase. Trade editions; New York: Schocken, 1963 (hard cover), 1965 (paperback). (*Alphabet of Creation* is one of the legends from the *Sefer Ha-Zohar,* or *Book of Splendor,* an ancient Gnostic work written in Aramaic by the thirteenth-century Spanish scholar Moses

de Leon: This is a free adaptation by Shahn from several sources.)

"In the Mail: Art Versus Camera." *New York Times,* February 13, 1955, sec. 2, p. 15. (A letter to the editor in which Shahn takes exception to a review by Aline B. Saarinen, "The Camera Versus the Artist," which discusses the photographic exhibition "The Family of Man," organized by Edward Steichen.)

The Biography of a Painting. Fogg Picture Books, no. 6. Cambridge, Mass. Fogg Museum, 1956.

"Nonconformity: Excerpt from *The Shape of Content.*" *Atlantic Monthly,* September, 1957, pp. 36–41.

The Shape of Content. Cambridge, Mass.: Harvard University Press, 1957 (hardcover); New York: Random House, 1960 (paperback).

"Realism Reconsidered." *Perspecta* (1957), pp. 28–35. (Text of talk given at the Institute of Contemporary Art, London, February, 1956, in connection with the Tate Gallery's exhibition, "Modern Art in the United States.")

The Shape of Content. New York: Vintage, 1960. (The Charles Eliot Norton Lectures of 1956–57 reprinted as Vintage book V-108. Published in Japanese in 1965; in Italian in 1964.)

"Shahn in Amsterdam." *Art in America,* no. 3, 1961, pp. 62–67. (Shahn presents and interprets a wide selection of his paintings, some of which are later shown in a major retrospective exhibition arranged by the International Council of The Museum of Modern Art, New York.)

"Bill." *In the Visual Craft of William Golden.* Cipe Pineless Golden, Kurt Weihs, Robert Strunsky, eds. New York: Braziller, 1962. (Includes reproductions of works Shahn did for the Columbia Broadcasting System.)

Love and Joy About Letters. New York: Grossman, 1963.

"In Defense of Chaos." Talk at the Aspen Design Conference, Colorado, July, 1967. Appeared in *The Collected Prints of Ben Shahn,* Philadelphia Museum of Art, 1967; also in *Ramparts* Magazine, December 14, 1968.

The Biography of a Painting. New York: Paragraphic Books, 1966; Canada: FitzHenry and Whiteside, Ltd., 1966. (Same text as 1956 edition, but more profusely illustrated.)

"Imagination and Intention." *Review of Existential Psychology and Psychiatry,* Winter, 1967.

Writings Illustrated by Ben Shahn

(In chronological order)

Levana and Our Ladies of Sorrow (a portfolio of 10 lithographs by Ben Shahn and text of Thomas De Quincey's essay). Brooklyn, N.Y.: Philip Van Doren Stern, 1931. Edition of 212 portfolios containing 10 original lithographs drawn on the stone, 10″ x 13″ and printed in sepia on Canson & Montgolfier's *Papier Ancien;* 1–12 contain a suite of mounted and signed lithographs. (De Quincey's essay, never before printed separately since original publication in *Blackwood's Magazine* in 1845, issued especially for this edition,

was set in Goudy's Deepdene type and printed on Alexandra Japan.)

A Partridge in a Pear Tree. New York: The Museum of Modern Art, 1949. Revised, 1951; fifth printing, 1967.

MAUND. *The Untouchables*. New Orleans: Southern Educational Conference, 1955.

ALEICHEM, SCHOLOM. *Eine Hochzeit Ohne Musikanten*. Frankfort, Germany: Insel-Verlag, 1955.

Sweet Was the Song (musical score and calligraphy by Ben Shahn). New York: The Museum of Modern Art, 1956.

OWEN, WILFRED. *Thirteen Poems by Wilfred Owen*. Northampton, Mass.: Gehenna Press, 1956. Four hundred copies. Portrait of Owen wood-engraved by Leonard Baskin from a drawing by Ben Shahn and printed from the wood block; 1–35 bound in half leather with an extra proof of wood engraving printed on Japanese vellum and signed by artist and engraver.

BERRYMAN, JOHN. *Homage to Mistress Bradstreet*. New York: Farrar, Straus & Cudahy, 1956.

Jubilate Agno Poem of Christopher Smart. Cambridge, Mass.: Fogg Museum, 1957. (Christopher Smart was an early 18th-century poet.)

DAHLBERG, EDWARD. *The Sorrows of Priapus*. New York: New Directions, 1957. Limited edition of 150 on mold-made Arches paper, signed by author and artist; also a trade edition.

REID, ALASTAIR. *Ounce Dice Trice*. Boston and Toronto: Little, Brown, 1958.

SAMSTAG, NICHOLAS. *Kay Kay Comes Home*. New York: Ivan Oblensky, Inc., 1962.

ISH-KISHOR. *A Boy of Old Prague*. New York: Pantheon, 1963.

BERRY, WENDELL. *November Twenty-Six Nineteen Hundred Sixty-Three*. New York: Braziller, 1964.

UNTERMEYER, LOUIS, ed. *Love Sonnets*. New York: Odyssey Press, 1964.

SHAHN, BEN, ed. *Maximus of Tyre*. New York: Spiral Press, 1964.

HUDSON, RICHARD. *Kuboyama and the Saga of the Lucky Dragon*. New York and London: Thomas Yoseloff, 1965. (Text by Richard Hudson is based on the book *The Voyage of the Lucky Dragon* by Ralph E. Lapp.)

Haggadah for Passover. Introduction and historical notes by Cecil Roth. Boston: Little, Brown, 1965

Ecclesiastes or, The Preacher, in the King James translation of the Bible, with drawings by Ben Shahn. Engraved in wood by Stefan Martin. Calligraphy by David Soshensky. New York: Spiral Press, 1965.

Psalm 24. New York: Doubleday, 1965.

DUGAN, A. "Branches of Water or Desire." *Art in America,* October, 1965, pp. 30–1.

ALEICHEM, SHOLOM. *Inside Kasrilevke*. New York: Schocken, 1965.

PORTER, KATHERINE ANNE. *The Christmas Story*. New York: Delacorte, 1967.

Ecclesiastes (handwritten and illustrated by Ben Shahn). Paris: Trianon Press, 1967. Twenty-six copies, lettered A–Z on Arches Grand Velin, containing two original lithographed drawings signed by the artist, with extra set of illustrations and a progressive series of states of the plates; 200 copies, numbered 1–200 on Arches Verge, containing one original lithographed drawing signed by the artist. Reprinted in 1971 by Grossman-Trianon.

The Cherry Tree Legend. New York: The Museum of Modern Art, 1967.

I Sing of a Maiden. Self-produced, 1968.

Love and Joy. Self-produced, 1968.

For the Sake of a Single Verse (from *The Notebooks of Malte Laurids Brigge* by Rainer Maria Rilke). New York: Atelier Mourlot, 1968. Edition of 950 containing 24 original lithographs, each sheet 22½″ x 18″; 1–200 on Richard de Bas handmade paper, numbered and signed by the artist; 201–950 with lithographs signed on stone; all portfolios signed by hand by the artist.

Hallelujah. New York: Mourlot Graphics, 1971. A portfolio of 14 prints in black and white from drawings by Ben Shahn, illustrating Psalm 150; 25″ x 30″ on *velin d'Arches*. Limited to an edition of 100–150.

Selected Works Incorporating Discussions of Ben Shahn

(In alphabetical order)

BAUR, JOHN, ed. *New Art in America: Fifty Painters of the 20th Century.* Greenwich, Conn.: New York Graphic Society in cooperation with Praeger, 1957.

"Ceramics by Twelve Artists." *Art in America,* December, 1964, p. 40.

CHARLOT, JEAN. *Art: From Mayans to Modern.* London: 1938.

CONNOLLY, CYRIL. "An American Tragedy." *New Statesman and Nation,* June 29, 1946, pp. 467–68. (Review of the Tate Gallery exhibition of American art.)

ELIOT, ALEXANDER. *Three Hundred Years of American Painting.* New York: Time, Inc., 1957.

GOODRICH, LLOYD, and JOHN BAUR. *American Art of Our Century.* New York: Whitney Museum of American Art and Praeger, 1961.

GUITAR, MARY ANNE. *Twenty-two Famous Painters and Illustrators Tell How They Work.* New York: McKay, 1965.

LARKIN, OLIVER. *Art and Life in America.* New York: Rinehart, 1949.

MORSE, JOHN D. "Henri Cartier-Bresson." *Magazine of Art,* May, 1947, p. 189. (Shahn's opinion on the photographer and on photography in general.)

PEARSON, RALPH M. *The Modern Renaissance in American Art.* New York: Harper, 1954.

RODMAN, SELDEN. *Conversations with Artists.* New York: The Devin-Adair Co., 1957.

SOBY, JAMES THRALL. *Contemporary Painters.* New York: The Museum of Modern Art, 1948.

"200 Years of American Painting." *St. Louis Museum Bulletin* XLVIII (1964): 45.

VOLLMER, HANS. *Allgemeines Lexikon der Bildenden Künstler*, vol. 4. Leipzig: 1958.

WILENSKI, R. H. "A London Look at U.S. Painting in the Tate Gallery Show." *Art News*, August, 1946, pp. 23–29. (Refers to Shahn's *Liberation*.)

Selected Works Primarily About Ben Shahn

(In alphabetical order)

ABELL, WALTER. "Art and Labor." *Magazine of Art*, October, 1946, p. 231+. (Discusses Shahn's contribution to the CIO Political Actions Committee.)

Art News, November, 1961, p. 20. (Review of Downtown Gallery show.)

"Aspen, Quote Unquote." *Print*, September, 1966, p. 44+.

BARR, ALFRED H., JR. "Gli Stati Uniti alla Biennale: Shahn e de Kooning—Lachaise, Lassaw e Smith." *La Biennale di Venezia*, April–June, 1954, pp. 62–67.

Ben Shahn. Masterpieces of the World, vol. 16. Tokyo: Heibonsha Publishers, 1965.

"Ben Shahn." *Harper's*, December, 1957, pp. 79–81. (About Shahn's illustrations for the magazine.)

"Ben Shahn: Drawings and Graphics at Kennedy Gallery." *Arts Magazine*, February, 1969, p. 63.

"Ben Shahn, Ill." *New York Times*, December 19, 1966, p. 51, and December 21, 1966, p. 29.

"Ben Shahn: The Downtown Gallery." *Art News*, April 19, 1932, p. 10. (Review of Sacco-Vanzetti show.)

"Ben Shahn: The Downtown Gallery." *Art News*, May 13, 1933, p. 5. (Review of *The Mooney Case* show.)

"Ben Shahn at Kennedy." *Arts Magazine*, September, 1968, p. 22. (Illus.: *Our House in Skowhegan*.)

"Ben Shahn Shows in London." *Studio International* (Kent, England), June, 1964, pp. 240–41. (Illus.: *Maximus*, drawing for *Labyrinth; Shakespeare*, drawing; *Labyrinth*, in color.)

"Ben Shahn Wins National Institute of Arts and Letters Gold Medal." *New York Times*, January 28, 1964, p. 28.

BENTIVOGLIO, MIRELLA. *Ben Shahn*. Rome: De Luca, Editore, 1963.

"The Bronx—A Typical Treasury Competition." *Art Digest*, June 1, 1938, p. 26.

BRYSON, BERNARDA. "The Drawings of Ben Shahn." *Image* (London), Autumn, 1949, pp. 39–50. (Includes reproductions of drawings for the CBS programs "Fear Begins at Forty" and "Mind in the Shadow," and for articles in the *New Republic, Fortune*, and *Harper's*.)

BUSH, MARTIN. *Ben Shahn: The Passion of Sacco-Vanzetti*. Syracuse, N.Y.: Syracuse University Press, 1968.

BRANDON, HENRY. "A Conversation with Ben Shahn." *New Republic*, July 7, 1958, pp. 15–18. (A taped conversation for *The Sunday*

Times, London, which appeared in the March 16, 1958, issue of the newspaper.)

CHANIN, A. L. "Shahn, Sandburg of the Painters." *The Sunday Compass,* October 30, 1949, p. 14.

CHARLOT, JEAN. "Ben Shahn." *Hound and Horn,* July–September, 1933, pp. 632–34.

COATES, ROBERT. "Should Painters Have Ideas?" *New Yorker,* March 14, 1959, pp. 154–55. (Review of Downtown Gallery show.)

DAVIS, STUART. "We Reject—the Art Commission." *Art Front,* July, 1935, pp. 4–5. (Protests the rejection of the Rikers Island mural by the Municipal Art Commission; illustrations of a section and a detail of the proposed mural.)

"Excerpt from Introduction to Lionni's Exhibition in Milano." *Domus* (Milan), January, 1967, p. 53.

"Exhibition at Kennedy Galleries." *Apollo News Series* (London), November, 1968, p. 392. (Illus.: *Portrait of Senator Fulbright.*)

"Exhibition at Kennedy Gallery." *Art News,* October, 1968, p. 67. (Illus.: *Farmer Seated on a Porch; Vox Pop.*)

"Exhibition at Kennedy Gallery." *Art News,* February, 1969, p. 68.

"Exhibition at Leicester Galleries." *Apollo News Series* (London), June, 1964, p. 508. (Illus.: *Portrait of a Man,* drawing.)

FARR, DENNIS. "Graphic Work of Ben Shahn at the Leicester Galleries." *Burlington Magazine* (London), December, 1959, p. 470.

"Fine Arts Medalist." *American Institute of Architects Journal,* May, 1966, p. 16.

FRANKEL, H. "Glass Houses and Green Rooms." *Saturday Review,* May 15, 1965, p. 30.

GELLERT, HUGO. "We Captured the Walls!" *Art Front,* November, 1934, p. 8. (About the proposed rejection of murals submitted for The Museum of Modern Art exhibition.)

GETLEIN, F. "$475 Bargain." *New Republic,* April 30, 1966, pp. 27–28.

———. "Letter and Spirit." *New Republic,* January 25, 1964, pp. 25–26.

GILROY, HARRY. "A Happy Response to Ben Shahn in Amsterdam." *New York Times,* January 21, 1962, sec. 2, p. 17. (A report of the exhibition circulated by the International Council of The Museum of Modern Art.)

GOLDEN, CIPE P. "Ben Shahn and the Artist as Illustrator." *Motif,* September, 1959, pp. 94–95.

———. *A Medal for Ben.* New York: American Institute of Graphic Arts, 1959. (Remarks delivered by Mrs. Golden at the presentation of the medal of the American Institute of Graphic Arts to Ben Shahn at dinner meeting in New York, November 13, 1958.)

GREENBERG, CLEMENT. "Art" (column). *The Nation,* November 1, 1947, p. 481. (Review of The Museum of Modern Art retrospective.)

GUERCIO, ANTONIO. *Ben Shahn.* Rome: Editore Riuniti, 1964.

GUTMAN, WALTER. "The Passion of Sacco-Vanzetti." *The Nation,* April 20, 1932, p. 475. (Review of Downtown Gallery show.)

HALE, HERBERT D. "Ben Shahn." *Art News,* April, 1959, p. 13. (Review of Downtown Gallery show.)

HESS, THOMAS B. "Ben Shahn Paints a Picture." *Art News,* May, 1949, p. 20+. (Photographic story by Thelma Martin.)

"In Homage." *New Yorker,* September 29, 1962, pp. 31–33. (Interview with Shahn on the memorial dedicated to Franklin D. Roosevelt in Roosevelt, N.J.)

JOSEPHSON, MATTHEW. "Passion of Sacco-Vanzetti." *New Republic,* April 20, 1932, p. 275.

KRAMER, HILTON. "Ben Shahn: Retrospective." *New York Times,* October 27, 1968, sec. 2, p. 25.

————. "Month in Review" (column). *Arts,* April, 1959, pp. 44–45. (Review of Downtown Gallery show.)

LEVINE, J. *Nation,* March 31, 1969, p. 390.

LIONNI, LEO. "Ben Shahn. His Graphic Work." *Graphis 62* (Zurich), 1965, pp. 468–85. (Includes selection from *Paragraphs on Art:* cover by Shahn.)

LOUCHEIM, ALINE B. "Ben Shahn Illuminates." *New York Times,* August 30, 1953, sec. 2, p. 8. (About Shahn's drawings for off-Broadway production of *The World of Sholom Aleichem.*)

"Mellowed Militant." *Time,* September 15, 1967, pp. 72–73.

MOE, OLE HENRIK. "Ben Shahn." *Kunsten Idag* (Oslo), no. 1, 1956, p. 30+. (Text in Norwegian and English.)

MORSE, JOHN D. "Ben Shahn: An Interview." *Magazine of Art,* April, 1944, pp. 136–41.

"New Deal Defeatism." *New York Daily Mirror,* October 16, 1944, p. 17. (Election campaign; anti-Roosevelt editorial using as its starting point Shahn's poster "For Full Employment After the War —Register—Vote.")

New York Times, September 11, 1968, p. 49. (Interview.)

————, October 13, 1968, sec. 2, p. 39. (Interview.)

————, March 15, 1969, p. 1. (Obituary.)

————, March 23, 1969, sec. 2, p. 30. (Tribute by John Canaday.)

Newsweek, March 24, 1969, p. 94. (Obituary.)

PECK, EDWARD S. "Ben Shahn, His 'Personal Statement' in Drawings and Prints." *Impression,* September, 1957, pp. 6–13.

"Personal Backgrounds." *House and Garden,* December, 1965, pp. 178–79.

"Portrait: Ben Shahn." *Art in America,* Winter, 1957–58, pp. 46–50. (Photographs of the artist at work by Fernandez.)

ROBERTS, K. "London Exhibition." *Burlington Magazine* (London), June, 1964, p. 354.

RODMAN, SELDEN. "Ben Shahn." *Portfolio* (Annual of the Graphic Arts), 1951, pp. 6–21.

————. "Ben Shahn: Painter of America." *Perspectives USA,* Fall, 1952, pp. 87–96.

————. *Portrait of the Artist As an American. Ben Shahn: A Biography with Pictures.* New York: Harper, 1951.

————, ed. "Ben Shahn Speaking." *Perspectives USA,* Fall, 1952, pp. 59–72.

"Shahn Mural at Syracuse." *American Institute of Architects Journal,* Winter, 1968–69, p. 202.

SOBY, JAMES THRALL. *Ben Shahn.* The Penguin Modern Painters. New York: The Museum of Modern Art and Penguin Books, 1947.

————. "Ben Shahn." *Graphis 22* (Zurich), 1948, p. 102+.

————. "Ben Shahn." *Museum of Modern Art Bulletin,* Summer, 1947, pp. 1–47. (Special issue devoted to Shahn retrospective; supplement to the Penguin monograph *Ben Shahn.*)

————. *Ben Shahn: Graphic Art.* New York: Braziller, 1957.

————. *Ben Shahn: Paintings.* New York: Braziller, 1963.

————. "Ben Shahn and Morris Graves." *Horizon* (London), October, 1947, pp. 48–57.

STERMER, D. "In Memoriam: Ben Shahn." *Ramparts,* May, 1969, pp. 17–20.

TASSI, ROBERTO. *I Maestri Del Colore.* Milan: Fabbri Editore, 1969.

Time, March 21, 1969, p. 67. (Obituary.)

"Trianon Press Offers Limited Editions of Haggada Illustrated and Lettered by Ben Shahn for $450–$1,600." *New York Times,* April 10, 1966, p. 65.

WERNER, ALFRED. "Ben Shahn." *Reconstructionist,* October 3, 1958, p. 16+.

————. "Ben Shahn's Magic Line." *The Painter and Sculptor* (London), Spring, 1959, pp. 1–4.

WHITING, PHILIPPA. "Speaking About Art: Rikers Island." *American Magazine of Art,* August, 1935, pp. 492–96. (About the rejection of sketches by Shahn and Block; includes opinions of the prisoners.)

WILLARD, C. "Drawing Today." *Art in America,* October, 1964, p. 64.

WILLIAMS, HON. HARRISON A., JR., of New Jersey, in the Senate of the United States. "Death of Ben Shahn." *Congressional Record,* April 1, 1969, E2529–30. (Includes article "Shalom, Ben Shahn" by P. Lewis, from Trenton *Sunday Times–Advertiser, Pleasure,* March 23, 1969.)

index